picturing modernism

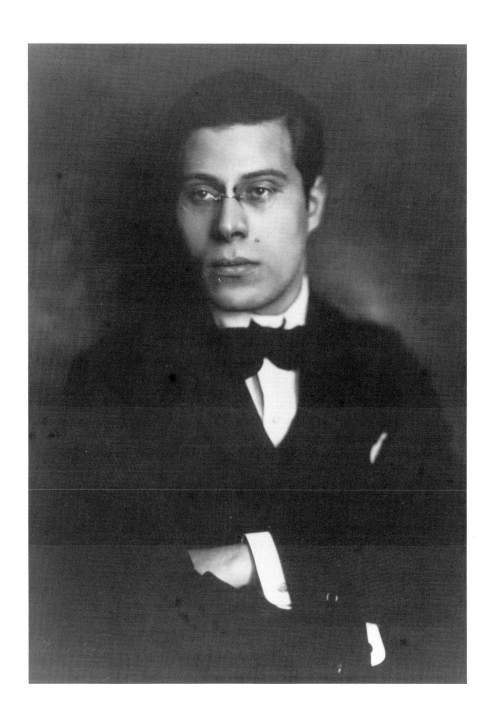

moholy-nagy and photography
in weimar germany

picturing modernism

eleanor m. hight

the mit press cambridge, massachusetts london, england

This book was set in Helvetica by DEKR Corporation, Woburn, Massachusetts, and was printed and bound in the United States of America.

Library of Congress Cataloging-in-Publication Data

Hight, Eleanor M.
 Picturing modernism : Moholy-Nagy and photography in Weimar Germany / Eleanor M. Hight.
 p. cm.
 Includes bibliographical references and index.
 ISBN 0-262-08232-2
 1. Moholy-Nagy, László, 1895–1946. 2. Art and photography—Germany. 3. Modernism (Art)—Germany. I. Title.
 TR140.M584H54 1995
 770′.92—dc20 94-21225
 CIP

Frontispiece: Erzsi Landau, *Portrait of László Moholy-Nagy, Budapest,* before 1920. Collection of Hattula Moholy-Nagy, Ann Arbor.

Title page illustration: László Moholy-Nagy, *Chute,* 1923. The Museum of Modern Art, New York. Gift of Sibyl Moholy-Nagy. (See page 164.)

contents

List of Illustrations — vi

Acknowledgments — xii

1 Reading and Misreading Moholy — 2

2 From Berlin to the Bauhaus — 12

3 Production / Reproduction — 42

4 Light: Medium and Message — 56

5 Camera Vision as Modernist Metaphor — 96

6 The Experience of Modernity — 128

7 The Bauhaus Books — 174

8 The New Vision, Language of Modernism — 196

9 Exile — 208

Notes — 216

Selected Bibliography — 236

Index — 250

illustrations

Frontispiece: Erzsi Landau, *Portrait of László Moholy-Nagy, Budapest,* before 1920.

1. Unknown photographer, *László Moholy-Nagy with Soldiers, World War I,* ca. 1915. Page 13

2. *Épits! Épits! (Build! Build!),* 1919. Page 16

3. *Peace Machine Devours Itself,* 1921. Page 17

4. *Bridges,* ca. 1920–1921. Page 18

5. *Large Railway Painting,* ca. 1920–1921. Page 19

6. *Composition 19,* ca. 1920. Page 22

7. *Glass Architecture,* 1922. Page 23

8. *Composition Q VIII,* 1922. Page 25

9. *Wood Sculpture,* ca. 1921. Page 26

10. *Nickel Construction,* 1921. Page 28

11. Vladimir Tatlin, *Monument to the Third International,* 1920. Page 29

12. *Kinetic Constructive System (Design for a Light Machine for Total Theater),* 1922. Page 30

13. *Telephone Picture EM2 (Telephonbild),* 1922. Page 31

14. *The Dada-Constructivist Congress in Weimar,* 1922. Page 35

15. *Metal Sculpture (Metallkonstruktion),* 1921–1923. Page 39

16. Illustrations from Kassák and Moholy-Nagy, *Buch neuer Künstler.* Page 46

17. *Untitled (Photogram),* 1922. Page 50

18. *LIS,* 1922. Page 51

19. Hans Richter, *Prelude* (detail), 1919. Page 53

20. Lucia Moholy, *László Moholy-Nagy at the Dessau Bauhaus,* ca. 1925. Page 58

21. *Untitled* (three photograms), 1922. Pages 62–64

22. Christian Schad, *Schadograph,* 1919. Page 65

23. Hans Arp, *Composition,* ca. 1915. Page 66

24. *Untitled (Photogram with Eiffel Tower and Gyroscope),* ca. 1925. Page 68

25. Man Ray, *Delicious Fields—Comb,* 1922. Page 69

26. Illustrations from *Malerei, Photographie, Film.* Page 71

27. *Photogram,* 1924. Page 75

28. *Untitled (Photogram with Arcs),* n.d. Page 77

29. *Photogram,* n.d. Page 78

30. Kazimir Malevich, *Suprematism (Supremus No. 50),* 1915. Page 79

31. *Untitled (Photogram),* ca. 1925. Page 80

32. *Photogram,* n.d. Page 81

33. *Photogram,* n.d. Page 82

34. *Untitled (Photogram),* n.d. Page 84

35. Irmgard Sörensen-Popitz, *Hanging Sculpture (Schwebende Plastik),* 1924. Page 85

36. *Untitled (Photogram),* n.d. Page 86

37. *Construction,* 1922. Page 87

38. *Untitled (Photogram),* 1922. Page 88

39. Cover design for journal *Foto-Qualität,* 1931. Page 89

40. El Lissitzky, *The Constructor (Self-Portrait),* 1924. Page 90

41. *Untitled (Photogram with Ellipse and Straight Lines),* 1927. Page 91

42. *The Light-Space Modulator,* 1930. Page 92

43. *The Light-Space Modulator,* from *Die Form* (1930). Page 94

44. Stills from Moholy's film *Lightplay Black-White-Gray (Lichtspiel schwarz-weiss-grau),* 1930. Page 95

45. Photographer unknown, *Portrait of László Moholy-Nagy,* n.d. Page 98

46. Heinrich Kühn, *My Garden (Mein Garten),* 1908. Page 99

47. Albert Renger-Patzsch, *Blast Furnaces,* 1927. Page 102

48. *Street Drain (Rinnstein),* 1925. Page 105

49. Lucia Moholy (?), *László Moholy-Nagy and the Danish Painter Franziska Claussen, Paris,* 1925. Page 106

50. *Notre Dame de Paris,* 1925. Page 108

51. *Paris (Eiffel Tower),* 1925. Page 109

52. Book jacket for Sigfried Giedion's *Bauen in Frankreich, Bauen in Eisen und Eisenbeton,* 1928. Page 111

53. *Bauhaus Balconies (Bauhausbalkone in Dessau),* ca. 1926–1928. Page 113

54. Alexander Rodchenko, *House on Myasnicka Street,* 1924. Page 115

55. Theo van Doesburg, *Counter-Composition V,* 1924. Page 116

56. *Dessau,* ca. 1926–1928. Page 117

57. Lucia Moholy, *Bauhaus Building at Dessau: Balcony of Student Apartment,* ca. 1926–1927. Page 119

58. Alvin Langdon Coburn, *The Octopus,* 1912. Page 120

59. Illustrations from "Geradlinigkeit des Geistes—Umwege der Technik." Page 122

60. *Berlin Radio Tower,* ca. 1928. Page 123

61. *From Radio Tower, Berlin,* 1928. Page 124

62. Hansa Luftbild, GmbH, *The Funkturm, Berlin,* ca. 1930s. Page 125

63. *View from Pont Transbordeur, Marseilles (Aerial View of Cords Piled in a Circular Pattern),* 1929. Page 126

64. *At Coffee (Bei Mokka),* n.d. Page 130

65. *Lucia Moholy, Ascona,* ca. 1926. Page 132

66. *Ascona (In the Shade),* 1926. Page 134

67. *Dolls,* 1926. Page 135

68. *Portrait of Lucia Moholy,* n.d. Page 136

69. *Portrait of Lucia Moholy,* ca. 1926. Page 137

70. *Behind the Back of God,* 1926. Page 139

71. Lucia Moholy, *Florence Henri, Paris,* ca. 1926–1928. Page 140

72. *Ellen Frank,* ca. 1929. Page 141

73. *Untitled (Lucia Moholy),* 1925. Page 143

74. *Repose,* n.d. Page 144

75. *Untitled (Portrait of Ellen Frank),* 1930. Page 145

76. *Nude (Positive),* 1931. Page 148

77. *Nude (Negative),* 1931. Page 149

78. *The Farewell (Der Abschied),* 1924. Page 151

79. Max Ernst, *Untitled,* 1920. Page 152

80. *The Shattered Marriage (Die zerrüttete Ehe),* 1925. Page 154

81. Max Ernst, *Untitled,* 1922. Page 155

82. *Composition A XX,* 1924. Page 157

83. *Militarism (Militarismus),* 1924. Page 159

84. *In the Name of the Law (Massenpsychose),* 1927. Page 160

85. *Rape of the Sabines (Raub der Sabinerinnen),* 1927. Page 162

86. *The Girls' Boarding School; Dream of Girls' Boarding School (Das Mädchenpensionat; Traum des Mädchenpensionats),* 1925. Page 163

87. *Chute,* 1923. Page 164

88. *A Chick Remains a Chick; Poeticizing of Sirens (Huhn bleibt Huhn; Sirenenverdichtung),* 1925. Page 166

89. *Love Your Neighbor; Murder on the Railway Line (Liebe deinen Nächsten; Mord auf den Schienen),* 1925. Page 167

90. *Poly-Cinema,* 1925. Page 168

91. *Jealousy: The Fool (Eifersucht),* 1925. Page 170

92. Lucia Moholy, *László Moholy-Nagy at the Dessau Bauhaus,* ca. 1925. Page 171

93. *City Lights (Die Lichter der Stadt),* ca. 1928. Page 172

94. *14 Bauhaus Books,* cover design for an eight-page prospectus of the Albert Langen Verlag, 1929. Page 175

95. Prospectus for eight Bauhaus Books, Albert Langen Verlag, 1927. Page 178

96. Brochure for Bauhaus Books in preparation, 1927. Page 179

97. Book jacket for *Malerei, Fotografie, Film,* second edition, 1927. Page 180

98. Two pages from the film script *Dynamic of a Metropolis.* Page 184

99. Illustrations from *Malerei, Photographie, Film:* shell and photogram. Page 185

100. Illustrations from *Malerei, Photographie, Film:* photogram and Moholy's painting K_x. Page 186

101. Book jacket for *Von Material zu Architektur,* 1929. Page 188

102. Illustration from *Von Material zu Architektur:* revolving drum for testing contrasting textures of materials. Page 190

103. Illustration from *Von Material zu Architektur:* photographs illustrating textures. Page 191

104. Illustration from *Von Material zu Architektur:* facade of the Dessau Bauhaus. Page 192

105. Illustration from *Von Material zu Architektur:* view up an elevator shaft. Page 193

106. Title page of the prospectus for the *Film und Foto* exhibition, 1929. Page 204

107. View of Room 1, *Film und Foto* exhibition, Stuttgart, 1929. Page 206

108. *Untitled (Deck of Ship),* 1930. Page 214

acknowledgments

My project on Moholy-Nagy's photography has spanned more than a decade and has had several lives: as an exhibition, a dissertation, and now this book. During that period many people have helped me in innumerable ways. While I was a graduate student at Harvard my original interest in photography was nurtured by the late Davis Pratt, then curator of photography at the Fogg Art Museum. My interest in Weimar Germany and the Bauhaus developed while working at the Busch-Reisinger Museum with Charles W. Haxthausen, whose knowledge and deep engagement with the period led me to switch fields; he subsequently became my dissertation advisor. As the Fine Arts Department at Harvard has never offered courses in the history of photography, I traveled across the Charles to study at Boston University with Carl Chiarenza, whose classes on photography and guidance in the early phases of my research on Moholy were invaluable.

Any research on Moholy must begin with the recent ground-breaking work on this artist and the Hungarian avant-garde, and I am especially indebted to the scholars Krisztina Passuth, Andreas Haus, Irene-Charlotte Lusk, Steven A. Mansbach, and Julie Saul. My work was aided by many people over the years, but I would particularly like to thank James Hodgson, Peter Hahn, Peter Nisbet, Emilie Norris, David Travis, Ann Tucker, Weston Naef, Gordon Baldwin, Susan Kismaric, Robert Sobieszek, Ute Eskildsen, Jürgen Wilde, and Ellen Frank. Beaumont Newhall and Lucia Moholy, both of whom died recently, were generous with their files and their memories and knowledge of Moholy and his work. I would also like to thank my colleagues at the University of New Hampshire; Dan Valenza, Mara Witzling, David Andrew, and David Smith have been particularly kind and encouraging. At the MIT Press Roger Conover and his readers helped me to focus and shape the book in its final stages. The National Endowment for the Humanities and the University of New Hampshire provided critical financial support.

All along the way I have benefited greatly from the knowledge, comments, friendly advice, and generosity of Moholy's daughter, Hattula Moholy-Nagy.

I would also like to express my gratitude to friends who have both listened patiently and offered sustenance along the way: Joan Esch, Christine Kondoleon, Andrée Wynkoop, Susan Welsh, Eva Hoffman, Kitty Finkelpearl, Wendy and Dan Rowland, Andrea Kaliski Miller, Louise and John Stebbins, and Marion True. My family, of course, probably suffered the most and has my love and gratitude; Anne Hight and Ellie and Bernie Baker have offered continual support over the years, as have Maj and Ernst Huf. And I sorely missed Tom, Nicholas, and Maja in those long evening and weekend hours.

My greatest debt of all goes to Phil Finkelpearl and Mark Haxthausen who each offered me inspiration through his scholarly example, thoughtful commentary, and unwavering friendship over the years. Without their encouragement the book would never have been written. It is only fitting that I humbly dedicate my first book to them.

picturing modernism

1

READING AND MISREADING MOHOLY

"'The illiteracy of the future,' someone has said, 'will be ignorance not of reading or writing, but of photography.'"[1]

In his seminal article "A Short History of Photography" of 1931, the Marxist critic Walter Benjamin thus paraphrased a famous and loaded sentence from the writings of László Moholy-Nagy. Although he never met Moholy, Benjamin developed ideas on photography and its effect on art and the public that had striking similarities to those of the Hungarian artist, and on a number of occasions Benjamin referred to Moholy's texts or photographs from the 1920s when discussing the social impact of photography. Through his use of provocative combinations of scientific, commercial, and artistic photographs in his writings, Moholy demonstrated the ways in which photography could be used to expand visual perception and thus, he thought, heighten one's understanding of contemporary culture. His photographic theory proposed a new language of seeing ideally suited to the modern world, one that, like any language, had to be learned. Behind all of Moholy's work in the medium was the conviction—endorsed by Benjamin—of the vital importance of visual literacy in the Age of Photography.

When Moholy first turned to photography, his world was Germany of the Weimar era, when postwar passions over industrialization and mass production ran from idolatry to fear. Through industrialization, many believed, the old order that had brought on the calamity of the First World War would be overthrown. Society would be liberated, reorganized. The rationality of mass production would serve as the paradigm for the clean, efficient, and beautiful new social order. After experimenting with a number of "technological media"—industrial metals, porcelain enamel, and the like—Moholy came to feel that photography and film provided the supreme language for analyzing all aspects of *Modernismus,* the condition of modernity and contemporaneity in Weimar Germany's urban life, from the vogue for Einstein to women's liberation. His method of visual analysis, based on a variety of photographic devices (such as close-ups, cropping, unusual viewpoints, high contrast), laid the foundation for his concept of the "New Vision." Though seemingly cool because of his formalistic approach, Moholy's imagery depicts at once the freshness and excitement as well as the disorientation and anxiety of German industrial expansion after the war.

As elaborated upon in a series of articles, Moholy's New Vision offered a "modern" way of seeing. Because of its emphasis on technique, the New Vision has often been inappropriately identified with the formalist photography that became mainstream by the late 1920s. Yet Moholy was not entrapped by the limitations of self-reflexivity in the kind of modernist aesthetic in which the means of photographic production become the content of the work. Instead, his photographs and writings reveal an intense involvement with the most progressive scientific, architectural, and social theory as well as the anxieties of the tumultuous postwar period in Europe. It was this pertinence to contemporary life, and its potential to shape it, that led Moholy and Benjamin to endorse photography as the most powerful medium of communication of the day.

Although today the monograph on an individual artist often holds a lower priority than the more generalized cultural analysis, such an approach is justified in Moholy's case for several reasons. First, for many historians Moholy holds a position in the history of photography as a leader of the so-called modernist/formalist school in which the content of a photograph centers on purely formal issues. Secondly, it is important to recognize that Moholy essentially invented photographic education in the United States through his program at the New Bauhaus and the Institute of Design in Chicago. His Bauhaus Book *The New Vision* (the English version of *Von Material zu Architektur*), which advocated giving photography a prominent role in an art curriculum, became a standard art school text. As a result, his program for art education and his own photographs had a major impact on young photographers and graphic designers for several decades after the Second World War. Thus, any critical view of photography's last half century needs to address Moholy's work and influence.

However, this book does not deal with either Moholy's photography after he left Germany or the process of his canonization. Instead, the aim is to see Moholy and his work as an integral part of a dynamic and richly varied culture in Germany during the Weimar period. For this reason, the focus of the book is necessarily restricted to a narrow time period, 1920–1933, or his years in Germany. This is not meant to imply that he stopped working in photography upon his departure from Germany, for he did not. But the Weimar era and this chapter of Moholy's career both came to an end with Hitler's rise to power in 1933. By this time Moholy's vision of photography became submerged in his need to make a living as a commercial artist while living in exile. Nevertheless, despite this book's orientation toward German cultural studies, it is hoped that it will lay the groundwork for a new analysis of Moholy's impact on postwar photography.

Modernism, Formalism, and *Modernismus*

From the beginning, it is clear that we must make a distinction between the cultural manifestations of *Modernismus,* which Moholy strove to analyze through photography, and a somewhat generalized and nebulous formalist/modernist model of photography. In traditional histories, the 1920s began the "modern" era of photography, a period of new beginnings displacing the turn-of-the-century "art" photography (also referred to as "pictorialism") after the hiatus in photographic production caused by the First World War. As in other media, modernism in photography came to be synonymous with formalism, where technique became the content of a work. Moholy himself inadvertently helped establish this view of modernism in photography through the repeated misinterpretation of his intentions by critics. In his discussions of the New Vision and its application (in, for example, his photographs or his installation of the 1929 *Film und Foto* exhibition in Stuttgart), Moholy indexed different camera techniques that constituted his visual language. This methodology, with its emphasis on technique, was then taken at its face

value, without heeding the subject matter of the New Vision, that is, the modern industrial world and contemporary urban life. While Alfred Stieglitz was indisputably the leader of modernist photography in the United States, Moholy was recognized, certainly by the 1930s, as a central figure of photographic modernism in Europe.

Two of the foremost spokesmen for this formalist/modernist model of photography, and for Moholy's pivotal role in it, were Franz Roh in Germany and Beaumont Newhall in the United States. Roh's two books, *Foto-Auge* (a selection of photographs from the *Film und Foto* exhibition edited with Jan Tschichold) and *Moholy-Nagy: 60 Fotos,* both published in 1929, followed Moholy's technical categories for presenting photography and, in turn, exalted formal diversity in photographs. Newhall's early admiration for Moholy can be seen in the Hungarian photographer's prominence in Newhall's first curatorial endeavors at the Museum of Modern Art in New York in the late 1930s. He appointed Moholy to an advisory committee for his landmark *International Exhibition of Photography* of 1937 along with Edward Steichen, Edward Weston, and four others (Stieglitz refused, though the show was dedicated to him). Newhall also chose a group of Moholy's photographs as his first purchases for the photography collection at the Modern.[2] In addition, the format for Newhall's history of photography published in 1937 adheres to Moholy's approach.[3] Newhall's stance was particularly influential because of his position at MoMA and then as director of the George Eastman House in Rochester. Until the 1980s, because of its wealth of photographic exhibitions and published catalogues, MoMA set the example in the United States and Europe for the incorporation of photography as an art into the museum setting. In these two institutions Newhall built the largest collections of Moholy's photographs available anywhere in the world today.

We have come to realize the narrowness of the formalist notion of modernism in photography for a number of reasons. First of all, it negates the value of pictorialism as a pivotal movement in photography's history. By placing such an emphasis on the pictorialists' use of form and technique, it overlooks the fact that, despite its symbolist orientation, pictorialism had a major impact on the development of experimental and abstract photography in the twenties. In so doing, this view denies the increasingly symbiotic relationship between photography and more traditional artistic media, especially painting and printmaking, in the first quarter of this century. During that time, the increased emphasis on essential elements of "pure" form and color was shared by artists working in photography as in other media. With few exceptions artists explored these reductive formal elements for more than their purely aesthetic values. Abstracted forms took on a number of associative properties, enabling them to function in a wide range of roles, from blueprints for architecture and urban design to metaphors of spiritual degeneration and renewal.

While the current interest in Moholy is largely dependent upon the formalist view of photographic history perpetuated by figures such as

Roh and Newhall, this view obscures the complexity and richness of his work. Although often considered narrowly formalist, Moholy's approach to photography was essentially the opposite. (The issue of formalism is further complicated by the fact that Moholy was greatly influenced by a contemporary Russian movement of literary criticism also known as formalism, which will be discussed in chapter 8.) In fact, the issues that he explored through his photographs and to a limited extent through film have recently become central concerns of the so-called postmodernist photographic criticism, and thus a study of his work is especially relevant today. He set out to define the unique characteristics of photography and examined how they could be exploited for their greatest creative potential *and* signifying value. Having defined photography as the manipulation of light on photosensitive materials, he explored how to use light creatively as a medium while simultaneously having his technique refer to recent scientific theories of bodies moving through space. His method of working eradicated boundaries between the abstract and representational, between the artist's creativity and the seemingly objective, documentary nature of the camera image. He probed the manner in which the value of a photograph changes as the context for its viewing changes. In his photomontages he became a master of appropriation. In addition, Moholy dispelled the notion of the unique, hand-printed photograph by emphasizing its very reproducibility through anonymous commercial printing and reproduction. While striving to solve these problems, Moholy created a body of work marked by a singular vision, photographs that are at once daring, analytical, mysterious, provocative, and aggressively modern.

Dissemination and Reception

His photographs alone could have established his place in twentieth-century art, but Moholy was additionally a prolific polemicist for his approach to photography. From 1922 to 1930 he wrote over 30 articles, more than half of which were devoted to photography and film; published two books, both of which integrated photography into the Bauhaus program; participated in major international photography exhibitions; and was the photograph and film editor of the Dutch periodical *i 10: Internationale Revue.* His articles appeared in art periodicals (*De Stijl, Broom, Cahiers d'art*), photography journals (*Photographische Korrespondenz, Der Photograph, Photographische Rundschau*), and in the important journal of the Deutscher Werkbund, *Die Form.* Like the American photographer Alfred Stieglitz, Moholy maintained almost complete control over the way his photographs were seen and his views publicized. In this regard he served as his own best promoter; his widely published writings about photography were lavishly illustrated with his own work. By the end of the decade the success of his photographic activities could be seen in his extensive involvement in the 1929 *Film und Foto* exhibition, arguably the most important photography exhibition ever held. He played a major role in determining the focus of the exhibition as well as in selecting and installing the photographs.

Because of his insistent proselytizing about photography's importance to modern life and because of the extensive exposure his work received, the critical responses to Moholy's work have also been numerous and often quite impassioned. They have run the gamut from high praise and absolute adulation to accusations of plagiarism and bitter condemnation. These swings in reception reveal much about differing modes of photographic criticism since the First World War and often show only a shallow understanding of his work. Most of the more positive reactions to Moholy's photography are based on the concept of modernism defined by a self-reflexive focus on formal elements, as outlined above. As the earliest, negative critical reviews of Moholy's work by his compatriots Ernö (Ernst) Kállai and Alfréd Kemény in the 1920s make clear, the distortions of Moholy's purposes are not new and often center on Moholy's relationship to the Russian avant-garde.

From his first years in Berlin in the early 1920s, critics praised the incorporation of technological materials and processes into his art as a timely and progressive endeavor, but soon he was reproached by leftist critics for his bastardization of elements of Russian productivism, which, as we will see, did exert a major influence on his work. In an article published in the Hungarian periodical *Ma* in 1921, Kállai, a prominent art critic in Berlin, addressed Moholy's solutions for integrating technology in his new work.[4] Moholy's blending of cubism and dada, Kállai wrote, produced forms that alluded to the contemporary world of machines. "Moholy-Nagy the constructivist is fascinated by the energies, the rhythms and technical power of new life." Yet Moholy's unbounded enthusiasm and vitality he described as a "naïve admiration of the eternal-primitive child-barbarian."[5] This epithet, though unflattering, nevertheless captures what must have been Moholy's awe when confronting Berlin, vibrant and frenzied center of modern urban life, after Budapest with its turn-of-the-century elegance. Three years later Moholy's position toward technology was clearer, as was Kállai's analysis of it. In the *Jahrbuch der jungen Kunst,* Kállai extolled the intellectual discipline with which Moholy created mathematically precise forms, interrelated in a dynamic yet controlled manner.[6] This essay focused on Moholy's so-called *Telephonbilder* (Telephone Pictures), made in a factory out of porcelain enamel on metal in 1922–1923 according to directions by the artist to the artisan over a telephone. These works Kállai saw as milestones for their utilization of industrial materials, their reproducibility, and the positive, utopian spirit behind their conception.

Moholy's turn to photography was initiated by this interest in using modern, technological materials for art, but Kállai was less enthusiastic about Moholy's promotion of photography as the technological medium of the future. His apparent prejudice against photography, because he saw it as a merely technical means for reproduction rather than a creative artistic endeavor, was revealed in his controversial article "Malerei und Photographie" (Painting and Photography), published in *i 10* in 1927.[7] Influenced by ideas current among the Russian avant-garde, Kállai based his argument on the importance of the concept of *faktura,*

the physical evidence of the manipulation of artistic materials, that was a cornerstone of the work of the Russian constructivists in their "laboratory" period (1914–1917). Because the dematerialized nature of the photographic image did not exploit this element, according to Kállai, the medium was of limited relevance. In fact, *faktura* figured prominently in Moholy's artistic explorations in other media, and he was able to argue for its presence in photography as well. While revealing his ignorance, or at least a misunderstanding, of the major role photography played in the Russian constructivist movement, Kállai's attitude nonetheless represents the growing influence of Russian avant-garde thinking on the Hungarian avant-garde in Berlin at the time.

Similar roots can be cited for the criticism of Moholy by Alfréd Kemény. Kemény's animosity toward Moholy from the mid-twenties onward seems to have stemmed from their diverging views on the relationship between radical politics and art. Kemény's trips to Moscow had served Moholy as an important source of information on current Russian art. A result of their early friendship was their joint theoretical treatise "Dynamisch-konstruktives Kraftsystem" (Dynamic-Constructive Energy System), a response to the "Realistic Manifesto" written by the Russian sculptors Naum Gabo and Antoine Pevsner in 1919.[8] Like Kemény's, Moholy's political leanings in the early 1920s were clearly to the left. However, Moholy endorsed a point of view, typical of the Hungarian avant-garde, in which he strove for a socially constructive art that remained outside of active political involvement. Kemény soon came to feel that Moholy's work did not focus on the sorts of political and social issues that were the goals of Russian constructivism. This viewpoint was clearly expressed in Kemény's response to a 1924 article in *Das Kunstblatt* by Paul F. Schmidt that claimed Moholy was then the primary representative of Russian suprematism.[9] Instead, Kemény felt Moholy's work could not be considered on the same level as the Russians' due to its lack of ideological content.[10] Kemény labeled Moholy's art uncreative and sterile and referred to him as self-promoting.

Other attacks came from the Russians themselves. While at first admiring Moholy's constructivist tendencies (because they paralleled his own work), El Lissitzky later claimed that Moholy seemed to be gaining recognition by writing on ideas that were then circulating freely among the Russians in Berlin, ideas about which Moholy probably learned most from Lissitzky himself.[11] Likewise, the Russian art historian Alexei Fedorov-Davydov expressed both positive and negative reactions to Moholy in his foreword to the Russian edition of Moholy's book *Malerei, Fotografie, Film*.[12] The book's value, he said, rested in Moholy's recognition of the impact photography and film have on the way we perceive and react to our world. Moholy presented photography as an artistic language conceived out of modern technology and reflecting its impact on our culture. Yet like Kemény, Fedorov-Davydov criticized what he interpreted as Moholy's experimentation with media for the sake of experimentation and his emphasis on the creative as an "essentially bourgeois bias." Thus he considered Moholy's incorporation of concepts

from Russian constructivism and the literary movement of Russian formalism to be a defection, rather than a far-sighted and creative translation of Russian theory into something appropriate and viable for the avant-garde in the West.

Although Moholy's work in photography received much critical attention in the 1920s and 1930s, it tended to be slighted in the following three decades. This odd shift was due in no small part to the influence of his second wife Sibyl, whose lack of interest in his photography can be seen both in her biography of her husband and in the collection of his writings edited by Richard Kostelanetz with her cooperation.[13] Until the English edition of Krisztina Passuth's monograph was published in 1985, Kostelanetz's book remained the primary source for Moholy's translated texts, but it was inadequate for this purpose for several reasons. The unbalanced selection of essays minimizes the importance of Moholy's German years and the central role photography played in his art and theory. Of the more than 50 essays included in the collection, less than a third date from the decade of the twenties, when Moholy developed his artistic theory and when his most innovative writing was published. Moholy's articles from the 1930s and 1940s were generally a rehashing of his earlier ideas. In addition, Kostelanetz included only four articles from these decades on photography, despite the fact that Moholy wrote more on photography than any other subject. Sibyl's oversight has been attributed to the widespread belief that during their marriage, Moholy spent less and less time with photography. In reality, he continued to be active in photography after he came to the United States, but Sibyl did not recognize the medium's importance in his oeuvre.[14]

During the 1970s, a period marked by a renewed interest in experimentation and mixing of media, more detailed analyses of his art were made by Hannah Steckel-Weitemeier and Terrence Senter in their dissertations and subsequent essays for exhibition catalogues. More recently, our picture has been filled in by the research of several Hungarian scholars, particularly the monograph on Moholy by Passuth with its wealth of primary source material and documentary photographs. Nevertheless, the important scholarship of each of these three historians relegates photography to a mere corner of his artistic output.[15] Even though it can be argued that Moholy's greatest contribution to twentieth-century art was in photography, it was not until the 1970s and 1980s that a number of German scholars, most notably Andreas Haus, Irene-Charlotte Lusk, and Ute Eskildsen, began to focus on this area of his work. In their ground-breaking monographic studies of Moholy's photograms and photographs and of his photomontages, Haus and Lusk both chose to narrow their studies rather than examine Moholy's photographic writings and work in their entirety. Eskildsen's scholarship on the New Photography brought an awareness that its content went far beyond mere formalism and that Moholy figured prominently in this movement.

However, just as scholars began seriously to reconsider his work, Marxist critics renewed the attack on the politics behind his aesthetics. We find Herbert Molderings in 1978 criticizing Moholy's New Vision as

■

"an aesthetically fragmented perception, less human than technical and mechanical in its effect."[16] For Moholy, Molderings said, photographic technique became the content of photography and dominated any concern with the impact of photography on society. Benjamin had addressed this problem earlier:

[Photography] becomes more and more subtle, more and more modern, and the result is that it can no longer photograph a run-down apartment house or a pile of manure without transfiguring it. Not to speak of the fact that it would be impossible to say anything about a dam or a cable factory except this: the world is beautiful! . . . It has even succeeded in making misery itself an object of pleasure, by treating it stylishly and with technical perfection.[17]

Molderings likewise found that many examples of the New Photography of the 1920s offered little information about the actual thing represented, that they were separate objects revered for their stylish beauty rather than their ability to inform or instruct.

Thus, in their attack on the institution of "art photography," Marxist critics have become interested in the viability of the formalism used by Moholy and other new German photographers. Abigail Solomon-Godeau has argued that these photographers first usurped Russian radical formalism from figures such as the literary critic Viktor Shklovsky and the artist Alexander Rodchenko and then transformed it into an ideologically bereft art.[18] It is important to recognize, however, that Solomon-Godeau's argument was based on theoretical statements and photographs by Russian photographers from the late twenties. A careful reading of events shows that while Moholy clearly learned much from Shklovsky, Rodchenko, and the film maker Dziga Vertov, his book *Malerei, Photographie, Film* and many of his photographs predate developments in Russian formalist photography. Nevertheless, Solomon-Godeau's provocative article raises important questions about the nature of Moholy's formalism and his relationship to Rodchenko specifically and to Russian formalist photography in general.

In this book I propose to show that such criticism, beginning with Kállai, Kemény, and Fedorov-Davydov in the 1920s and continued by Marxist critics today, misrepresents Moholy's photographs and his theoretical writings on the medium. To dismiss his photographs because of their apparent emphasis on form (a view, I admit, that is often supported by Moholy's own writings) is to ignore how their implications go beyond such narrow considerations. I shall argue that his formalism is not of the closed variety, for he used technique most often as a means for visual analysis of the modern urban environment of Weimar Germany, not as an end in itself. For even though Moholy's term the "New Vision" has been loosely applied to vast numbers of photographs from the period that exploited technique in the name of art or as a device of persuasion in advertising or propaganda, these photographs do not as a group wholly represent Moholy's definition of this much abused term.[19]

On closer inspection, both his photographs and his ideas may be distinguished from other radical photography of the period. We will find that his theories of space, as they developed in relation to contemporary developments in scientific theory, Russian constructivism, and Bauhaus architectural theory, determined the presentation of subject matter in his abstract and representational photographs and his photomontages. But we will also discover that his images again and again scrutinize the physical manifestations and underlying beliefs of contemporary German culture. While Benjamin in the 1930s quite properly became concerned with the negative propaganda value of the photographic image when under Fascist control, Moholy, always the optimist, wanted to use it to expand humankind's awareness of itself and of the modern world.

Although Moholy's name has remained prominent in histories of photography, the proliferation of formalist photographic theory and practice in the past sixty years has diluted the original visual impact and obscured the motivation and circumstances of his photography. In addition, it is now clear that the failed vision of a technological utopia that Moholy shared with other artists of the twenties was transformed into the reactionary modernism that fueled the rise of fascism in the late 1920s and 1930s. This book attempts to break through this cloud of antimodernist criticism to identify the influences and essential concepts that Moholy synthesized in his photographs and the contexts in which they were created and used. I hope not only to facilitate a decoding of the original message of Moholy's photography, but also to provide an alternate path into the culture of *Modernismus* in Weimar Germany.

2 CHAPTER

FROM BERLIN
TO THE BAUHAUS

In 1919, having been deserted by his father, wounded in war, and threatened by the Hungarian counterrevolution, Moholy set out to build a new world through his art. Born in 1895 on the Great Plain of southern Hungary, he had followed a meandering course from the rural countryside to Szeged and then Budapest; he would go on to Vienna, Berlin, Weimar, Dessau, Amsterdam, London, and Chicago.[1] Yet it was during his stay in Germany, from 1920 to 1934, that he matured as an artist. There Moholy produced a body of work and theoretical writing that would make a significant contribution to the discourse of modernism. Although he explored a variety of media, his engagement with photography produced the most innovative and provocative results. But in order to appreciate this aspect of his work, it is important to see how his aesthetic was shaped by the impact of machine technology on the world in which he lived. His particular approach—at once fresh and analytical, mysterious and perturbing—stems from his transformation from a young, deracinated Hungarian Activist into a prominent member of the international constructivist movement in Berlin and an influential pedagogue at the Bauhaus.

By his early twenties, Moholy had already established a reputation in Hungary as an artist coming to terms with modernism. Though his art education was limited to a few classes, he learned much from one of his teachers, the prominent painter Róbert Berény. Soon he was associated with the radical artists known as the Activists, especially their leader Lajos Kassák, who published the avant-garde art periodical *Ma* (Today). The exhibition of his work received positive reviews, and a few

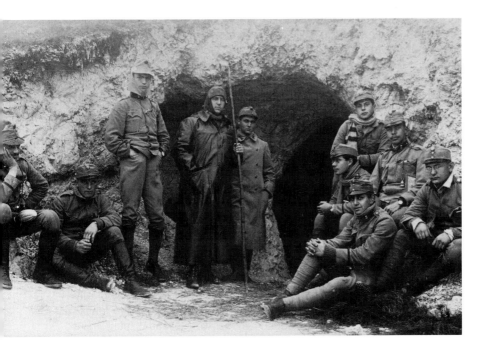

1. *László Moholy-Nagy with Soldiers, World War I,* ca. 1915. Moholy is the fourth seated figure from the right. Location and photographer unknown. Collection of Hattula Moholy-Nagy, Ann Arbor.

drawings were purchased by the National Museum in Budapest. However, Moholy's string of modest artistic successes came to an abrupt halt with the Hungarian counterrevolution of August 1919. He left Hungary for Vienna in the winter of 1919–1920 along with many members of the *Ma* group and other left-wing political and cultural leaders.

The precise reasons for Moholy's departure from Budapest are unclear, but he undoubtedly left because conditions in the capital had become intolerable. The brutality of the counterrevolution, known as the "White Terror," and the ensuing regime of Admiral Miklós Horthy destroyed the nucleus of the Hungarian intelligentsia in Budapest. Drawing support from the "Christian" middle class, the new government sought to annihilate the core of the "alien" Jewish community, which supplied the leaders for industry and finance and also formed the critical mass of the Kun regime and the intelligentsia. Moholy was not active politically, nor was he a member of the Communist party.[2] However, he was associated with the outspoken Activists, and he signed the confrontational Activist manifesto written by Kassák in March 1919. After the fall of the Council of Soviets in August 1919, Moholy left Budapest first for Szeged and then for Vienna. Many intellectuals, including such prominent ones as Georg Lukács and Kassák, would stay in Vienna until the second half of the twenties. Moholy, on the other hand, felt he was "rotting there" and after only six weeks moved on to join the large Hungarian community in Berlin.[3]

Berlin and the Industrial Landscape, 1920–1922
Within a year of his arrival in Berlin in late January 1920, Moholy became a prominent member of the international avant-garde. His associations included such artists as the dadaists Raoul Hausmann, Hannah Höch, and Hans Richter; the De Stijl artist and architect Theo van Doesburg; and, after his emigration from Russia in December of 1921, the constructivist El Lissitzky. All of these artists regularly visited the studio of Moholy and his wife Lucia Schultz, an ethnic German from Prague whom he married in January 1921. Within this milieu, Moholy's art evolved from a naïve groping through the lessons taught by van Gogh, Cézanne, and the artists of the *Ma* group to a nonfigurative, geometric abstraction. The stages of this artistic transformation, made in a mere two years, are linked by Moholy's unceasing pursuit of ways to address the issues of industrialization and urbanization.

Moholy's passion for the machine and the industrial landscape was no doubt originally fueled by the futurist art and writings published in *Ma* in 1919–1920. Early evidence of the impact of the futurists' rhetoric and typographical innovations can be seen in his drawing *Épits! Épits! (Build! build!),* now lost, 1919 (fig. 2). The frenzied scattering of words, lines, bridges, and wheels, as well as the determination of the exclamation marks and the words themselves, serve as expressive vehicles for Moholy's new interest and enthusiasm. His treatment of technology briefly became more whimsical after exposure to dada, particularly the "dada-machinist" style of Francis Picabia, whose work Moholy must have

known through his contacts with the Berlin dadaists and through reproductions in various dada periodicals.[4] Illustrated on the cover of the 15 September 1921 issue of *Ma* devoted to his work, Moholy's *Peace Machine Devours Itself* reveals his indebtedness to Picabia through the combination of imaginary mechanical apparatus and paradoxical title (fig. 3).

Yet it was Berlin itself, he later said, that provided the essential fuel for his youthful technomania:

In 1919, I lived in Vienna, lost among the depressed conformists of the postwar period. Coming from a farm in the agricultural center of Hungary, I was less intrigued with the baroque pompousness of the Austrian capital than with the highly developed technology of industrial Germany. I went to Berlin. Many of my paintings of that period show the influence of the industrial "landscape" of Berlin. They were not projections of reality rendered with photographic eyes, but rather new structures, built up as my own version of machine technology, reassembled from the dismantled parts.[5]

Berlin's industrial cityscape provided subject matter for his work, which underwent further transformation from the painting *Bridges* (ca. 1920–1921) to *Large Railway Painting* (ca. 1920–1921) (figs. 4, 5). The former offers a colorful rendition of the chaos and dynamism of steel bridges and railway cars. These objects join together in a montage with a claustrophobic centripetal arrangement; the frenzied, awesome metropolis overpowers an upside-down, silhouetted figure in the center. In *Large Railway Painting* the artist now exerts his control over these urban symbols and offers a more positive encounter with technology. Flat, geometric shapes and sets of lines and poles, are pieced together in a more stable, gravity-bound composition. However, the title and the letters ("E" for *Eisenbahn* [railway]? "R" for *Reise* [trip]?) counteract the abstraction of the image by giving us clues to the painting's subject. Not until his contacts with artists of De Stijl and Russian constructivism did he move to complete abstraction.

Elemental Art

In October 1921 Moholy's interaction with dada, constructivist, and De Stijl artists resulted in his coauthorship of the manifesto entitled "Aufruf zur elementaren Kunst" (Manifesto of Elemental Art) with Hausmann, Hans Arp, and Ivan Puni.[6] This article represents the merging of Zurich and Berlin dada (through Arp and Hausmann) with concepts from De Stijl. In addition, their collaboration with Puni, the Russian artist who, along with his wife, the artist Kseniya Boguslavskaya, came to Berlin in early 1920, reflects the rising interest in Russian art in Berlin at this time. The manifesto most closely resembles the theoretical approach of De Stijl as expressed by its leader Theo van Doesburg, with whom Moholy had many contacts in Berlin in the early 1920s. The manifesto was published in De Stijl's journal.[7]

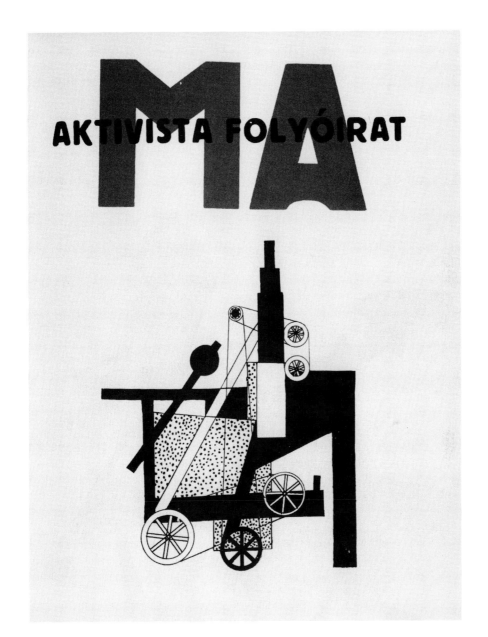

3. *Peace Machine Devours Itself*, 1921. Cover of *Ma* (15 September 1921).

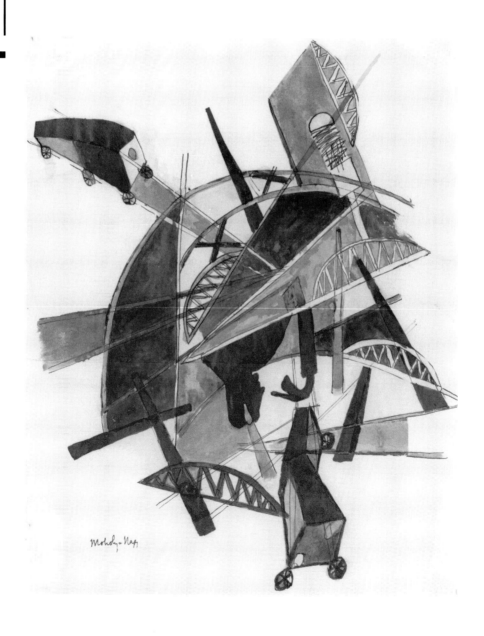

4. *Bridges*, ca. 1920–1921. Watercolor and ink on paper, 33.5 × 25.5 cm. Collection Haags Gemeentemuseum, The Hague.

5. *Large Railway Painting*, ca. 1920–1921. Oil on canvas, 100 × 77 cm. Fundación Colección Thyssen-Bornemisza, Madrid. Copyright VEGAP, Madrid, 1994.

from berlin to the bauhaus

Like Marinetti's "Futurist Manifesto" (1909) and Gabo and Pevsner's "Realistic Manifesto" (1920), the "Manifesto of Elemental Art" called for a new art that was both product and symbol of the spirit of the time. It was not to look back on tradition or ahead to the future; it was against both historicism and utopianism. This brief "Manifesto" presented the premise that would unify the eclectic and diverse elements of Moholy's aesthetic: it was the artist's duty to discover a universal language of art suitable to the era of the machine. It is not hard to understand how Moholy, traveling as he had from rural Hungary to Berlin, could find the idea of an international language of art appealing. And in fact Kassák and the *Ma* group, as well as other movements such as De Stijl and Russian constructivism, promoted the idea of an international community of artists.

For many artists of the 1920s, the machine provided the basis for a new universal art. Initially dadaists (of many nationalities) employed machine imagery as symbols for the evils of society, tradition, and the past, and they portrayed key figures of the establishment as mindless, soulless automatons. On the other hand, the Russian constructivists revered technology for the positive values they assigned to it: logic, clarity, geometry, precision, efficiency. Technology, the salvation of the postwar period, would deliver their agrarian economy into modernity. Technology would serve as a means to mass-produce the products they designed and disseminate Communist propaganda. The identification of the artist and art production with the worker and assembly line necessarily meant the end of easel painting, of art as a commodity for the elite patron. This idea was expounded by many Russians, including the critic Nikolai Tarabukin in his book *From the Easel to the Machine.*[8] Soon Moholy began to incorporate drafting techniques and industrial materials into his practice and proposed several methods (using gramophone recordings, photography, film) in which technology could provide the means for formulating a new art.

The use of machine elements and a montagelike pictorial construction, seen in Moholy's work from 1920, gave way to a style in which disparate geometric shapes, colors, and lines were organized and balanced like building blocks, as in his painting *Composition 19* (fig. 6). Since this painting was included in the Moholy issue of *Ma* and in the *Buch neuer Künstler,* coauthored by Moholy and Kassák in 1922, Moholy himself must have regarded it as an important stage in the development of his art. The individual elements Moholy uses—flat geometric shapes, sets of lines, poles, typography—repeat those found in the *Large Railway Picture.* Now the composition is more regular and structurally balanced, more architectonic. He eliminated the title referring to the railroad, and the significance of the number 19 remains elusive (does it refer to the year he left Hungary?). Here we see the final break from representation or collages of signs referring to modern industrial society in favor of complete abstraction; at the same time Moholy adhered to those machine-inspired values of clarity, precision, structural integrity, geometry. This change, which coincides with the publication of the "Aufruf zur

elementaren Kunst," follows the article's mandate: to utilize geometric forms and unmodulated color areas and to minimize the subjective response of the artist to the world. In the 1920s this kind of approach became widespread in the visual arts and also in architecture and design.

The "Glass Architecture" and "Transparent" Paintings

A year after the publication of the manifesto, Moholy began to create constructions of architectonic forms with drafting techniques in a series of paintings and graphic works entitled *Űvegarchitektúra* (Glass Architecture) (fig. 7). Through his technique and the title of the series, Moholy self-consciously linked his painting with architecture, the medium a number of Russian, German, Dutch, and Hungarian artists turned to in the 1920s. Moholy's concept of the constructive, architectonic massing of forms in this series related directly to the similar concerns of his compatriots László Péri, a sculptor who was trained as an architect, and the painters Sándor Bortnyik and Kassák.[9] Moholy's title alludes to the glass architecture theories advanced by Berlin expressionist theorists and architects of the late 1910s and early 1920s such as Paul Scheerbart and Bruno Taut, who were concerned with the ability of light to animate architecture through the use of transparent and reflecting surfaces. Moholy applied their ideas not merely to his painting, printmaking, and sculpture but to his photography as well. He also identified his work with their utopian visions of a future in which artists and architects would join together to create an environment that would nourish a spiritual regeneration of society.[10]

During the period from 1919 to 1922 in Germany—the situation was even more extreme in Russia—economic conditions limited new architectural projects primarily to speculative drawings and models. The massive inflation after World War I, which reached its peak in 1923, had devastating consequences: a shrinking industrial output, food shortages, and widespread poverty. Limited materials and resources essentially brought new building construction to a halt. As a result, architectural projects often became increasingly fantastic, less related to real building problems, and more emotional, romantic, even spiritual in tone. Then as the construction industry picked up after the stabilization of the German mark in the end of 1923, building programs became more pragmatic and empirical under the influence of problem-solving models culled from the sciences.

Moholy's use of geometric forms and hard-edged mechanical drafting techniques parallel this trend toward rationalism in architecture. Borrowing techniques from architecture and engineering in his series of *Glass Architecture* works, Moholy arranged arc-shaped and rectilinear forms drawn with a ruler and compass, rather than freehand, in simple parallel and perpendicular configurations punctuated with an occasional diagonal. Mechanically drawn forms, employed as early as 1915 by the Russian artist Alexander Rodchenko, also tie Moholy to a general movement among abstract artists to remove the artist from the final art product. He

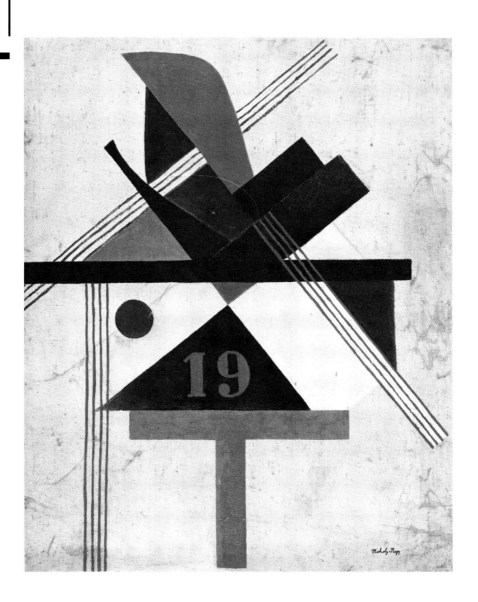

6. *Composition 19*, ca. 1920. Oil on canvas, 111.8 × 92.7 cm. Courtesy of the Busch-Reisinger Museum, Harvard University Art Museums. Gift of Sibyl Moholy-Nagy.

Moholy-Nagy: Üvegarchitektura

MA

AKTIVISTA FOLYÓIRAT

7. *Glass Architecture*, 1922. Cover of *Ma* (30 August 1922).

minimized evidence of the artist's hand (sometimes using techniques such as spray painting to avoid brush strokes), omitted his signature, and assigned impersonal, objective titles consisting merely of letters and Arabic or Roman numerals (as in the titles for his paintings *Q XXI* of 1923 and *Composition Z VIII* of 1924). In addition, there is a political subtext. Mechanical drafting techniques allude to the notion of the "artist-engineer," an identification with the urban working class repeatedly discussed by dada artists and constructivists of the left.

In February 1922 the Galerie Der Sturm held the first major exhibition of Moholy's work in Berlin.[11] It was a two-man exhibition with Péri, who exhibited his new constructivist reliefs entitled *Raumkonstruktionen* (Space Constructions). Moholy's paintings in the exhibition showed a new constructivist phase in his art, a logical step from his elementary art and his glass architecture works (fig. 8). He created compositions of overlapping, transparent planes against a solid light background or limitless space. These were no doubt influenced by the spatial constructions in the suprematist paintings of Kazimir Malevich and the use of transparency in the *Prouns* of Lissitzky. From this point onward, overlapping transparent planes may be recognized as a characteristic element in Moholy's work, his oil paintings on canvas and plastics, his Plexiglas sculptures, and his photograms. He later described the impetus behind these paintings, which he called "transparent" pictures, as the desire to free his images from elements reminiscent of nature, "in contrast, for example, with Kandinsky's paintings, which reminded me sometimes of an undersea world."[12] Once freed, Moholy said, he could concentrate on the relationships between pure form and color. Both the *Glass Architecture* and "transparent" paintings demonstrate his informed understanding of formal elements found in recent Russian constructivist art.

Moholy now also applied constructivist principles to sculpture for the first time. A wood sculpture from around 1921, known in a photograph only, represents a translation of a *Glass Architecture* composition into three dimensions (fig. 9). The work incorporates his now familiar motifs of vertical and horizontal bars tied together by a diagonal arc shape. These elements retain the light, open appearance of the paintings through the minimal thicknesses of the forms. The only surviving sculpture from this group, *Nickel Construction,* dated to 1921, builds on the same principles (fig. 10). The highly polished metal and the clean, precise lines of the forms offer a more pointed reference to a manufactured art untouched by the artist's hand.

Although he retains the perpendicular format of the wooden sculpture, Moholy has now attached a spiral from the upper area of the vertical member to the corner of the base. Such a spiral form had been employed previously by Vladimir Tatlin, a leading Russian constructivist sculptor, in the *Monument to the Third International* of 1920 (fig. 11). For Tatlin, the spiral shape and its diagonal orientation imparted the sensation of movement through space that would symbolize the commanding position of the new Communist society. Moholy himself used the spiral

from berlin to the bauhaus

in another work from this period, a drawing entitled *Kinetic-Constructive System (Design for a Light Machine for Total Theater),* 1922 (fig. 12). In both the drawing and *Nickel Construction,* Moholy explored the principles of "dynamic" (as opposed to "static") construction presented by Gabo and Pevsner in their "Realistic Manifesto" and reformulated in the program outlined by Moholy with Alfréd Kemény in their manifesto, entitled "Dynamic-Constructive Energy System."[13] At this point movement was only implied in Moholy's sculpture, or speculated upon in the drawing.[14] However, the balancing of the sleek geometric forms, dematerialized by their own reflective surfaces, and the added spark of the spiral make *Nickel Construction* a sophisticated testament to the constantly fluctuating world of the machine.

The *Telephonbilder*

Moholy's best-known flirtation with industrially produced art came after the Der Sturm exhibition at the end of 1922, in his so-called *Telephonbilder* (Telephone Pictures), entitled *EM 1, EM 2,* and *EM 3,* manufactured in porcelain enamel on metal (fig. 13).[15] They represent his analyses of how varying the scale of several suprematist forms—a yellow, red, and black rectangle, bar, and cross shape—changes their relationship to each other. Lucia Moholy attributed the impetus for the *Telephonbilder* to Moholy's frustration at not being able to create by hand paintings identical in terms of color and composition in different sizes.[16] Manufacturing the works, he thought, would eliminate the inevitable inconsistencies inherent in manual production that would detract from the comparisons he wanted to make. The process of production and the scientific-sounding titles (I believe *EM* is actually an abbreviation for *Email,* the word for "enamel" in Hungarian and German), would remove signs of the artist's hand.

The historical significance of the *Telephonbilder* has remained controversial, for the original purpose in manufacturing the works conflicts with both his later analysis of their importance for constructivist art in the early 1920s and what others have seen as their potential for the mass production of art. In his *Abstract of an Artist* Moholy described ordering their manufacture over the phone, although this fact was later disputed by Lucia Moholy.[17] More significant than whether or not Moholy originally used the telephone for the order are the industrial materials and techniques he used in them: mechanical drawing for plotting points on graph paper, colors selected from the factory color chart, and the medium of porcelain enamel. But the fact that Moholy used such a procedure for artistic production only once does not diminish their importance. As we shall see, neither did Moholy capitalize on photography's reproducibility, and in fact most of his photographs survive at most in only several prints.[18] The *Telephonbilder* reflect his ongoing interest in experimenting with a variety of materials, among them porcelain enamel, transparent glass, aluminum. He apparently valued the works as representing a new medium that could be pursued, though he chose not to do so himself, and referred to the *Telephonbilder* often in his writings.

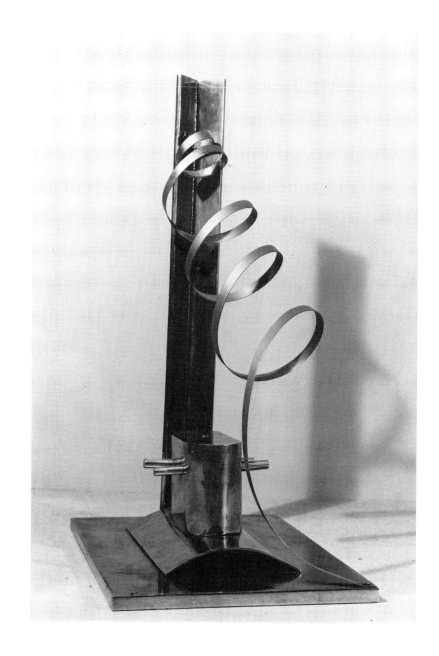

10. *Nickel Construction*, 1921. Nickel-plated iron, welded, 35.6 × 17.5 × 23.8 cm. The Museum of Modern Art, New York. Gift of Mrs. Sibyl Moholy-Nagy.

11. Vladimir Tatlin, Monument to the Third International, 1920. Drawing reproduced in Nikolai Punin, Pamyatnik III Internatsionala (The Monument to the Third International). Pamphlet (Petrograd, 1920).

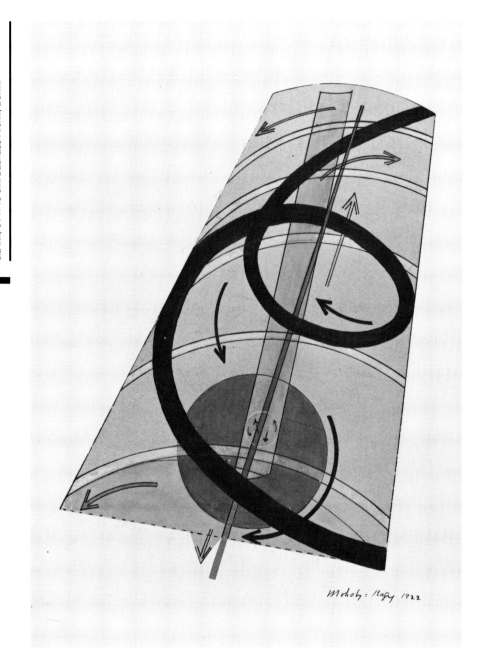

from berlin to the bauhaus

13. *Telephone Picture EM2 (Telephonbild)*, 1922. Porcelain enamel on steel, 47.5 × 30.1 cm. The Museum of Modern Art, New York. Gift of Philip Johnson in memory of Sibyl Moholy-Nagy.

Moholy and Russian Art

Even though El Lissitzky would later say that in 1921–1922 he did not take Moholy's painting seriously, that Moholy did not "know the first thing about that [painting]," his initial review of the Moholy/Péri Der Sturm exhibition demonstrates his early support of Moholy's work:

Begotten of the revolution in Russia, along with us they [Moholy and Péri] have become productive in their art. . . . Against the background of jellyfish-like German non-objective painting, the clear geometry of Moholy and Péri stands out in relief. They are changing over from compositions on canvas to constructions in space and in material.[19]

Lissitzky seemed pleased to find the constructivism of Moholy and Péri to be oriented toward his own art. Lissitzky used the term "productive" in praising Moholy's work, although Moholy at this time was hardly a "productivist" in the sense the Russians of the early 1920s used the term to describe those interested in designing mass-produced objects and propaganda literature. Instead, Lissitzky meant that Moholy's works were creative in their use of materials, that necessary ingredient for initiating new art forms. Nevertheless, the experimentation with industrial materials (metal for Moholy and concrete for Péri), the exploration of abstract art in two and three dimensions, and an apparent rejection of traditional modes of art associate both artists with the Russian constructivists. The work of Péri and Moholy seen in their Der Sturm exhibition offered a more accomplished constructivism than any other work by non-Russian artists in Berlin at the time.

It was through an unusual set of circumstances that the Hungarian avant-garde gained knowledge of recent developments in Russian art and assimilated many of its elements into their own work before most of their colleagues in Germany. Since Russia had suffered an economic and cultural blockade from 1918 to 1921, it was not until the *Erste russische Kunstausstellung* (First Russian Art Exhibition) held at the Galerie van Diemen in October 1922 that the abstract art of the Russian avant-garde developed in the preceding decade became widely known in Berlin, or for that matter anywhere in the West. Moholy, who had already incorporated many of the artistic concerns of Russian constructivism into his art by his Der Sturm exhibition in February of that year, had undoubtedly learned of Russian art through his contacts with *Ma,* which had developed early avenues of exchange with the Russians because of political and artistic affinities at a time when travel between Germany and Russia was not possible. As early as November 1920 *Ma* held a "Russian evening" in Vienna. The Russian critic Konstantin Umanskii, serving as the Vienna correspondent of *Tass,* gave a lecture illustrated with slides of work by Malevich, Tatlin, and Rodchenko. Although Moholy may have heard news of this lecture, he was not in Vienna when it was given. Neither was Umanskii's book, *Neue Kunst in Russland 1914–1919,* published in 1920 and the first book in German on the new Russian art, a likely source, since this book did not include the most recent developments.[20] In Berlin Moholy must have gained exposure to

the formal issues of Russian art from several Hungarians who had traveled to Moscow in 1921, among them his friend Kemény and the painter Béla Uitz.[21]

However, Moholy's most direct sources were the few Russians who had arrived before the *Erste russische Kunstausstellung,* especially Ivan Puni and Lissitzky, with whom Moholy had heated debates on issues of constructivism.[22] As one of the first converts to suprematism (though he would reject it by 1922), Puni's constructed reliefs from the mid-teens translated the lessons of Malevich into three dimensions. Although he left the reliefs behind when he came to Berlin, he apparently reconstructed some of them in Germany.[23] He also supplied a meeting place at his apartment for many of the Russians visiting the city who would have an impact on Moholy's development, including the primary spokesmen of Russian formalist literary criticism, Osip Brik and Viktor Shklovsky.[24]

After the *Erste russische Kunstausstellung,* the term "constructivism" came to be widely used in the West. Stylistically, the western offshoot, as it appeared in such work as Moholy's, was characterized by nonfigurative, geometric forms and often suggested movement through an infinite space. By 1922, the primary goal of Russian constructivism was to provide designs for the factory production of utilitarian goods and to transmit Communist ideology to the masses. However, in Berlin the work of Russian artists and the budding group of "international constructivists" had a different tenor. El Lissitzky and the sculptor Naum Gabo were more interested in the viability of the art object. Their desire to work independently of government programs separated them from their more politically active associates back home. The orientation of Lissitzky and Ehrenburg's short-lived journal *Veshch',* meaning "object," makes this point clear; as Manfredo Tafuri has aptly stated, it asserted "the need for intellectual work that stopped at the doors of industrial production."[25] Thus, Lissitzky represents a faction of contructivism where pure ideology dominated political ideology. Lissitzky's positive review of Moholy's Der Sturm exhibition demonstrates the ideological affinities of these two artists in 1922. But several years later, as Lissitzky turned his attentions back to the Soviet government's needs and Moholy infiltrated the capitalist-oriented Bauhaus, their relationship (at least on the part of Lissitzky) soured.

Moholy, on the other hand, was caught between his interest in the art object and his belief in creating art for a "collective good." Yet this dilemma, one of the great contradictions between his theory and his practice, was not his alone. The "aesthetic" constructivism of Malevich and Lissitzky, as well as the neoplasticism of Mondrian and van Doesburg, raised similar issues. Van Doesburg, particularly, addressed the problem of creating a "collective art" in his pivotal theoretical statement of 1922 entitled "Der Wille zum Stil" (The Will to Style).[26] He referred to his art as experimental and as a means for engendering a greater visual awareness and understanding in society. Like the Hungarian Activists, van Doesburg described the need to produce "collective" solutions for

both artistic and economic problems and advocated the use of the machine in creating the new style. Moholy embraced a set of characteristics attributable to machines for similar ends. As the works exhibited at his first Der Sturm exhibition and the subsequent *Telephonbilder* show, by late 1922 Moholy had brought together elements of both Russian constructivism and De Stijl to create a new art coming to terms with the ever-looming presence of the machine. Without this synthesis his photography, if he had even taken up the medium, would have had a different motivation and message.

In the fall of 1922, Moholy's career took a decisive turn. At the Dada-Constructivist Congress in Weimar, he joined a group of artists in proclaiming a "contructivist international" committee. Van Doesburg, the principal organizer of the congress, was then living in Weimar and teaching a constructivist design course for a group of Bauhaus students to offer a balance, he said, to what he thought was the expressionist orientation of the school. Simultaneously, a student group called KURI (*Konstruktive, Utilitäre, Rationale, Internationale*), consisting mostly of Hungarians, was pushing for a more constructivist curriculum.[27] Once the *Erste russische Kunstausstellung* was seen at the Galerie van Diemen in Berlin in the fall of 1922, Russian art and constructivism became the rage. Under pressure from van Doesburg and many progressive architects in Germany, Walter Gropius decided to expand the approach of the Bauhaus to include the current constructivist movement. After van Doesburg and El Lissitzky, Moholy was the most visible and vocal representative in Berlin of this new art.[28] Thus, in late 1922, after the exhibition of his new constructivist paintings and metal sculptures at Der Sturm, the publication of the *Buch neuer Künstler* with Kassák and his two articles on photography, and his participation in the Dada-Constructivist Congress, Moholy was invited by Gropius to join the teaching faculty of the Bauhaus at Weimar.

Arrival at the Bauhaus

Moholy arrived at the Bauhaus in the spring of 1923 at a crucial moment in the development of its curriculum. At that time Gropius announced a new concerted effort by the school to achieve his goals for the integration of art and industry. His program now was oriented toward the project of the Deutscher Werkbund, an association of architects, artists, and industrialists who sought to raise Germany's place in the international marketplace through the design and production of new consumer goods. Over the next five years, Moholy would play a major role in the implementation of the school's new program through his teaching, his art and writings, and the editing and design of a series of publications that promoted the school's image. Conversely, the newly focused direction of the Bauhaus served to strengthen the emphasis on technology in Moholy's aesthetics, an emphasis that would find its most extensive realization in photography. As will be explored in later chapters, Moholy's teaching methods directly affected his intense engagement with photog-

raphy, in particular his innovative choices of techniques and subject matter, during his Bauhaus years.

Gropius first met Moholy in February of 1922 when the architect Adolph Behne took Gropius to see Moholy's Der Sturm exhibition, in which he showed his new transparent paintings and constructivist sculpture. Gropius later reported that he was impressed by "the character and direction" of Moholy's work.[29] In addition, Gropius must have found Moholy's positions on art, architecture, and technology, as set forth in his 1922 article "On the Problem of New Content and New Form," compatible with his own views.[30] At a time when Gropius and other Berlin architects were turning away from the expressionist and utopian toward the geometric, machine-inspired art of the Russians and De Stijl, Moholy brought constructivism to the Bauhaus.

The arrival of the 27-year-old Moholy struck the younger students and the well-established, older faculty quite differently, as the Dutch artist Paul Citroen, then a student at the school, later recalled. Citroen saw in Moholy's appointment a conscious decision by Gropius to reorient the Bauhaus toward a more constructivist program. The students seemed to back Moholy's appointment; his Russian-influenced art provided a welcome contrast to that of the older generation of "masters," as teachers at the Bauhaus were called, such as Paul Klee, Vasily Kandinsky, and Lyonel Feininger.[31]

The older artists often reacted rather negatively, not only because of their distance from Moholy's kind of art but more importantly because

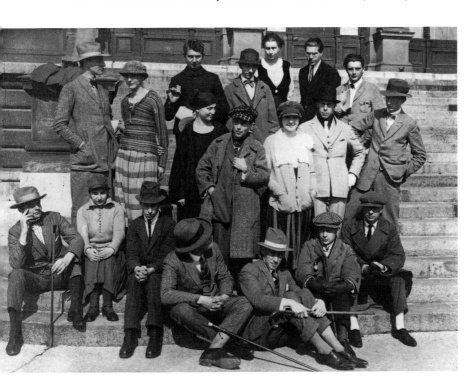

14. *The Dada-Constructivist Congress in Weimar,* 1922. Photographer unknown. Netherlands Architecture Institute, Collection Van Eesteren. Upper row, left to right: Max and Lotte Burchartz, Karl Peter Röhl, Hans Vogel, Lucia Moholy, László Moholy-Nagy, Alfréd Kemény; middle row: Alexa Röhl, El Lissitzky, Nelly and Theo van Doesburg, Bernhard Sturzkopf; bottom row: Werner Graeff, Nini Smith, Harry Scheibe, Cornelis van Eesteren, Hans Richter, Tristan Tzara, Hans Arp.

Moholy actively supported and symbolized the new direction Gropius wanted the Bauhaus to take. Gropius wished to change the emphasis from handicraft instruction and painting (as represented by Klee, Kandinsky, and Feininger) toward two- and three-dimensional design, graphic design, and typography in order to create prototypes for mass production. Gropius outlined his revamped program in a lecture delivered during the 1923 "Bauhaus Week" to the Deutscher Werkbund. Its title, "Art and Technology: A New Unity," which became the unofficial motto of the Bauhaus, caused problems for some of the older masters. Lyonel Feininger wrote: "I reject the slogan 'Art and Technology: A New Unity'—this misinterpretation of art is, however, a symptom of our times. And the demand for linking it with technology is absurd from every point of view."[32]

Yet for Moholy Gropius's new approach was a perfect match, and he conformed to it with great enthusiasm. He soon became Gropius's closest ally, disparagingly called Gropius's "prime minister" by the irritated master Oskar Schlemmer.[33] "And then the question of Moholy and his influential opinions," wrote Feininger in 1925, "these would not bother me were they not considered by Gropi [Gropius] to be the most important at the Bauhaus. . . . Moholy is the only person of practical importance."[34] However, despite some early resistance to Moholy's presence, what mattered most to both the young artist and the Bauhaus community as a whole was Gropius's acceptance. In fact, Gropius often stated in later years that Moholy was the model Bauhaus teacher, and their ongoing friendship and devotion to each other was evident. For Moholy, Gropius served as a mentor whose ideals and rhetoric helped to shape the development of Moholy's own career.

Moholy's *Vorkurs* and Metal Workshop

Gropius appointed Moholy as master of the *Vorkurs,* the basic design course, and the metal workshop, both formerly taught by Johannes Itten. The changes that took place in these courses under Moholy's leadership reflect Gropius's intentions for the curriculum, particularly in regard to the integration of art and industry. In his "First Bauhaus Proclamation" of 1919 Gropius spoke of the collaboration of painters, sculptors, craftsmen, and architects in the building of the new architecture—that "crystal symbol of the new faith of the future."[35] There was no reference to technology. As Franciscono has pointed out, Gropius's temporary retraction of the Deutscher Werkbund's more positive position on the potential exchanges between art and industry seems to have been caused by his belief that the modern, industrial organization was at least in part responsible for the First World War.[36] Even though he had served for four years in the war, probably because of his Hungarian background and his youth Moholy did not feel the same kind of pessimism about the integration of art and industry that troubled the older Gropius after the war. Immediately upon his arrival at the Bauhaus Moholy was able to apply his belief in an industrially inspired art to the teaching of his courses.

By 1923 the school's program was moving closer to the goals of the Werkbund, and Moholy's arrival facilitated and hastened that change. Gropius outlined his new goals for the school in an essay first published in the 1923 Bauhaus exhibition catalogue.[37] Now he advocated that the teaching of crafts should be directed toward the design of prototypes for industry. The school should establish contacts with industry for "mutual stimulation" and to expose students to the manufacturing process. The structure of Moholy's *Vorkurs* and metal workshop reinforced the principles set forth by Gropius in the 1923 exhibition.

Although headed by Moholy, the *Vorkurs* was jointly taught with Josef Albers, one of Itten's students who had begun to teach part of the course several months before Moholy's arrival. Today it is extremely difficult to separate the individual contributions of Albers and Moholy. My emphasis here, however, is on the ways in which Moholy's teaching affected the selection and manipulation of media in his own art. Under Moholy, the course was expanded to two semesters, with Albers teaching the first and Moholy the second. Both semesters incorporated Itten's methods of "learning by doing": the exploration of such properties of materials as their strength, flexibility, and weight. Unlike Itten's emphasis on the role of intuition and personal expression, Albers and Moholy focused on a more rational, "scientific" analysis of a material's structural properties and on its most economical applications. Moholy seems to have been less systematic than Albers and to have stressed issues related to three-dimensional form. With the exception of wood, Moholy employed industrial materials such as metal, wire, and glass rather than the natural materials preferred by Itten. The exercises Moholy assigned on equilibrium, kinetics, and the spatial articulation of materials closely follow his own work in sculpture and parallel studies in the foundation course contemporaneously taught by Alexander Rodchenko at the Russian school VKhUTEMAS. Moholy based his classes on the constructivist principles of geometry, the massing of elemental forms, and the sort of industrially inspired art that informed his own art of the period.

In the metal workshop Moholy made more direct ties to industry and formulated an aesthetic to express that connection. For the first several years, Moholy taught the workshop with Christian Dell, who served as crafts master (basically the technician) from 1922 until 1925, when he decided not to move with the school to Dessau. Having trained under the Belgian Jugendstil artist and architect Henry van de Velde, Dell was an experienced silversmith who worked in the crafts tradition of the turn-of-the-century *Werkstätte,* using fine metals to create precious objects. The workshop's products incorporated simple geometric shapes with a minimum of applied ornamentation. Under Moholy the form requirements became stricter. Only the so-called "Phileban solids" (geometric shapes made with a ruler and compass), straight edges, and circular forms were allowed. New, too, were the materials used in the course: instead of gold and silver, apprentices employed chrome, aluminum, nickel, glass, and other industrial materials. In accordance with Gropius's plan, the students visited factories, and the workshop estab-

lished ties with specific companies. Light fixtures, in particular those designed by Marianne Brandt, were produced commercially and became viable economic commodities that created an income for the workshop. The move of the Bauhaus to Dessau in 1925 facilitated the metal workshop's shift to industrial art. At last it had the facilities and materials as well as the power tools to produce utilitarian objects. Even the working atmosphere was keyed to industrial applications: the various stages of the design process were separated and set up in the workshop on the model of mass production.[38] The compositions of geometric forms used for objects designed in the workshop echo in three dimensions the forms found in Moholy's paintings and prints at the time. Thus, one might say that his art, created as it was with drafting tools and techniques, and the student work of his *Vorkurs* indirectly served as preliminary blueprints for his students' industrial designs.[39]

That Moholy's style of art differed dramatically from the work of other Bauhaus teachers can be seen by even the most cursory glance at the illustrations in *Staatliches Bauhaus in Weimar, 1919–1923,* the book that was published to accompany the Bauhaus exhibition of 1923. The strict geometry of Moholy's sculpture illustrated in the catalogue stands in striking contrast to the work of artists like Kandinsky or Klee (fig. 15). Fabricated by the Bauhaus metal workshop out of steel, copper, brass, and nickel, Moholy's *Metal Sculpture* embodies Gropius's vision of the ideal Bauhaus curriculum in a number of ways.[40] Neither the work itself nor any records of it still exist, but several important elements are apparent from the photograph. First, Moholy used highly polished metal to create a grouping of simple cubic shapes. The clear, precise lines, the metal and its treatment, continue the kind of industrially inspired sculpture he executed in 1921–1922. In the new Bauhaus piece we also sense the exploration of spatial relationships between voids and volumes that is an integral part of any study of architecture and urban design. In fact, *Metal Sculpture* looks like a model of a series of buildings grouped around an urban space.

Typography and Photography

The exhibition catalogue provides us with other clues about the position Moholy had gained in the Bauhaus only six months after his arrival. The catalogue was designed by Moholy in a bold typographical style that would be pursued at the school by Moholy, Herbert Bayer, Joost Schmidt, and others.[41] Moholy's design was characteristic of what became known in the mid-1920s as the New Typography in its asymmetrical compositions, use of primary colors and black, straight lines and geometric forms, and new streamlined typefaces. As far as we know, this was the first typographical design Moholy undertook, but it is difficult to believe such a progressive book design could have emerged all at once full-blown. Moholy explored the theoretical ramifications of typography in an article that was published in the catalogue.[42] This article advocated the establishment of typography as a new field of communication. The most effective communication could be achieved, Moholy

said, when typographical designers observed the basic criteria of clarity of expression, efficiency, and "optical" effect.

Moholy also pointed to the contribution the adaptable photographic medium could make to typography. Photography could fill the void left by the New Typography's renunciation of traditional forms of nineteenth-century art illustration, such as woodcuts and drawings. With new printing techniques, he said, it was now possible to use photographs instead. As an example, he cited scientific books that already combined photographs with text, although not even these had fully exploited the potential of photographic illustrations. If Moholy's choice of typography as the topic for his catalogue essay differed greatly from the contributions of the older Bauhaus painters (Klee for instance wrote on "Ways of Nature Study"), the final statement of his article sharpened the contrast. He boldly asserted that photography would lead to the replacement of literature by film, just as the telephone had already made letter writing obsolete.

It is clear that Moholy exerted a considerable influence on the curriculum of the Bauhaus in Weimar and Dessau from 1923 until he left the school in 1928. His significant pedagogical contributions can be deduced from his Bauhaus books *Malerei, Photographie, Film* and *Von Material zu Architektur*, which became the first textbook on the fundamentals of design to arise out of the modern movement in architecture

15. *Metal Sculpture (Metallkonstruktion)*, 1921–1923. Steel, copper, brass, and nickel. Illustrated in *Staatliches Bauhaus in Weimar* (Munich and Weimar, 1923), plate 127.

from berlin to the bauhaus

(see chapter 7 below). In addition, we should not overlook the impact he made through the sheer force of his personality on the intellectual atmosphere of the Bauhaus. As Feininger described it, "There is incessant talk of cinema, optics, mechanics, projection, and continuous motion and even of mechanically-produced optical transparencies, multi-colored, in the finest colors of the spectrum, which can be stored in the same way as gramophone records."[43] Where Itten preached values of intuition and asceticism, Moholy worked from the dramatically different model of mechanization.

In 1927 Gropius finally established a department of architecture at the Bauhaus. As its head he appointed the Swiss architect Hannes Meyer, whose functionalist approach to architecture and left-wing politics proved to be more extreme than those of Gropius and Moholy. Because of the school's sensitive relationship with the city and state officials who provided its operating funds, Gropius had carefully developed a position of political neutrality. Under attack by Meyer and his student supporters and wearied by the demands of public relations, Gropius must have found the prospect of undertaking several challenging, large-scale architectural projects, as Winfried Nerdinger has pointed out, his final impetus to leave the school.[44]

Moholy's writings indicate that his own radical views of the late teens and early twenties became more moderate at the Bauhaus due to the general change in the political climate and to the influence of Gropius. Regardless of earlier declarations of social commitment, Moholy, as we have seen, became more involved in defending art's autonomy from politics. Art alone had the power to raise humanity to a higher level. After Gropius appointed Meyer as his successor as head of the school, Moholy, along with Marcel Breuer and Herbert Bayer, left too. In his five years at the Bauhaus, Moholy had become an integral part of the school and an influential voice in its program. Even Feininger was apparently won over by Moholy's vitality. He reacted to news of the Moholys' departure in the following way:

Now the Moholys are leaving too! All the many people who were welcomed next door at number 2 with large cheers! Moholy's friendly and strong voice which could be heard in the studio during his conferences! He provided for the exchange and circulation of Bauhaus ideas and was the most amiable and helpful, most vital person.[45]

CHAPTER

With his boundless energy and insatiable curiosity, Moholy rapidly assimilated and tested the theoretical premises of Hungarian Activism, Berlin dada, Russian constructivism, and De Stijl in the period between 1918 and 1922. The impressive, one might even say spectacular, results, a series of sophisticated and innovative abstract paintings and sculptures utilizing technological materials and processes, ultimately led to his involvement with the "technological" media of photography and film. Moholy's first concentrated efforts in the field of photography explored two opposing principles, production and reproduction, that had important consequences for the ways in which photography could be utilized for making and understanding art. In the *Buch neuer Künstler,* which he published with Kassák in 1922, he explored through photographs the relationship between machines and modern art, architecture, and engineering.[1] And in the same spring he articulated a set of ideas on the creative use of photography in his article "Produktion-Reproduktion," and created his first photographs with his wife Lucia.[2] The book, article, and photographs formed the basis for much of his subsequent theory and practice of photography.

Moholy's continued close involvement with the Hungarian *Ma* group and with Kassák served to reinforce his Activist roots and stimulate his interest in architectonic formal constructions. *Ma* also provided Moholy with his first opportunities in art publishing, an activity he would continue to pursue at the Bauhaus and later. Like van Doesburg, Moholy became an impassioned publicist, and despite frequent discrepencies between his writings and his art, it is inconceivable to think of them as separate entities. Although Moholy never exhibited with the *Ma* group, he was an established member by the time they published his work in the March 15, 1921, issue of their periodical, which after 1920 was published by Kassák in Vienna. In the next issue of April 25, Moholy was listed as the Berlin representative, a capacity in which he served through July 1922.

At first the periodical *Ma* had been devoted to literature, poetry, and criticism; each issue had an average of only four or five black and white illustrations of graphic works by Hungarian Activists. With Moholy's characteristically lively input the change in *Ma* was sudden and dramatic. The periodical boasted a new emphasis on international developments in cubism, futurism, dada, and Russian constructivism. The number of illustrations in each issue, now often reproduced through photographs, doubled or even tripled. The expanded selection also included stills from experimental films and photographs illustrating architecture, engineering, and modern technology. Since Moholy gathered the visual material and articles on these topics and sent them on to Kassák in Vienna for final approval, it seems safe to surmise that the selection reflects Moholy's own taste and the contacts he had made in Berlin.

During Moholy's association with *Ma,* individual issues of the periodical focused on the cubism of Picasso, Fernand Léger, and Albert Gleizes; on Alexander Archipenko, George Grosz, Ivan Puni, Hans Arp, and Theo van Doesburg; and on the experimental films of Viking Eggeling and Hans Richter. Moholy and Kassák themselves were also given separate

issues. The April 25, 1921, issue, for example, the first in which Moholy collaborated, was devoted to the Russian artist Archipenko, who lived in Berlin from 1921 to 1923. Moholy's personal stake in the issue is reflected in a letter he wrote to Iván Hevesy in Budapest: "What *Ma* has achieved is the best that can appear today in the Hungarian language. . . . Have you seen the Archipenko number with its fifteen illustrations? Do you know of anything superior to it?"[3] Indeed, the Archipenko issue was one of the most elaborate *Ma* ever published. Photographs of works were used for the first time, probably because sculpture rather than the more easily reproducible graphic art was being illustrated. In May 1922 there appeared an even more elaborate and far-reaching issue, one that can be viewed as the climax of Moholy's influence on the periodical. The illustrations included Tatlin's *Monument to the Third International,* architecture by the De Stijl architect J. J. P. Oud, and anonymous photographs of New York, an American suspension bridge, and a drilling machine. This combination of photographic images—art, architecture, engineering, machines—establishes his approach for defining what he saw as the new visual culture of the future.

Buch neuer Künstler

This diverse selection of visual material was separated from the literary context of *Ma* in the next and most important collaboration of Kassák and Moholy, their *Buch neuer Künstler,* which was published in Vienna in 1922. *Buch neuer Künstler* predated other anthologies of modern artistic movements by several years and is particularly distinguished by its focus, by the predominance of illustrations over text, and by the manner in which the authors intended to educate their public visually.[4] Although Kassák and Moholy presented work by artists from Europe and Russia as they had in *Ma,* their book placed primary emphasis on the importance of constructivism, more specifically Russian constructivism.

Divided into two sections, the *Buch neuer Künstler* contained a brief introductory essay by Kassák and a section of illustrations chosen and arranged by Moholy. Kassák argued that the futurists had taken art beyond what Kassák saw as its previous function, a passive reflection of the world. However, it was cubism with its analytical methods and its exploration of the fundamental elements of art that served as the forerunner of the new art. For Kassák the truly new, most progressive and purposeful art of 1922 was that which, starting from cubism's contribution, constructed an elemental, universal language of art (the elementary art of the "Aufruf zur elementaren Kunst") through a synthesis of science and technology with aesthetics.

Moholy assembled over a hundred illustrations to exemplify the triumph of constructivism over representational art, with the machine given a central role. The uncluttered format of each page—photographs without accompanying text surrounded by large white margins—and the striking visual impact of the photographs themselves drive these points home in a way words could never do. The variety of the visual material and

media was undoubtedly influenced by works like the *Blaue Reiter Almanac* and the periodicals *De Stijl* and *L'Esprit nouveau*. Although many of the illustrations had already been published in *Ma*, their juxtapositions in the *Buch neuer Künstler* were highly innovative and strikingly *au courant*. Works of art and photographs of architecture, engineering projects, and machines or machine parts are grouped together. The message is clear from the beginning of the illustrations: the machine and other products of technology are important not only as sources of artistic inspiration but as works of art in themselves.

The illustrations of the *Buch neuer Künstler* make a powerful and startling statement. First Moholy presents a photograph of a high-tension tower followed by two pages with a movie camera and an aerial view of the New York Public Library: in short, a monumental work of contemporary engineering, next a machine (one that represents an increasingly important art form, film), and then that supreme example of "modern" civilization, New York, with the traditional architecture of the New York Public Library surrounded by skyscrapers and seen in a contemporary perspective from above. Not until the third set of illustrations do we at last see a painting, a work by the Italian futurist Umberto Boccioni. Two symbols of futurism flank the Boccioni: photographs of a racing car (speed) and a dynamo (power). Machines pair off with works of art. Two paintings by Léger are juxtaposed to a drilling machine driven by a series of gears (two years later Léger's use of machine parts in his painting was translated into film in his *Ballet mécanique,* with its rhythmic sequences of turning machine gears). Moholy combined other examples of modern architecture and engineering with painting and sculpture: the iron framework of a huge American airplane hangar under construction is implicitly compared to the spiral structure of Tatlin's *Monument to the Third International;* a painting by van Doesburg to a drawing and photograph of architecture by fellow De Stijl architect Oud; a close-up of the interior of a steel suspension bridge to suprematist works by Kazimir Malevich and El Lissitzky (fig. 16). The illustration of works by "new artists" ends much as it began with photographs of airplanes and a sequence of drawings for an experimental film by Viking Eggeling.

The diversity of movements and nationalities of the artists indicates Moholy's thorough awareness of the main trends of the day as well as his own preferences. From the table of contents of the *Buch neuer Künstler* we can see that he combed the important art periodicals of the period for illustrations: *Ma; L'Esprit nouveau,* edited by Amédée Ozenfant and Charles-Édouard Jeanneret (the architect known under the pseudonym Le Corbusier) in Paris; *De Stijl,* edited by van Doesburg in Amsterdam; *Veshch'/Gegenstand/Objet,* edited by El Lissitzky and Il'ya Ehrenburg in Berlin; and *Der Sturm,* Herwarth Walden's Berlin periodical. Several photographs of grain silos in America came from Eugen Diederichs, the publisher of the *Werkbund Jahrbuch.*[5] Moholy obtained other photographs for the book from one of the largest industrial firms in Germany at the time, the AEG or Allgemeine Elektrizitäts-Gesellschaft. This company was a logical source for photographs, for as a manufac-

turer of light machines, turbine engines, and electrical appliances, the AEG became a dominant force in the industrialization of Germany in the first decades of the century.[6]

The variety of sources for illustrations in the *Buch neuer Künstler* reveals how indispensable photographs were for Moholy's familiarity with a broad spectrum of contemporary art. Yet the more profound message of the book centered on the way in which the camera could serve as a means of developing a basic visual language that could expand people's awareness of their environment. Such an approach to photography required a redefinition of its functions. If the artist's primary mission was to enable a widespread visual literacy, the camera became a tool for education and thus an instrument with a positive social function. This increasingly became the fundamental point of Moholy's artistic faith.

First Experiments with Photography

Shortly before the appearance of the *Buch neuer Künstler,* Moholy made his first photographs and also published his article "Produktion-Reproduktion." Lucia, who was his collaborator in his early photogram production, described the origins of Moholy's creative involvement with photography:

16. Illustrations from Kassák and Moholy-Nagy. *Buch neuer Künstler* (Vienna, 1922), unpaginated.

The beginning of the idea dated back to the pre-Bauhaus period. I clearly remember how it came about. During a stroll in the Rhon Mountains in the summer of 1922 we discussed the problems arising from the antithesis Production versus Reproduction. This gradually led us to implement our conclusions by making photograms, having had no previous knowledge of any steps taken by Schad, Man Ray and Lissitzky (or others for that matter). . . . The deliberations which formed the basis of our activities were published in *De Stijl* 7/1922 and reprinted in other magazines.[7]

From this passage we can reconstruct the theoretical basis for their initial experiments with "photograms," i.e., photographs made without a camera by placing objects on photographic paper that was then exposed to light (see fig. 17). Although a date of 1920 or even earlier is sometimes given for these first experiments in photography, Lucia's date of 1922 is more consistent with Moholy's theoretical development, which by that time centered on the essentially constructivist desire to use machine technology for artistic ends.[8] Moholy's article was published in July, and it appears that the first photogram experiments took place around the time it was written. Though not recognized as such in print at the time, Lucia served as coauthor, helping to refine Moholy's ideas in the German text.[9]

As the development of his career makes clear, Moholy's turn to photography was a logical step in a series of experiments he made using technological materials for art making. Nevertheless, others have tried to claim credit for turning Moholy to the medium. In a letter to his wife, El Lissitzky reported that he had suggested that photography be Moholy's "special subject" in a periodical Lissitzky was planning with Moholy and Hausmann. Lissitzky also maintained that the concept of "productive" versus "reproductive" was his own basic theme for the proposed (but never realized) periodical and that therefore Moholy had also usurped this theme from him.[10] On the other hand, Lucia Moholy felt she was primarily responsible for her husband's first involvement with photography at a time in which, she later claimed, he was looking for a new area in which he could make a special contribution, and her experience in photography helped him develop as a photographer.[11] Lucia herself became interested in photography first as a hobby and later, after working as a photographer's apprentice, as a profession.[12] Her mastery of photographic techniques, her editorial skills, and her more sophisticated knowledge of German were undoubtedly important in Moholy's development as a theoretician and photographer. Other inspiration may have come from the Berlin dadaists, who utilized photography extensively in their work, while the avant-garde in general speculated frequently in print on the potential power of the medium. Regardless of these possible influences, it is important to stress that from this point onward Moholy pursued photography's possibilities both theoretically and practically with greater thoroughness and enthusiasm than did any other abstract artist of his circle.

"Produktion-Reproduktion"

In the *De Stijl* article "Produktion-Reproduktion" of 1922, Moholy made a connection that appears repeatedly in his writing, between a person's physical ("biological") capabilities and his or her creative potential. He maintained that artistic creativity had as one of its "important missions" the task of expanding awareness so that one's physical potential could be used to the fullest. This concept had its basis in Hungarian Activism, where the artistic and social revolutions were inextricably entwined. Like many of the modern architects of the time, Moholy would make the "satisfaction of biological needs" a primary concern for his vision of utopian architecture. New design concepts developed by artists in "laboratories" like the Bauhaus, or later the School of Design he founded in Chicago, would contribute to the "production" of new, ideal environments in which humans could evolve as fully as possible. He equated productivity with creativity, the aim of which was the fulfillment of a person's potential.

Published in *De Stijl,* this article again shows the influence of the periodical's publisher van Doesburg and other De Stijl artists, particularly Mondrian, on Moholy's thinking at the time. However, it also illustrates the divergence of his approach to the relationship between art and society from that of De Stijl. In "Der Wille zum Stil" of 1922, van Doesburg emphasized the role of art in balancing the polar opposites of matter and spirit. In Mondrian's theory the visual materialization of spiritual values was also a central theme. On the other hand, through Moholy's emphasis on perceptual rather than intellectual or spiritual awareness and his interest in developing a person's biological or physical capabilities, he replaced the spiritual basis of art with a scientfic one. This impulse to merge scientific investigation with artistic inquiry and practice shaped the methodology he used in all his subsequent theoretical writing.

Moholy's article argues that production or "productive creation" (*produktive Gestaltung*) could produce new sensory relationships crucial for expanding human awareness. New forms of auditory and visual expression might be found by exploring alternative means for creative activity. For each of his proposed areas of experimentation—gramophone recordings, photography, and film—he attempted to establish essential characteristics that in turn suggested additional uses. For example, instead of merely reproducing the sounds of an orchestra, the gramophone could be used to generate new sounds by direct scratching of the wax plate (the predecessor of the record). In the same way, film could be used to produce mobile light projections rather than replicate visual relationships already existent in nature.

It is important to note that, as was the case with the *Telephonbilder,* Moholy valued these media for their creative possibilities, not for their reproducibility. The creation of new sensory experiences, which would have an inherent social value by expanding a person's awareness, was far more important to him than the idea of mass production. In his idealism and aestheticism, he did not focus at first on the actual delivery

and dissemination of his new "art products." By the time he wrote *Malerei, Photographie, Film* in 1924, he made what was for him the obvious next step of proposing that the new art could be disseminated through the mass media, both in print and in film.

In "Produktion-Reproduktion" Moholy analyzed the potential of photography in the following way:

The photographic camera fixes light phenomena by means of a silver bromide plate placed at the back of the camera. Up till now we have used this capacity in a secondary sense only: for the fixation (reproduction) of single objects as they reflected light or absorbed it. If we desire a revaluation of this field, too, we must exploit the light-sensitivity of the silver bromide plate to receive and to fix upon it light phenomena (moments from light displays) composed by ourselves with contrivances of mirrors or lenses, etc. For this, too, many experiments are needed: astronomical pictures (taken through telescopes) and X-ray pictures were interesting forerunners in this field.[13]

Up to this point, Moholy thought, photography had been used only to reproduce objects from nature. He suggested that the medium should now be explored in terms of its inherent characteristics, that is, the reaction of light-sensitive materials to the manipulation of a light source (or sources). Such experimentation means, in effect, that the actual photographic process determines and ultimately becomes the content of a photograph.

The absorption in medium and artistic process had characterized much avant-garde art, in France and the United States particularly, since the second half of the nineteenth century; once isolated from its historical context, this aspect of avant-garde art defined the formalist concept of modernism developed by the English critics Clive Bell and Roger Fry and later by Clement Greenberg and his followers. Nor was the emphasis on medium and materials new to photography: for example, the German photographer Albert Renger-Patzsch spoke of being "true to the medium" in the mid-twenties. Renger-Patzsch (and modernist critics) identified photography's characteristics through such technical aspects as the cropping of the frame, rendering of sharply defined detail, maintenance of a wide range of gray values, freezing of motion, and reproducibility. Through these attributes, according to Renger-Patzsch, the photographer could isolate and study form in nature and achieve what he called realism.[14]

However, Moholy's initial interest in the formal properties of photography came neither from pure formalism nor from photography; rather, it can be traced to his search for an elemental art and to his knowledge of avant-garde Russian art. First for Tatlin and then for the productivists in Russia from around 1917 to 1922, "materialism" or *faktura,* the physical working of artistic materials, was a form of intellectual "work" that gave their status as artists ideological justification. The process of identifying and maximizing the effects of the properties of a material or medium would also be an important aspect of the *Vorkurs,* which Moholy

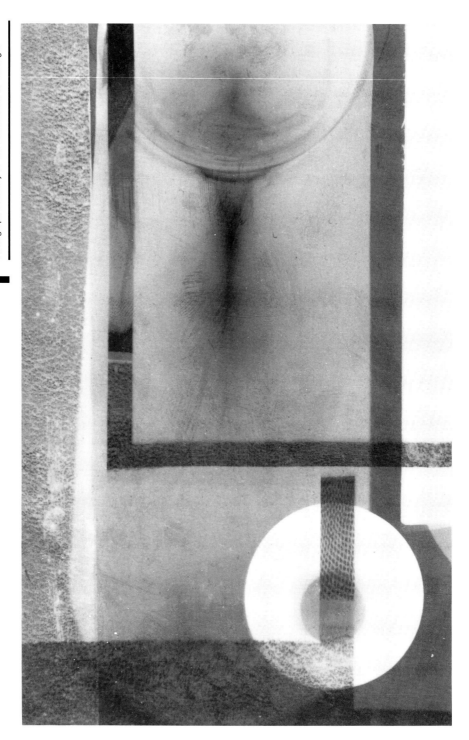

17. *Untitled (Photogram)*, 1922. Gelatin-silver print, 18.9 × 13.9 cm. The Art Institute of Chicago. The Julien Levy Collection, Special Photography Acquisition Fund, 1979.81. Photograph courtesy of The Art Institute of Chicago.

18. *LIS*, 1922. Oil on canvas, 131 × 100 cm. Kunsthaus Zürich, Zurich.

took over at the Bauhaus. Moholy initially reduced photography's unique qualities to one: the creation of form with light.[15] When several years later he moved from the photogram to working with a camera, he expanded his theory to include more widely held views about the medium.

As will be discussed in greater detail in the next chapter, Moholy's early experiments with photography, the photograms, parallel the compositions and spatial constructions in his nonobjective canvases (compare figs. 17, 18). What made these photographs innovative was the fact that they were nonrepresentational. Artists and critics had long stated that photography freed painting from representation, thus enabling painting to develop along other, nonfigurative lines. Moholy hoped that photography, too, could achieve a new degree of freedom. Rather than separating photography from painting, Moholy felt that both could be utilized for a common goal, the formulation of a new aesthetic for the industrial era.

Moholy's treatment of film in "Produktion-Reproduktion" included discussion of the work of the Swedish artist Viking Eggeling and his collaborator Hans Richter, both of whom were at the time personal friends of the Moholys, and the film experiments by Walther Ruttmann and Theodor Wilfred.[16] The films of Eggeling and Richter, admired also by van Doesburg, served as models for Moholy's exploration of the aesthetic possibilities of film.[17] In the closing lines of the article Moholy wrote:

However, the main task [of film] is the manipulation of motion as such. It is obvious that one cannot proceed to this without a self-produced play of forms as the agent of motion. . . . The most perfect work of this kind up to date is that of Eggeling-Richter. Instead of dramatic action [there] already [appears] a self-produced play of forms even if it still acts to the disadvantage of the manipulation of motion. For motion is still manipulated as such, but too much stress is laid on the development of forms, actually to the point of almost totally absorbing the forces of motion. The way ahead lies in the manipulation of motion in space without dependence on a direct development of forms.[18]

Even though they used animation (Moholy's *selbstgeschaffenes Formspiel*) rather than direct manipulation of light on the film surface, Eggeling and Richter were for Moholy the best practitioners of the kind of art he advocated, employing machine technology to create an abstract art incorporating actual motion. Richter's influence can be seen by a comparison of Moholy's *Üvegarchitektúra* (Glass Architecture) pictures of 1922 to the grouping of abstract shapes in the drawings for Richter's films (fig. 19). Unlike the dadaists who began with photomontage, Moholy was initially interested in creating abstract images. Yet, because of the pressing need inherited from artists such as Malevich, Lissitzky, and Gabo to show movement in space, by 1925 he says that "all photographic processes reach their highest level in the film."[19] Thus, his photograms can be viewed as an experimental step toward the creation of this new art form, the abstract film.

Richter

19. Hans Richter, *Prelude* (detail), 1919. Illustrated in Kassák and Moholy-Nagy, *Buch neuer Künstler* (Vienna, 1922), unpaginated.

Moholy elaborated further on the production of abstract images
through experimentation with photographic processes in his article
"Light—A Medium of Plastic Expression," published in the American little
magazine *Broom* in March 1923.[20] Here he argued that photography
had become stagnant because of its rigid adherence to the reproduction
of nature based on Renaissance perspective. Now, Moholy said, this
narrow focus, shared by photography and painting alike, had been "ren-
dered obsolete" by modern artists. The light sensitivity of photographic
materials offered infinite possibilities for avoiding perspective and real-
ism, and for utilizing light as a "medium of composition." Inspired by such
advances in scientific photography as extended time exposures and
X-ray photography, Moholy suggested a number of ways that light, even
when unseen by the naked eye, could be explored in a specially de-
signed "laboratory." Moholy realized his ideas for manipulating, control-
ling, and forming a composition by means of photography, or more
specifically of light, through his photograms.

CHAPTER

LIGHT: MEDIUM AND MESSAGE

Moholy's earliest engagement with photography was shaped by his definition of photography as the recording of forms made by light. Initially, the photogram offered him the means for working directly with light as a medium. With Lucia's technical assistance, he began his work in photography in 1922 with these abstract, cameraless photographs, the forms of which were closely associated with his paintings and prints of the period. As the Moholys' darkroom facilities and in turn printing techniques became more sophisticated, Moholy concentrated on the manipulation of light to expand his vocabulary of abstract forms and to convey a semblance of motion consistent with his constructivist aesthetic. In the process, his interests in the "dematerialized" flat surface of the medium and the depiction of objects or light moving through an infinite space became paramount. The photograms and, as we shall see, the camera photographs and photomontages show how an aesthetic originally formulated in painting and sculpture was enhanced and extended by the exploration of photography. Yet, as is the case with his other kinds of photographs, his photograms go beyond the level of merely illustrating his art theories. At their best they contain a new kind of imagery that relates to the world beyond, the cosmos, in both the astronomical and the spiritual sense.

Max Kozloff has described the photogram as "essentially a homeless medium which attracted attention because it seemed to validate a photographic mode with the literal stamp of advanced art."[1] It is true that although this photographic process had been used before the 1920s, chiefly for recording scientific specimens, its international recognition as an art form came through its promotion not by photographers but by such established visual artists as Moholy, Christian Schad, and Man Ray. As a result, Moholy and these other members of the avant-garde were able to give photography a stamp of approval and a prominent role in the major artistic movements developing in the twenties and thirties. Their photograms raised basic photographic issues that contributed to a freer approach to the medium in the 1920s and after. The radical nature of their approaches, perhaps ones only a nonphotographer might attempt, presented an irresistible challenge for many interested in creating a new kind of art for the postwar era.

Ultimately the study of Moholy's photograms helps us to integrate a number of issues associated with individual media into a more meaningful history of image making. In order to do so, we need to seek answers for several basic questions. Why was Moholy interested in light? What were the roots of his preoccupation with depicting the infinite, cosmic space advanced by Malevich? How did Moholy merge his two seemingly contradictory interests in *faktura* and a "dematerialized" art? Most importantly, how do the photograms transcend his strictly defined theoretical polemic to offer us a new kind of imagery related to the optimistic era of scientific discovery in the 1920s?

20. Lucia Moholy, *László Moholy-Nagy at the Dessau Bauhaus*, ca. 1925. Collection of Hattula Moholy-Nagy, Ann Arbor.

History of the Photogram Technique

The term "photogram" has taken on several definitions during the century and a half of photographic history. Used in the nineteenth century interchangeably with "photograph," by the early twentieth century the term referred specifically to scientific photographs. It has now assumed the meaning that Moholy assigned it, a cameraless photograph created by placing objects and materials, such as fabric or paper with varying degrees of opacity, on light-sensitive paper.[2] The paper is then exposed to a light source or sources and developed. The areas of the paper completely covered remain white, and those that receive exposure to light become transformed into a range of tones from light gray to black. The variety of grays depends upon the density of the materials blocking out the light and the length of the exposure. The resulting photogram, created without a negative, is a unique image. It can only be reproduced by making a negative of it from which additional prints can be made.[3] White objects or forms floating on a dark (highly exposed) ground characterize the majority of Moholy's photograms. It is a bit confusing that he referred to photograms as "negative" images: rather than using the photogram as an actual negative from which a "positive," or image with a light background, could be made, it is probable that Lucia made glass negatives of many of his works from which any number of variations and combinations of images could be created. Although the objects he used are sometimes recognizable, the forms in his photograms are more often abstract.

The photogram process actually preceded the development of the camera in the history of photography. The earliest seem to have been made around 1800 by Thomas Wedgwood, the son of the British ceramicist. Calling them "profiles by the agency of light," Wedgwood created negative silhouettes by placing insects and leaves on white leather coated with silver nitrate.[4] Better known are the images of another Englishman, William Henry Fox Talbot, who began experimenting with his "photogenic drawings" in 1833 and by 1841 had developed a negative/positive paper process called the Talbotype or calotype. Talbot published the results of his photographic work in his book *The Pencil of Nature* (London, 1844–1846).[5] His 24 "views" included still lifes and architecture, plus some examples of his "photogenic drawings," photograms made with plant materials. For nearly 80 years after the publication of Talbot's book scientists employed the photogram technique to a limited degree to record plant, animal, and microscopic forms. The German scientist Paul Lindner summed up current scientific applications of the photogram in his how-to book *Photographie ohne Camera* (Photography without a Camera), published in Berlin in 1920.[6]

In the late 1910s and early 1920s the dada artists Christian Schad and Man Ray turned to the photogram, not as a means for illustration but to explore its artistic possibilities. Both these dadaists approached the technique from the specific context of their work in other media. In the same way, Moholy first used the photogram to create the overlapping, transparent planes of his paintings and prints. Because the photograms

of Schad, Man Ray, and Moholy are generally grouped together by historians and critics, it is useful to take a closer look at the individual approaches to the photogram by each in order to assess properly Moholy's place among them. A recent case where their photographs were illustrated together without comment on the basis of superficial visual similarities can be found in the book *The New Vision: Photography between the Wars,* published in conjunction with an exhibition of the Ford Motor Company Collection of Photographs at the Metropolitan Museum of Art in 1989. There the photographs by Schad, Moholy, Man Ray, Francis Bruguière, and Maurice Tabard are grouped together without explanatory text in the illustrations purely on the basis of visual similarities.[7] Such an approach, based on comparisons of form rather than artistic motivation or historical context, was employed, for example, by Alfred Barr more than 50 years earlier in his exhibition catalogue *Cubism and Abstract Art* for the Museum of Modern Art. This approach does little either to distinguish or to illuminate the richness of the individual contributions of these artists.

First Photograms by the Moholys

The early photograms raise the issue of attribution, for they resulted from the collaborative efforts of Lucia and László Moholy. Although they were initially attributed to Moholy alone in publications and exhibitions of the 1920s, Lucia maintained that she should receive credit as well.[8] She does seem to have provided the technical knowledge with which Moholy explored constructivist concepts with the photogram. While not intending to overlook Lucia's contribution—it is doubtful that Moholy would have made photograms at all if her expertise had not been at hand—the following discussion focuses on the ways in which Moholy realized his goals for the "productive" use of photographic materials.

The first photograms created by Moholy and Lucia were made on printing-out paper, also known at the time as "daylight" paper, which when exposed to light produced a visible image without further chemical developing.[9] This type of paper was fairly primitive, but they chose it because it was cheaper and did not require a darkroom. The resulting images have a small format (no more than 19 × 14 cm) and a readily identifiable brownish tone; many appear to have faded considerably over the past 60 years due to the Moholys' inability to "fix" the image permanently through chemical developing. They created textural areas by "passing light through fluids like water, oil, acids, and crystal, metal, glass, tissue, and other materials."[10] The presence of fingerprints serve as additional evidence of their active manipulation of materials. It is difficult to determine the precise chronology of photograms in the first several years of their production. The early works are not dated nor are there other records that might indicate a sequence.

We can ascertain that in their first photograms the Moholys adapted collage techniques related to his paintings and reliefs from approximately 1921–1923. Although Moholy made an attempt, only partially successful, to translate his early photograms into a constructivist idiom

through his manipulation of shapes and crosses, their textural pattern-ing, light-dark contrasts, and centripetal compositions are closer to de-velopments in dada collage. In 1921–1922, when he shared a studio in Berlin with Kurt Schwitters, Moholy made a number of painted reliefs incorporating found objects. In a photogram from 1922 (now in Chicago), Moholy combined devices used in his collage reliefs and transparent paintings to construct the composition by overlapping rectangular and circular forms (figs. 17, 18).[11] As was characteristic of both Schwitter's *Merz* collages at the time and Moholy's reliefs, the assemblage of geo-metric shapes extends to the edge of the picture plane. He further tested the application of collage to photograms for the study of texture and figure-ground relationships by flipping the image over, turning it upside-down, or making a positive (reversal printing).

Moholy's earliest collage photograms also show striking parallels to photograms by Christian Schad dating from four or five years earlier (fig. 21). Schad's association in Zurich with dada's founders, Hans Arp and Tristan Tzara particularly, paved the way for his use of the technique (fig. 22). According to Schad, dada gave him the freedom to explore new means of artistic creation.[12] For creating their fragmented vision of contemporary society, the Zurich dadaists turned to the medium of collage as a way to break away from painting traditions and habits of the hand. Collage could easily be exploited to feed their growing concern with the role of chance or accident in the creation of a work of art. As was the case with Schwitters and Arp, Schad had a collection of found objects: a box full of paper, fabric scraps, feathers, nails, string.[13] These he placed on a sheet of photographic paper and covered with a sheet of glass. He used daylight paper, which he then exposed by placing the glass frame on a window sill. As he watched the image develop, he often rearranged the objects to adjust the composition.

Schad's use of recognizable materials such as newspaper and fabric emphasized the ambiguity of the division between art and life, the three-dimensional world and the flat picture plane. Although executed in the spirit of dada, Schad's "collage-photographs," dubbed "schadographs" by Tzara, concentrate on the exploration of formal values in darkness, shadow, and light, the same emphasis of his black and white woodcuts of this time. This emphasis resembles the use of collage by his friend Arp (fig. 23), yet Schad translated Arp's diversely textured, colored, three-dimensional scraps into two-dimensional, monochromatic, pat-terned shapes. Because of their essential flatness and lack of substance Herta Wescher referred to them as "immaterial collages."[14] Schad's interest in the photogram lasted only several months, and by the 1920s he rejected dada to become a leading Neue Sachlichkeit painter.

Rather than having direct links to the dada practice of collage, Moholy's interest in variations in the texture of materials was more explicitly an outgrowth of his adherence to the basic tenets of Russian constructivism and of his teaching at the Bauhaus. He used various thicknesses of paint, applications of varnish, and the weave of the canvas, in short the constructivists' *faktura*—the workmanship, the material qualities of the

21. *Untitled* (three photograms), 1922. Gelatin-silver prints, 19 × 12 cm. each (sight). Collection of Yasu Hattori, Tokyo.

22. Christian Schad, *Schadograph*, 1919. Gelatin-silver print, 16.8 × 12.5 cm. The Museum of Modern Art, New York. Purchase.

light: medium and message

23. Hans Arp, *Composition*, ca. 1915. Collage on cardboard, 23.8 × 19.9 cm. Kunstmuseum, Bern, Hermann and Margrit Rupf-Stiftung. Copyright by VAGA, New York.

surface—to produce a variety of light reflections from separate regions of a painting.[15] Although this focus on contrasts of texture does re-emerge later in his camera photographs and his film *Lichtspiel schwarz-weiss-grau* (Lightplay Black-White-Gray), by the mid-1920s he was no longer emphasizing it in his photograms. The Moholys' switch from textural studies to the rendering of "dematerialized" objects and the recording of light movements exemplified the aesthetic they were championing in their critical writing.

Moholy and Man Ray

After the publication of the *Broom* article, Moholy and Lucia turned from collagelike photograms to the employment of distinct objects, undoubtedly under the influence of Man Ray, the American expatriate living in Paris. Strong contrasts of light and dark typically delineate recognizable objects engulfed by a surrounding blackness (fig. 24). The oblique angles of the light sources distort the forms and give the illusion that they are disappearing into the shadows of the background. On a cursory examination, the early photograms of Man Ray and Moholy often seem similar in appearance, but ultimately their separate approaches to the medium were informed by different aesthetics: for Man Ray dada and surrealism, for Moholy suprematism and constructivism.[16]

Man Ray's photograms embody the dada practice of assembling unlikely combinations of images, sounds, or words to create new, often nonsensical meanings. His earliest photographs were conceptually related to the work of the early New York dadaists, Duchamp in particular: an image of an eggbeater (entitled *Man)* and a construction of reflectors and laundry pins (*Woman*), both of 1918, represent "photographic readymades" imbued with a typically Duchampian sexist perversity.[17] Although he turned to portrait and fashion photography to provide an income when he moved to Paris in 1921, Man Ray continued to explore photography as an artistic medium in the decade of the twenties. Unlike Schad, Man Ray gave photography a dominant position in his aesthetic outlook, and his innovative and unorthodox approach to photography, it can be argued, stands as his most important contribution to dada and surrealism.

In late 1921 Man Ray "accidentally discovered" (the words are his) the photogram process, which he called the "rayograph," while working in his darkroom. These photograms came to symbolize the relationship between the empirical world and the realm of the unconscious that was central to the emerging surrealist movement (fig. 25). The objects he used, taken from his living quarters, refer to his life, his art, his preoccupation (as was the case with other surrealists) with imagery related to sex and death. Though Man Ray arranged the objects on the photographic paper, the resulting images were often unexpected. Thus, for him the photograms were dependent upon both the role of chance and recognizable references to everyday life.

Coincidentally, Tristan Tzara, who also witnessed Schad's photogram experiments, lived at the time in the same Paris hotel as Man Ray and

24. *Untitled (Photogram with Eiffel Tower and Gyroscope)*, ca. 1925. Gelatin-silver print, 29.7 × 23.5 cm. Staatliche Museen Preussischer Kulturbesitz, Kunstbibliothek, Berlin.

25. Man Ray, *Delicious Fields—Comb*, from *Les Champs délicieux: Album de photographies* (Paris, 1922). Gelatin-silver print mounted on wove paper from portfolio, 22.2 × 17.1 cm. Collection of the J. Paul Getty Museum, Malibu, California.

came for lunch on the day of the photographer's discovery. Upon viewing the photograms pinned on the wall, Tzara proclaimed that they were "pure dada" and, according to Man Ray, called them "far superior" to the "simple flat, textural prints in black and white" made by Schad.[18] More important to dada for Tzara than Schad's flat collages were the repeated references in Man Ray's photograms to the real world through the arrangement of real objects in space while at the same time the black backgrounds and shadowed forms denoted the other world of the unconscious. The conflict and connections between the two worlds impart to the photograms mesmerizing and provocative qualities.

At Tzara's urging, Man Ray produced an album of photograms entitled *Les Champs délicieux* in December 1922.[19] The album, which included a preface by Tzara, established Man Ray's position as the preeminent photographer of the budding surrealist movement. The choice of *Les Champs délicieux* for the title makes his relationship to surrealism clear. It associates the photograms with the pieces of "automatic writing" entitled "Les Champs magnétiques" published by André Breton and Philippe Soupault in 1919–1920.[20] This connection implies a parallel between the "automatic" or free-flowing stream-of-consciousness writings that were at their peak in 1921 and the photograms as a kind of "automatic photograph." Even Man Ray's story of "discovering" the technique plays on the role of chance rather than premeditation in the artistic process. The title also invites a viewer response of intimacy and pleasure. The photograms provide a window onto Man Ray's private world. Objects from his studio—a key, comb, gyroscope, wine glass, metal food grater, or one of his sculptural objects (such as *Compass,* 1920, made from a revolver and a magnet)—comprise all but two of the 12 photograms contained in the album.

Although Moholy and Man Ray were both using recognizable everyday objects in their photograms at the time *Malerei, Photographie, Film* appeared in 1925, Moholy chose to illustrate Man Ray's photograms with two that looked distinctly different from his own reproduced in the book. Moholy placed one of his photograms, consisting of overlapping rectangular and circular planes, opposite a rayograph showing a hand and an egg (fig. 26). In the second edition of the book, Moholy more explicitly pointed out the surrealist character of Man Ray's work with the addition of the caption "New use of the material transforms the everyday object into something mysterious."[21] "I understood photograms differently from Man Ray," Moholy later wrote. "The optical miracle of black into white is to result from the dematerialized radiation of light without any literary secrets or secret associations, through the elimination of pigment and texture."[22]

Moholy described the effects possible in a photogram as "sublime, radiant, almost dematerialized," but he wanted to stress that unlike Man Ray he did not seek to record imagery of the unconscious.[23] Moholy's metal objects and manufactured tools were a far cry from Man Ray's "champs délicieux." A gyroscope alludes to mechanized motion, while a more specific icon such as the Eiffel Tower signifies progress and tech-

nology. Ironically, Moholy was minimizing the very characteristic, the mysteriousness, that makes his own later photograms so interesting.

Both Man Ray and Moholy claimed they had come upon the photogram technique independently and without prior knowledge of similar photographic experiments. We know that when Man Ray first made photograms, Tzara was a close friend, lived in the same hotel, and owned several schadographs. Yet while Man Ray's early photograms bear little resemblance to the collaged elements of Schad's work, some of the Moholys' first photograms do demonstrate a similar collage technique. Because of Moholy's infatuation with periodical literature, he could have encountered reproductions of Schad's photograms in *Dadaphone,* or he might have heard about work by Schad or Man Ray through Tzara.[24] However, as photography did not become a primary interest for Moholy until 1922, it is possible that he was not aware of the technique before that time. Although Man Ray made his first photograms half a year before Moholy (Man Ray in January 1922, Moholy in the summer of 1922), it seems credible that initially the Moholys were unaware of Man Ray's precedent. After their work was published together in *Broom* in 1923, Moholy briefly adopted Man Ray's use of everyday objects in his photograms, and in many instances their work from this time is not readily distinguishable.[25] Soon, however, Moholy would pursue his own path of experimentation.

Andreas Haus has astutely observed that the debate about the timing of the "invention" or "discovery" of the photogram points to the manner in which artists tied their searches for new art forms to invention or discovery in science and/or technology, by Einstein or Edison, for exam-

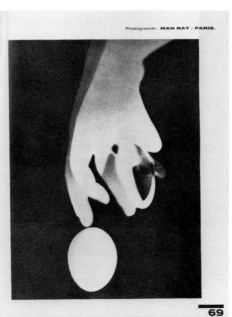

26. Illustrations from *Malerei, Photographie, Film* (Munich, 1925), pp. 68–69.

light: medium and message

ple. Art making received a certain validity as a form of production by stressing inventiveness and originality.[26] Moholy's claims to the independent discovery of the photogram have been repeatedly attacked by a number of artists.[27] Lissitzky wrote a lengthy letter to his wife accusing Moholy of plagiarism shortly after the publication of *Malerei, Photographie, Film,* in which Moholy elaborated on the theoretical implications of his own photogram technique. Lissitzky asserted that Moholy had been told about Man Ray's photograms by Tristan Tzara at the Dada-Constructivist Conference in Weimar in the spring of 1922 (in actuality, the conference was in September of 1922) and a little later by the American Harold Loeb, an editor of the periodical *Broom.*[28] Furthermore, Lissitzky maintained that Louis Lozowick, who translated Moholy's *Broom* article from German into English, described the way in which Moholy deliberately selected works by Man Ray to make the American's work look surrealist and his own constructivist. Not having the support from other artists for his photograms that Man Ray enjoyed, Moholy initially served as his own publicist, discussing what he saw as the relevance of his work and manipulating the illustrations to prove his point in articles in *De Stijl, Broom,* and his book *Malerei, Photographie, Film.* Nevertheless, despite Moholy's attempts to control his image as a constructivist photographer, his photographs' surrealist tendencies, often rivaling those of Man Ray, become ever more apparent in his photographs and photomontages.

The Imagery of Light
In 1922, as Moholy explored the pictorial forms of "glass architecture" and transparency in his paintings and graphic work, he began to experiment with the light effects that could be produced through photography. Light became the most important element of his work, whether in painting, sculpture, or photography, from this point to the end of his career. For him, it was the element that embodied the essential characteristics of a "modern" art, the emphases on form, space, movement. At the same time, the imagery of light was tied to scientific theory.

His early interest in light and transparency came from two very different sources. First, it had its roots in constructivism. Moholy knew of Lissitzky's use of transparent planes and three-dimensional forms. But the interest in light also had a basis in a more spiritually oriented art. The white backgrounds of Malevich's suprematist paintings refer to the all-encompassing light, the eternal being and nothingness, of enlightenment. The spiritual basis of Malevich's work would not have escaped Moholy, moving as he did among the Russian avant-garde in Berlin. Second, Moholy would also have come in contact with the light imagery of the expressionists, many of whom he knew as a member of the Sturm circle in the early 1920s. Not only the light architecture of expressionist architects such as Scheerbart and Taut but also graphic work in black and white by expressionist artists used the imagery of light to refer to spiritual regeneration or fulfillment. Such ideas circulated around the Bauhaus, most prominently in Kandinsky's spiritual basis of art and

Gropius's (and Feininger's) adoption of the crystal cathedral as a metaphor for the inspirational architecture of the future. In addition, as Haus has pointed out, Lothar Schreyer, who joined the Bauhaus in 1921, also shared this expressionist approach. "The aim of the work of art is the illumination of inner light," Schreyer said. "The forces unfold their power in the artist and teach him that he himself is this power which is more than the visible man. . . . He who wishes to announce the light, has to live in the light. Darkness gives birth to the light."[29]

In addition to expressionist and constructivist sources, it is important to look at the scientific discoveries of the time. As an artist seeking to invent an art that resulted from and symbolized the modern scientific and technological world, Moholy would have been highly interested in current developments in physics. The major discoveries of the first two decades of the twentieth century actually focused on light. In 1900 the German physicist Max Planck laid the foundation for quantum theory, the theory that light was composed of *quanta* or discrete increments of energy. This hypothesis followed the development of new, very powerful spectroscopic equipment that could measure radiation. In 1905 Albert Einstein expanded Planck's ideas into his theory that light was made up of energy particles that moved in groups, rather than in continuous waves. Einstein postulated that since light had mass, it could be affected by gravity.

General interest in the movement of bodies through space resulted from the publication and subsequent popularization of recent theories of non-Euclidean geometry, quantum theory, and Einstein's theory of relativity. In addition, Einstein's space-time continuum, his conception of a fourth dimension as time, influenced many artists. References to a fourth dimension were prevalent in artistic theory of the early twentieth century, but these generally refer to a higher dimension (that is, beyond the third) of space proposed by developments in non-Euclidean geometry in the late nineteenth century.[30] The idea of the "higher dimension" received particular attention for its spiritual ramifications in Russian art of the 1910s due to writings by the mystics Madame Blavatsky and P. D. Ouspensky. However, by the 1920s most of the artists of Moholy's circle turned to the newer definition based on theoretical physics.

While many scientists of the period were devoting their research to nuclear physics, Einstein developed his theories on more general laws of the universe, what he referred to as "the nature of God's creation." Though he did not believe in either organized religion or a personified God, Einstein's interest in the philosophical implications of the universe inspired his work. "Science without religion is blind," he said, "religion without science is lame."[31] Both Planck and Einstein developed their theories at Berlin's Kaiser-Wilhelm-Gesellschaft, now known as the Max Planck Institute for the Advancement of Science, which was started by a theologian.

By the 1920s Einstein had obtained a kind of cult status, and his "General Theory of Relativity" was popularized in the press. Ideas about the movement of objects and light through space over time became

topics of intense interest in intellectual circles. This is when Moholy came to believe that the ultimate artistic medium was light, creating forms in space, and that these forms would achieve their full realization when set into motion. Although the expressionist-spiritualist influence on his ideas about light and space might seem the antithesis of the constructivist-scientific approach (Einstein, too, embodied such opposites in his search for universal laws), in fact it is in their balancing of the seemingly opposing forces that Moholy's mature photograms suggest a seemingly infinite array of possible meanings.

The Moholys focused on using light as a medium and on its symbolic implications when they abandoned the rendering of textures and the distortion of objects in favor of more direct methods for composing light and dark masses on the picture plane. This they accomplished by recording light manipulations on photographic paper. Moholy saw this activity as the essential element of photography, a word that itself is derived from the Greek words for "light" and "to write." "The light-sensitive layer—plate or paper," Moholy wrote in 1928, "is a *tabula rasa,* a blank page on which one may make notes with light, just as the painter, working on his canvas in a sovereign way, uses his tools, brush and pigment."[32] Moholy went on to distill this definition even further: "The photographer is a creator with light; photography is the organization of light."[33]

In a photogram dated 1924 in the Museum Ludwig in Cologne, the gestural white lines contained within a circle present the illusion of drawing or writing with light (fig. 27). The overlapping rectangles create a spatial recession from the plane of the circle. Since the photogram process produces white areas when light is blocked out and dark areas through exposure to light, Moholy probably obtained these effects by drawing on a glass plate with a crayon and placing the plate over the photographic paper. The areas of crayon drawing then blocked out the light and appear white. Because Lucia has stated that they never worked on a scale greater than 18 by 24 centimeters, the large dimensions of the Museum Ludwig photogram (39.7 × 29.8 cm), and the existence of another example in Zurich, indicate that this is not a unique photogram but was printed from a negative.[34] Two examples in the collection of the Houston Museum of Fine Arts demonstrate Moholy's manual reworking of his photograms. He scratched a white circle into the black background of the photogram by actually scraping the photographic emulsion off the paper with a compass. Therefore, these works may be the result of any number of manipulations of the original unique photogram.

Light Constructions in the Cosmos
Once Moholy succeeded in composing with light and exploring figure-ground relationships with the photogram, he moved on to create more complicated imagery related to the movement of objects in space. These abstract forms floating in a black void were new creations from light sources rather than recorded traces of recognizable objects. As discussed in chapter 2, Moholy's involvement with compositions of forms moving through space stemmed from his contacts with Malevich's su-

27. *Photogram*, 1924. Gelatin-silver print, 39.7 × 29.8 cm. Museum Ludwig, Cologne.

light: medium and message

prematism, most probably through discussions with Lissitzky, and through Lissitzky's work as well. Works such as Malevich's *Suprematist Painting* (1917; The Museum of Modern Art) and Lissitzky's *Proun 99* (1925; Yale University Art Gallery) show the ways in which bodies are deformed by their positions relative to each other and their movements through space.

Moholy's interest in the movement of objects and light through space seems also to have been rooted more in science than in the literature of the occult. His was not a sophisticated knowledge of physics or astronomy, but rather a lay understanding of scientific developments and theories derived from the popular press. In fact, Moholy's very ethos was rooted in popular culture. He adapted a number of artistic processes and a vocabulary of forms to a specific world view that was not derived from a background of traditional training in the fine arts. That he consulted scientific writings and illustrations can be seen, for example, in his choice of photographs of star movements and a spiral galaxy, both images of forms created by light on a dark ground, for *Malerei, Photographie, Film.*[35] More importantly, the photograms themselves served in his view as a visual analogue to tracings of astronomical movements. "Sometimes, without intending it, I got pictures with almost cosmical and astronomical effects." However, he continued, "I tried to avoid this as I see in it the disadvantage of having material associations."[36]

Moholy seemed to believe that this so-called "dematerialized" characteristic of photography, because it was free of the material quality of manipulated pigment, was the perfect vehicle for rendering abstract forms moving through space. He later described what he was able to achieve: "Brushwork, the subjective manipulation of a tool is lost, but the clarity of formal relationships increased to an extent almost transcending the limitations of matter."[37] When Moholy and Lucia moved into their "master's house" at the Dessau Bauhaus, they were able to set up a proper darkroom for the first time. With their new facilities, their interest in experimenting with artificial light intensified.[38] They could record moving light sources and thus evoke the outdoor searchlights or "light architecture" that Moholy described in his writings (fig. 28).

Moholy specifically addressed the issue of a dematerialized art in response to an article on the alleged superiority of painting to photography written by the Hungarian art critic Ernst Kállai in the Dutch periodical *i 10.*[39] Kállai argued that photography, because of its inherent inability to possess *faktura,* could never equal painting as an expressive art form. No matter what pictorial means were used to create a tension between layers of the composition and the material surface of the picture plane, the surface of a photograph remains flat and dematerialized. The image always lies behind the picture plane, does not come to the surface, much less out into the viewer's space. Moholy's decisive counterstatement reveals how basic his earlier interest in *faktura* was for his photographic theory. *Faktura,* he said, was the manipulation of artistic materials, not texture per se; thus, the recording of light on photosensitive materials revealed the manipulation of the medium.[40]

Moholy's paintings of 1923–1925 were most typically constructivist compositions of geometric forms on a light background. A few photograms with similar figure-ground relationships, the so-called "positive" photograms, do survive. A photogram in the Museum of Modern Art offers a close parallel to his suprematist-inspired paintings of the time (fig. 29). The work creates an illusion of objects falling through space, as if dropped from an airplane, that was characteristic of Malevich's paintings of 1919–1920 (fig. 30). Moholy massed the overlapping transparent oval and bar shapes toward the upper left. As their density decreases toward the center, the forms appear to fall back and away from the picture plane in a stepped, planar recession into space. Moholy achieved a similar effect of movement through space in another "positive" photogram now in the Bauhaus-Archiv (fig. 31). He placed a circle containing groupings of rings toward the top of the composition. Psychologically, the viewer feels the downward pull we expect of gravity. The slight angle of the rings and their positioning directs this pull downward toward the right and thereby back away from the picture plane.

The Photogram and the *Vorkurs*

In a number of ways, Moholy's photograms embody concepts and experiments assigned in his Bauhaus *Vorkurs*. For example, he often printed photograms and camera photographs as negatives and positives, apparently in order to compare the different effects caused by

28. *Untitled (Photogram with Arcs)*, n.d. Gelatin-silver print, 20.2 × 25.3 cm. The Museum of Fine Arts, Houston, Museum purchase with funds provided by Bernstein Development Foundation.

light: medium and message

reversing the figure-ground relationship. Moholy extended his experimentation to couple a sense of diagonal spatial movement with his concern for figure-ground relationships in a photogram and its positive (with a light background) at the George Eastman House (figs. 32, 33). As in his "suprematist" photograms, there is a sense of diagonal spatial movement as twisting shapes come in and out of focus, up to and away from the picture plane. The light background of one work indicates the use of a negative, probably made by Lucia. The fact that Moholy kept both versions indicates his use of the photogram to explore a design issue relevant to his painting and his *Vorkurs.* Indeed, the reversed images do produce different kinds of effects. The one with the black background is more closely associated with outer space, while the other is more clearly related to the white light of Malevich.

Moholy also used the photogram technique to create suspended objects related to architectural constructions seen in the two- and three-dimensional work and that of others such as El Lissitzky and Gustav Klutsis (fig. 34). Resembling a kind of futuristic space station, the pictorial forms represent the constructivists' proverbial "blueprints" for the architecture of the future. Moholy's floating structures also relate more specifically to three-dimensional constructions created by his students in Dessau. His suspension of forms from the upper edge of a photogram finds its three-dimensional counterpart in a study of gravity by his student Irmgard Sörensen-Popitz (fig. 35).[41] Another floating structure appears to beam rays of light that form overlapping transparent wedges

29. *Photogram,* n.d. Gelatin-silver print with pencil, 16.8 × 23.2 cm. The Museum of Modern Art, New York. Anonymous Gift.

30. Kazimir Malevich, *Suprematism (Supremus No. 50)*, 1915. Oil on canvas, 97 × 66 cm. Stedelijk Museum, Amsterdam.

light: medium and message

31. *Untitled (Photogram)*, ca. 1925. Gelatin-silver print, 37.5 × 27.5 cm. Bauhaus-Archiv, Berlin.

32. *Photogram,* n.d. Gelatin-silver print, 38.6 × 29.6 cm. George Eastman House, Rochester.

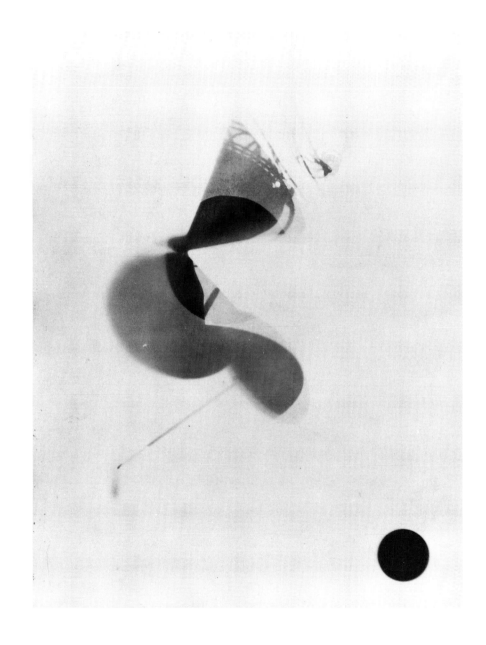

33. *Photogram,* n.d. Gelatin-silver print, 38.4 × 28.5 cm. George Eastman House, Rochester.

resembling the beams of colored light in several of his contemporaneous paintings (figs. 36, 37). Moholy was able to produce this effect in his photograms by directing light through a prism.[42]

True to the Bauhaus concept of giving artistic exploration practical application, Moholy adapted the photogram for use in typography and graphic design. Its possible uses in advertising he discussed in a number of articles that were illustrated with his own photograms.[43] The earliest examples of his own application of the technique can be found in his designs for a series of covers for the issue of *Broom* in 1922 included the first publication of his photograms and his first article devoted solely to photography (fig. 38).[44] Years later Moholy reused several of these photograms for advertisements and periodical covers. In one instance, he transformed two early photograms into a striking cover design for the periodical *Foto-Qualität* (fig. 39).[45] He printed the photograms in reverse with a light background and added typography and a superimposed photograph of a camera.

The *Foto-Qualität* cover not only displays a creative adaptation of a photogram for graphic design, but it also serves as an important visual statement about his attitude toward photography. In it Moholy connects visually the hand and the machine—the artist's manipulation of photographic materials with or without the camera. As Haus has pointed out, this image stands in striking contrast to Lissitzky's cover for Roh and Tschichold's book *Foto-Auge,* in which Lissitzky superimposed a self-portrait with the tools of his trade: a photograph of a hand holding a compass, graph paper, and stenciled lettering (fig. 40).[46] In Lissitzky's work the artist's eye replaces the camera. Hand and mind, not a machine, manipulate the graphic tools. But for Moholy, the artist's use of technology to create a work of art was of paramount importance.

Moholy's experiments at the Bauhaus with different ways to record light formations undoubtedly benefited from exposure to the moving light displays of the students Ludwig Hirschfeld-Mack and Kurt Schwerdtfeger, in conjunction with master craftsman Josef Hartwig. Their *Reflected-Light Compositions* were experiments in kinetic colored light projections that were carried out independently of any specific course or workshop at the school. Conceptualized around 1922 and produced over the next several years, the experiments built on color music theories and the symbolists' ideas about synesthesia, proposed by figures such as the Russian composer Alexander Scriabin, the American Theodore Wilfried, and Moholy's compatriot the pianist Alexander László. The Bauhaus experiments utilized cut-out templates through which moving colored lights were projected onto a screen. Though the accompanying music was often scored, improvisation also was used.

Moholy's interest in these light experiments is demonstrated by his devotion of an entire section of his Bauhaus book *Malerei, Photographie, Film,* entitled "Static and Kinetic Optical Composition," to the subject. Some of his photograms from the Dessau period have the appearance of light displays on a projection screen, which Moholy used in *Von Material zu Architektur* as an analogy to his photograms. He captioned

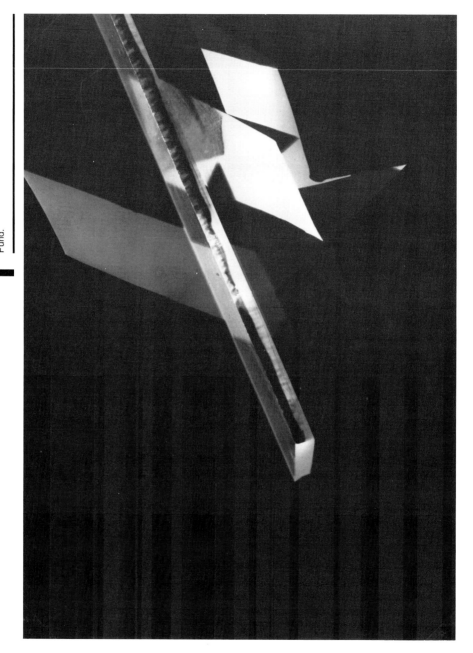

34. *Untitled (Photogram)*, n.d. Gelatin-silver print, 24 × 18 cm. The Museum of Fine Arts, Houston. Purchased with funds provided by The S. I. Morris Photography Endowment Fund.

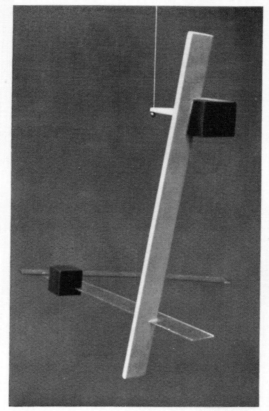

foto: eckner / weimar

abb. 138 irmgard sörensen-popitz (bauhaus. erstes semester 1924)
schwebende plastik (illusionistisch)

die materialwerte, biegsamkeit, dehnungsgrenze, elastizität usw. werden bei diesen arbeiten hin-
einkalkuliert. die untere glasplatte trägt z. b. ein maximal-gewicht.

20 moholy-nagy

153

35. Irmgard Sörensen-Popitz, *Hanging Sculpture (Schwe-bende Plastik)*, 1924. Illustrated in *Von Material zu Architek-tur* (Munich, 1929), fig. 138, p. 153.

light: medium and message

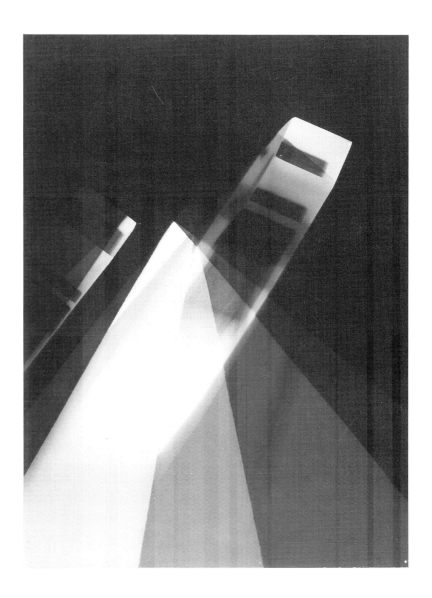

37. *Construction,* 1922. Oil on wood panel, 54.1 × 45.6 cm. Courtesy of the Busch-Reisinger Museum, Harvard University Art Museums. Gift of Mrs. Lydia Dorner in memory of Dr. Alexander Dorner.

light: medium and message

38. *Untitled (Photogram)*, 1922. Gelatin-silver print, 43.2 × 35.6 cm. Photograph courtesy of Eugene Prakapas.

39. Cover design for journal *Foto-Qualität*, 1931. 30 × 21 cm. Photograph courtesy of Jürgen Wilde, Cologne.

light: medium and message

40. El Lissitzky, *The Constructor (Self-Portrait)*, 1924. 29.7 × 20.7 cm. Cover for Franz Roh and Jan Tschichold, *Foto-Auge/Oeil et photo/Photo-Eye* (Stuttgart, 1929). Courtesy of the Busch-Reisinger Museum, Harvard University Art Museums. The Fredric Wertham Collection, Gift of his wife Hesketh.

one of his own works (fig. 41): "Photographic surface treatment by light: a 'photogram,' made without a camera. This is the recording of light as it hit a projection screen—in this case, the sensitive layer of the photographic paper." In the accompanying text Moholy declared that "from the standpoint of technical development—a picture painted by hand is surpassed by the physically pure, 'unblemished' light projection."[47]

The Light-Space Modulator

For Moholy, kinetics and the recording of projected light displays found their ultimate realization in film. He was able to achieve such a goal himself with what is his single most important project, *The Light-Space Modulator* (fig. 42). Moholy's opportunity to implement his ideas for combining kinetic sculpture and light displays, as outlined in *Von Material zu Architektur,* came in 1930 at the invitation of Walter Gropius. As the head of the German installation of the Werkbund section of the Exposition de la Société des Artistes Décorateurs held in Paris that May, Gropius invited Moholy to install a room. Moholy's designs for the *Light-Space Modulator* and its installation were then drawn up by Stefan Sebők, a Hungarian architect in Gropius's office. The sculpture itself was fabricated in the theater department of the AEG by Otto Ball in Berlin.[48] The finished piece, originally entitled *Lichtrequisit einer elektrischen Bühne* (Light Prop for an Electrical Stage), was housed in a box approximately four feet on each side and illuminated by over one hundred colored lights located on the inside of the box (fig. 43).[49] The *Light-Space Modulator* was made up of a number of geometric forms, mostly planes,

41. *Untitled (Photogram with Ellipse and Straight Lines),* 1927. Gelatin-silver print, 17.8 × 23.9 cm. The Art Institute of Chicago, The Julien Levy Collection, gift of Jean and Julien Levy, 1975.1142. Photograph courtesy of The Art Institute of Chicago.

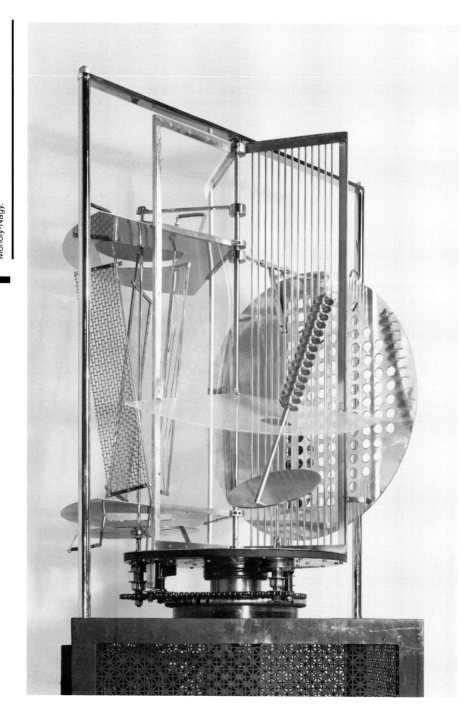

42. *The Light-Space Modulator*, 1930. Kinetic sculpture of steel, plastic, wood, and other materials with electric motor, 151.1 × 69.9 × 69.9 cm. Courtesy of the Busch-Reisinger Museum, Harvard University Art Museums. Gift of Sibyl Moholy-Nagy.

set into motion through a series of gears and a motor in the base. In its original form, the sculpture explored *faktura* through the incorporation of a number of different textures on the surfaces of the forms.[50] When the sculpture is set into motion and its parts begin to move, a variety of light reflections are thrown off its surfaces.

Undoubtedly inspired by the Russians, Moholy began to design kinetic sculptures in 1922, but his plans for the *Light-Space Modulator* were not produced until the spring of 1930. Tatlin's model for his *Monument for the Third International,* executed in 1920, offered important precedents for a sculpture involving geometric forms, mechanized movement, and film. The monument consisted of an open spiral structure containing four stacked geometrical forms: a cube, pyramid, cylinder, and hemisphere.[51] These units were each to house a specific government body and would rotate at different speeds. The news services located at the top of the *Monument* would project films into the sky.[52] Moholy's drawing with collage for a "Kinetic-Constructive System" from 1922 reflects Tatlin's schema (fig. 12). Also pertinent to Moholy's studies of kinetics was the work of Naum Gabo, especially his abstract sculpture *Standing Wave* (1920), in which a vertical metal rod was set into motion by a motor.

The *Light-Space Modulator* served several functions: it was a kinetic sculpture and a vehicle for producing mobile light displays (projections and environments). Most important for this discussion, the sculpture was the subject of Moholy's only abstract film, *Lichtspiel schwarz-weiss-grau* (fig. 44). Even though in the film we are always aware of the *Light-Space Modulator's* uniquely constructivist forms set in motion—the sculpture is clearly the star of the film—the film can be seen as a veritable moving photogram. The use of *faktura*—the variety of reflecting surfaces with the diversity of light effects they cast—is the closest Moholy came to using film as a projection screen on which to record mobile light forms.

Through photograms Moholy explored the form-creating properties of light, and because of their experimental nature, they are the photographic works that most closely correspond to his theories. "Experiments with photograms are of fundamental significance for laymen and for professional photographers," he wrote. "Anyone who has once mastered the meaning of writing with light in producing photographs without a camera (photograms) will be able to work with a camera."[53] Moholy prized the photogram as a method for recording manipulated light sources. The "abstract seeing" of the photogram "by means of direct records of forms produced by light" would result in the development of what Moholy called "optical formalism."[54] Once in command of the principles of formal, light-dark relationships, the student could proceed to camera photographs. The progression from photogram to photograph was the road Moholy himself happened to take. His own experience demonstrated its usefulness, and finally, years later, he was able to incorporate this progression into the curriculum of his Institute of Design in Chicago. However, such an explanation of the photogram's place in art education should not obscure the fact that the technique also offered the artist a way, avoiding the camera's propensity for realism, to create abstract forms suspended in outer space.

light: medium and message

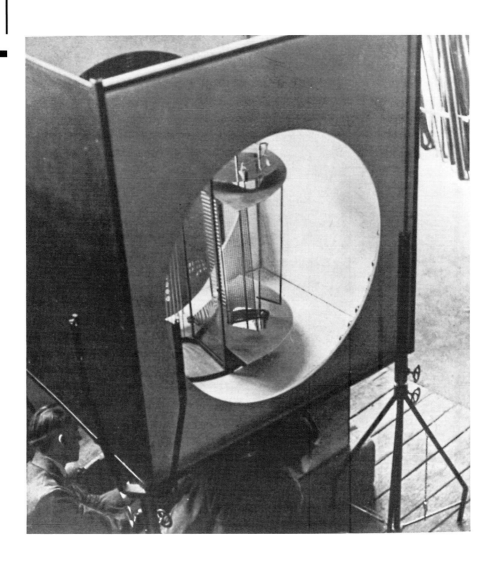

44. Stills from Moholy's film *Lightplay Black-White-Gray* (*Lichtspiel schwarz-weiss-grau*), 1930. From *Telehor 1* (February 1936), figs. 61–62, p. 108.

light: medium and message

CAMERA VISION AS
MODERNIST METAPHOR

CHAPTER

While the photogram played an important role in shaping Moholy's constructivist aesthetic, his camera photographs and photomontages provided a representational outlet from his otherwise rigid adherence to abstraction. In his photograms, Moholy manipulated light to determine pictorial structure and to create forms moving through space. He strove for the same goals in his painting through variations in color and facture. In turn, the basic principles of form and composition of the photograms provided a foundation for his work with camera photographs and photomontage. But once he turned to representation, new issues arose that separated his camera photographs from his photograms and paintings. Focusing on the world around him, Moholy introduced new imagery into his art. We must ask whether his imagery is somehow connected to the meaning of his paintings and photograms. How did Moholy interpret the world through the camera lens and what ultimately was his message? Did representation lead him to a different conception of art?

On preliminary examination, Moholy's camera photographs make a convincing argument for the ways in which the optics of a camera can produce an abstract image. The camera photographs seem to emphasize the peculiarities and distortions of camera vision while minimizing the attention paid to the object photographed. Thus, we are led to believe in the value of the photograph as the object, an object we contemplate for new perspectives on the relationship of forms to each other in space. To emphasize formal elements, Moholy used techniques to separate objects from their natural settings: disorienting viewpoints, radical cropping, strong figure-ground relationships, compositions oriented on the diagonal. Moreover, he rarely discussed his subject matter in his writings, unrelentingly adhering to the formalism and pedagogical motivation of his intensely optical art.

Yet, despite the often radical distortions, the subjects photographed maintain a connection to the thing that was photographed. Well-informed about current work by German and Russian photographers, Moholy chose to diverge from his path of abstraction to travel new and unfamiliar artistic terrain. His camera photographs, his photomontages, and ultimately his concept of the New Vision depend upon representation to define his interpretation of the new, "modern" culture and the kind of art needed to represent it.

From *Kunstphotographie* to New Photography

Moholy's involvement with photography came at a time of crisis for the medium in Germany. After the First World War, photographers and critics struggled to chart a new direction that would differ radically from the *Kunstphotographie* (art photography) of the previous decades. Their reaction against art photography did, in fact, give rise to a new era.[1] The photography from the postwar period in Germany has been variously referred to as Neue Sachlichkeit (New Objectivity) Photography, "Bauhaus Photography," and the "New Photography," as well as the "New Vision," but these terms are by no means synonymous and need to be distinguished from each other. While Neue Sachlichkeit photography

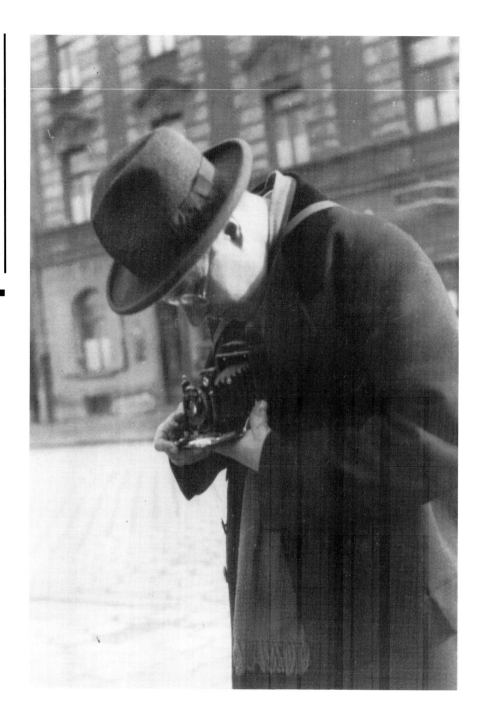

45. *Portrait of László Moholy-Nagy.* Date, location, and photographer unknown. Collection of Hattula Moholy-Nagy, Ann Arbor.

stressed the formal beauty of a given object, Bauhaus photography, if we can say there was such a thing, emphasized creativity—originality, new subjects and techniques. The New Photography became a more general term referring to photography that felt contemporaneous. But Moholy's "New Vision" had a higher aim. As will be discussed in chapter 8, it addressed the role art could play in the renewal of perception as formulated by Russian literary critics, particularly Viktor Shklovsky, in the period from 1914 to 1930. Moholy was one of a group of photographers and filmmakers—Rodchenko and Vertov foremost among them—who tried to solve photography's crisis in definition and direction by constructing a new language and iconography of seeing.

In the 1890s and early 1900s, as part of the ongoing international battle to reinforce photography's status as art, many photographers of central Europe turned to painting as a source for subject matter and technique. Led by the Austrian group Das Kleeblatt ("The Trifolium"—Heinrich Kühn, Hugo Henneberg, and Hans Watzek) and the German brothers Oskar and Theodor Hofmeister, a group of photographers limited their subjects primarily to the sorts of landscape, still life, and figure studies associated with bourgeois taste. Their style, influenced by *fin-de-siècle* tonalist painting, was characterized by softly focused images rendered to evoke the techniques of fine prints, particularly etchings. Surface patterns formed by the juxtaposition of large continuous tonal areas predominate (fig. 46).

After the war *Kunstphotographie* or "pictorialism" appeared hopelessly dated. Postwar photographers demanded new subjects and pictorial

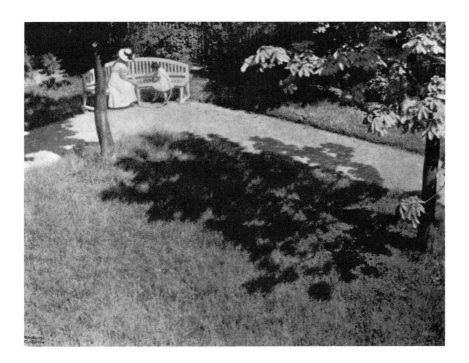

46. Heinrich Kühn, *My Garden (Mein Garten)*, 1908. Platinum print, 32.7 × 44.7 cm. The Metropolitan Museum of Art, Alfred Stieglitz Collection.

camera vision as modernist metaphor

forms that would reflect a changing social and economic order. However, *Kunstphotographie* did have its uses, first in the pictorialists' interest in experimenting with different printing techniques, and second in their emphasis on form. The pictorialists' treatment of figure-ground relationships and flat surface pattern would survive in the sharply focused images of the new photographers. However, in the 1920s photographers tried to develop a style that would exploit what was unique about photography rather than echoing the appearance of painting and printmaking.

The catalyst needed to capitalize on pictorialism's experimental and formal emphasis to develop new photographic strategies came in part from outside the photographic community, from the dadaists. Their search for nontraditional techniques and unorthodox combinations of media provided a new motivation for photography that radically changed its form and content. Like the modernists in other media, photographers turned inward, attempting to define photography's essence, its unique characteristics. As the transitional figure Heinrich Kühn put it presciently, "The time is not far off . . . [when] it will everywhere be recognized that the value of photography lies in its purely photographic qualities."[2] This approach had its parallel elsewhere in Europe and in the United States in the debate over the artistic superiority of "pure" or "straight" over "manipulated" photography.

By 1924 the German mark had stabilized and industrial production resumed with new vigor. It was during the period of relative economic stability from 1923 to 1929 that a wave of experimental photography flourished, including that of Moholy. The need to rebuild the country and make it competitive with other more industrialized nations, on the model of the United States (with its Ford and Taylor systems of mass production), gave technology an almost messianic role: the machine was seen as the savior of the new urban society. This atmosphere and the revitalized economy after 1923 led to a movement that Herbert Molderings has referred to as "urbanism and technological utopianism."[3] Photography came to be the medium for the visual imagery of this aspect of *Modernismus.* The social and aesthetic elements of this tendency nurtured what came to be known as Neue Sachlichkeit photography, a name taken from the contemporary movement in painting.[4] The term had its roots in the concept of *Sachlichkeit,* or objectivity, first popularized at the turn of the century by Alfred Lichtwark, director of the Hamburger Kunsthalle, and Hermann Muthesius, a founder of the Deutscher Werkbund.[5] As a technological medium photography embodied *Sachlichkeit* in the form Muthesius originally conceived it: "The word has the connotation of restraint, sobriety, and objectivity in conformity with the purpose of the object."[6]

The German photographers of the 1920s were, of course, not the first to use photography for documenting the particular material signs of their culture; in fact, photography had been used for such a purpose since its inception. Hans Gotthard Vierhuff identified the French photographer Eugène Atget and the American Paul Strand as forerunners in the early

twentieth century for this development in German photography.[7] Though similarities can be found in Atget's unpopulated views of the urban environment in Paris, it should be kept in mind that Atget's purpose was different. Although he worked in the early twentieth century, Atget used nineteenth-century photographic technology to record an era about to be destroyed by modern urbanization. He was *recording* destruction rather than depicting objective, dehumanized essences. Paul Strand exaggerated Atget's light-dark contrasts, cropping, and unusual points of view in a series of photographs of New York City made during the First World War and published in Stieglitz's *Camera Work* in 1916–1917. Strand clearly found the forms of urban architecture and machines (his Akeley movie camera, for example) aesthetically pleasing and personally inspiring. He used their forms to explore abstract issues of photographic practice: how the textures and colors of the world are translated into tones of gray plus black and white, and the ways in which these translations create forms and planes that move backward and forward, often illogically, within the constructed picture space. While precedents such as these exist, whether they were widely known to German photographers through publication in French and American journals is unclear. And despite similarities, the specific character of the technological boom in Germany and the accompanying need to see the world in a more sobering, factual way during that country's period of reconstruction evoked unique responses in the subject matter and form of the New Photography.

The approach of Neue Sachlichkeit photography is perhaps most fully developed in the works of Albert Renger-Patzsch. The title of Renger-Patzsch's book, *Die Welt ist schön* (The World Is Beautiful), and the photographs in it emphasized the idea that beautiful forms can be found in commonplace objects and, more importantly, in details of machines and industrial products.[8] Rejected by his publisher, Renger-Patzsch's original title, *Die Dinge* ("things"), more clearly connoted the "thingness" or essence of an object inherent in the term *Sachlichkeit*. For Renger-Patzsch, photography's unique characteristics determined the methods appropriate to rendering the industrial world. Isolation of the detail through extreme cropping, delineation of form by means of sharp focus, and dramatic oppositions of light and dark to highlight details exalted technology through associations of power and economy (fig. 47). Details of machines and manufactured products emphasized the beauty of their clean, sleek forms. Photography's capacity for clarity and precision constituted its "realism," its "objectivity" (*Sachlichkeit*).[9] "The secret of a good photograph—which, like a work of art, can have aesthetic qualities," Renger-Patzsch claimed, "is its realism. . . . Let us therefore leave art to artists and endeavor to create, with the means peculiar to photography and without borrowing from art, photographs which will last because of their photographic qualities."[10]

However, as Bertolt Brecht pointed out, such "realistic" photographs, most often showing only isolated details, by Renger-Patzsch and others tell us very little *about* the objects or the institutions they represent.[11]

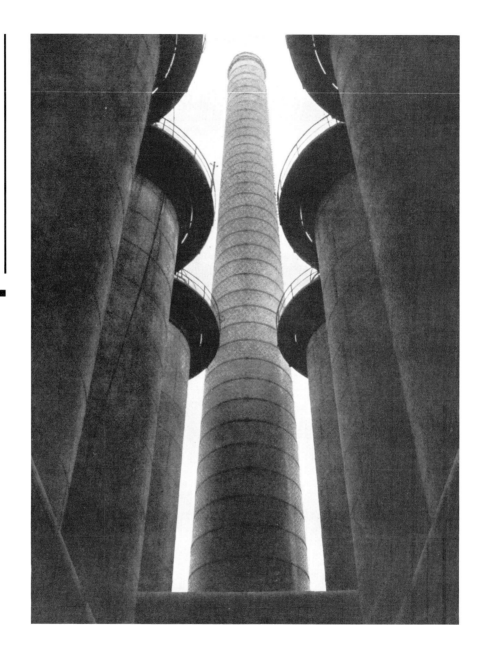

47. Albert Renger-Patzsch, *Blast Furnaces*, 1927. From Albert Renger-Patzsch, *Die Welt ist schön* (Munich, 1928), p. 91.

Instead of offering factual information, Renger-Patzsch alluded more generally to the glories of industrialization and the ensuing growth of capitalism using his rendering of beauty of form in the detail as a metaphor for the values of the thing photographed. Such an emphasis in his work became more evident at the end of the twenties when he concentrated on industrial subjects.[12] Photographs of rows of newly designed products coming off the assembly line transformed the conventional genre of still life into what Molderings called the "pictorial expression of commodity fetishism."[13] Popularized through photographic journals, photo books, and advertisements in the mass media, this approach was adopted by many photographers. The Werkbund, which encouraged the cross fertilization of artistic endeavor and mass production, indirectly promoted such Neue Sachlichkeit photography through its journal *Die Form.*[14]

The Neue Sachlichkeit photographers' reverence for the machine and its products reinforced an interest in photography's use as a medium of technology, identified its appropriate subject matter, and affected the way a photograph was supposed to look. This new attitude would have been impossible in Germany several years earlier, when the unstable economy of the postwar period had brought about a hiatus in the development of photo technology as well as shortages of photographic supplies. However, with economic stability and industrial expansion, Germany, the home of the Leica, became the locus of the most advanced photo technologies in the world. The availability of new photographic materials stimulated an enthusiasm for photography demonstrated by the increase in the number of photography exhibits and a wide use of photographs as illustrative material in the printed media. Machines with their promise for renewing society provided much of the subject matter. Thus the way was prepared for the altogether more radical photographic aesthetic that Moholy gradually formulated in the 1920s.

Early Photographs, Paris 1925

Although we know fairly precisely, thanks to Lucia's later recollections and the publication of "Produktion-Reproduktion," that the Moholys began working with the photogram in the spring or summer of 1922, the date of Moholy's first camera photographs remains elusive. Nor can we determine positively whether Moholy's work with the photogram led him to the camera or to photomontage. The first edition of *Malerei, Photographie, Film,* which appeared in 1925, contained ten works by Moholy; half were photograms, four photomontages, and one a camera photograph, an uninspired close-up of a phonograph record. Although this fails to provide conclusive evidence that his initial work with photomontage preceded that with a camera, it does seem to indicate at least that he was more confident about his photomontages at this time. His photography no doubt flourished in Dessau after the Moholys set up their darkroom in 1926; the next year, in the second edition of

Malerei, Photographie, Film, Moholy reproduced seven of his camera photographs.

As we have seen, Moholy believed the photogram, which he defined as "abstract seeing," to be a necessary first step in exploring the ways in which photographic materials could be used to reinforce and expand his constructivist aesthetic. Good photographs, he continued, rendered texture, structure, and "chiaroscuro" (for Moholy this meant light-dark relationships) successfully.[15] As a preliminary step, the artist should perform "practical experiments" that would lead to the use of the camera "on the basis of new and extended laws" of the medium.[16] The creation of new objects and spatial configurations with light provided the foundation for his use of the camera.

Although Moholy made most of his photograms and photomontages at the Bauhaus, he apparently took the majority of his camera photographs on his travels, just as a painter might take a sketchbook along when away from home. Such was the case in the summer of 1925 when he traveled to Paris to see the Exposition Internationale des Arts Décoratifs et Industriels Modernes. At this point two people very close to him were photographers, his wife Lucia, who accompanied him to Paris, and a friend from Hungary, the photographer Erzsébet (Egri) Landau, who was living in Paris at the time. From this, Moholy's first visit to Paris, we have his earliest datable photographs, a series of images that indicate a fully developed camera aesthetic. The manipulation of light contrasts and reflections, the radical cropping and unusual camera angles, and the architectural subject matter of the Paris photographs define many of the essential characteristics of his photographs from the late 1920s.

One of these Paris photographs, *Street Drain* (*Rinnstein*), represents his natural progression from the photogram to the camera photograph (fig. 48). The variety of textural and tonal areas that he advocated for the photogram dominate this image. Moholy distilled his subject matter to an optical experience by relying on several technical devices, namely the angle of view, the extreme close-up, and the play of light. By eliminating the horizon and any other spatial or contextual frame of reference, Moholy cut the image from its surroundings, holding any semblance of logical spatial recession in a recognizable world to a minimum. He then turned to strictly photographic means for controlling the way in which the viewer's eye moves around the image. The more sharply delineated textures in the upper section, particularly in the left corner, attract attention away from the areas of softened focus in the lower half of the photograph. The asymmetry, the lack of strict horizontals and verticals, the patterns of light reflections, and the variety of textures also pull the eye from one area of the picture to another and imbue the picture with a sense of motion. Moholy transformed a mundane, even unpleasant object into a sparkling study of light reflections in which he forces us to participate actively in the image.

Street Drain relies on one of Moholy's preferred means for controlling the composition of an image: the disorienting isolation of fragments from a larger view. This "estrangement," to use a term of the Russian formalist

48. *Street Drain (Rinnstein)*, 1925. Gelatin-silver print, 29 × 20.8 cm. George Eastman House, Rochester.

camera vision as modernist metaphor

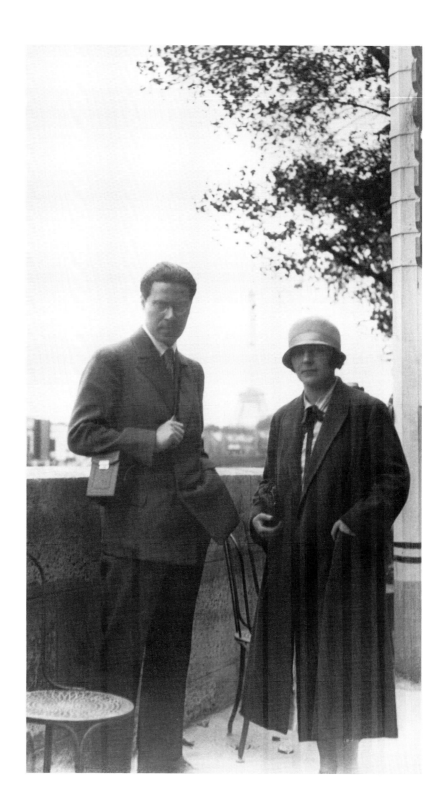

49. Lucia Moholy (?), *László Moholy-Nagy and the Danish Painter Franziska Claussen, Paris*, 1925. Collection of Hattula Moholy-Nagy, Ann Arbor.

critic Viktor Shklovsky, of an image from its context forces the viewer's attention toward formal relationships that would pass unnoticed with the normal, "lazy" habits of seeing. "Thanks to the photographer," Moholy wrote, "humanity has acquired the power of perceiving its surroundings, and its very existence with new eyes."[17] Nevertheless, this and other Paris photographs do refer to what lies beyond, through the way in which the compositions extend to and beyond the edges of the picture frame. At the same time our seeing is focused and our experience of the work is controlled. *Street Drain* is an artistic tour de force. By telling us his subject through the title, Moholy makes clear his pursuit of the large goal of the New Vision—the expansion of our perception. With the new kind of vision possible through the camera, even a view of a gutter can be an enlivening visual experience.

However, *Street Drain* is more than a provocation, in Renger-Patzsch's terms, to examine the beauty to be found everywhere and anywhere (for Moholy this was specifically in the city). To take Shklovsky at his most literal, there *is* something *strange* about the photograph. Materials in the image take on qualities that are the opposite of those we would normally assign to them. The pavers in the lower right corner are rounded and slick, like living tissue. The metal top of the drain loses substance in its reflections. A piece of cloth, stiff detritus, makes an unsettling connection to the human absence. The piece of dry land in the upper left corner seems brittle and thin, about to peel away. In the end, the photograph is much more than an invitation to looking: it subverts our expectations and transports us into an unknown place. This is essentially the field of surrealist endeavor.

Architectural Photographs

As *Street Drain* suggests, Moholy's views of Paris in 1925 were hardly those of a tourist. His experience in Paris set his creative imagination afire; complex formal issues, uses of light, the dynamism of modern life all bombarded his senses with the most provocative results. Just as the Paris drain emphasizes textures and light reflections, Moholy used sharp contrasts of light and shadow to enliven two fragmented views of Parisian architectural icons, Notre Dame and the Eiffel Tower (figs. 50, 51). However, these two photographs move beyond the level of heightened optical sensations to give us new ways to experience architecture as well. As these two monuments are so familiar that each has become a kind of visual cliché, Moholy needed to devise a new format for viewing the structures. Employing the closely cropped view to isolate a part of each building, he played down their identities and in doing so assigned his own specific meaning to them.

Moholy avoided the traditional views of Notre Dame's western facade. In his photograph, the shafts of the compound piers on one of the cathedral's towers form light masses that shoot across the dark picture plane and create a diagonal movement between the upper right and lower left of the image. The downward view toward the base of the piers opposes their upward thrust, but because of the camera's distortion of

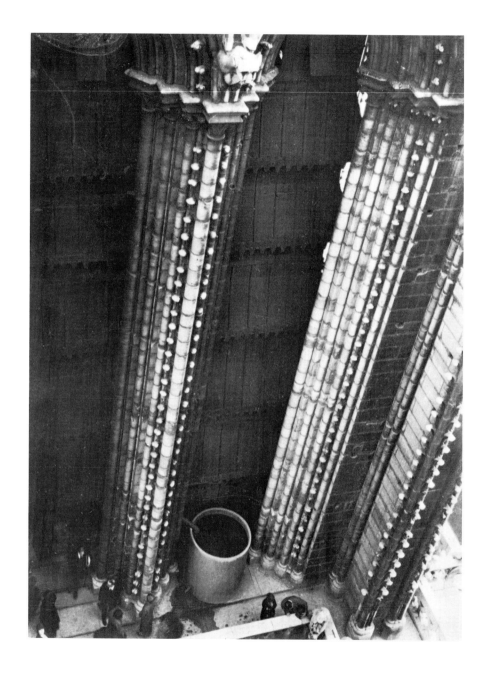

51. *Paris (Eiffel Tower)*, 1925. Gelatin-silver print, 22.7 × 16.9 cm. The Museum of Fine Arts, Houston.

camera vision as modernist metaphor

perspective the piers become larger as they ascend to meet the arches they support. The downward and upward pulls simultaneously contradict and assert the ascending verticality of Gothic architecture.

In the photograph *Paris,* Moholy views the Eiffel Tower up through one of the legs of the base. This viewpoint allows no frame of reference from which we can recognize the lines of a structure so famous that, as the title of the photograph implies, it signifies the city itself. The angle of vision and the tilting of the camera cut short the view through the tower and thereby suppress any impression of the soaring height of what was then the tallest structure in the world. Instead, Moholy accentuated the crisscrossing linear character of the steel construction. Though the eye tries to move back through the tangled web of steel dominating the foreground, it meets resistance in the forward push of the girders toward and out through the foreground and picture plane.

Given that these two photographs are not "portraits" of renowned architectural monuments, was Moholy's intention solely the search for new ways of seeing? Or does Moholy's New Vision incorporate a specific iconography as well? If we compare these two photographs to a work by Renger-Patzsch (fig. 47), the differences in their uses of isolated detail help define Moholy's own approach. Renger-Patzsch sought to uncover the integrity of form in an object, natural or man-made. His *Blast Furnaces* serves as a paradigm for what he thought was the beauty not only of the object as a whole but also of the world at large. Rather than defying the representational nature of the camera photograph in order to create what was essentially an abstraction, he retained key referents of his subjects as he and other Neue Sachlichkeit photographers turned increasingly toward industrialization and mass production for their subject matter in the second half of the twenties. Moholy, on the other hand, did not examine the detail of an object to glorify capitalist productivity. From the beginning he concentrated primarily on fragmented views of the built environment: buildings, bridges, pavement, towers. These are the same motifs that appeared in the collagelike paintings from his first years in Berlin. Through these views Moholy analyzed structural and spatial characteristics of modern architecture and engineering.

In his photographs of the structural elements of Notre Dame and the Eiffel Tower Moholy may have stressed formal principles of abstraction, but he clearly had a sophisticated interest in architecture as well. These photographs illustrate principles behind the construction of the two different building types: the ascent of the Gothic pier and arch versus the complex network of supporting beams in steel construction. In fact, as Haus has pointed out, Moholy traveled with the Swiss architectural historians Sigfried Giedion and his wife Carola Giedion-Welcker during this Paris trip. Giedion's book *Bauen in Frankreich, Bauen in Eisen und Eisenbeton* (Building in France, Building in Iron and Reinforced Concrete), which appeared in 1928 with a cover designed by Moholy, outlined a functionalist approach to architecture from the Gothic rib to modern iron construction (fig. 52).[18]

"Through photography," Moholy wrote in 1932, "we can participate in new experiences of space. . . . With their help, and that of the new school of architects, we have an enlargement and sublimation of our appreciation of space, the comprehension of a new spatial culture."[19] His stance echoed Gropius's more general statement that "the objective of all creative efforts in the visual arts is to give form to space."[20] The transformation of a pictorial rendering of space into architectural theory and practice formed a natural progression for many artists, including Malevich, van Doesburg, and Lissitzky. Their paths toward architecture resulted from the logical transformation of spatial depiction in two dimensions into real, three-dimensional constructions and from the aspirations of various artists to build a new urban environment. Moholy's case was a bit different. Although he worked on sculpture and to a limited extent on environments (stage sets and exhibition installations), he never tried architectural designing. Nevertheless, he developed spatial theories at the Bauhaus, initially inspired by constructivism, in which he wove various principles of architectural theory into his pedagogical program. He appropriated current architectural thinking on the measured ordering of space through the arrangement of planes (rather than the massing of volumes in premodernist architecture) for his two-dimensional work in painting and graphic arts, as well as for his photography.

In his photographs of Notre Dame and the Eiffel Tower, we see Moholy's complex visual thinking but a subjective interpretation as well. He developed sophisticated ways to use the camera lens to prod his subjects into fuller meanings. Adopting the most current elements of camera vision—cropping, isolation, tonal reversals—with ease and fluency, he

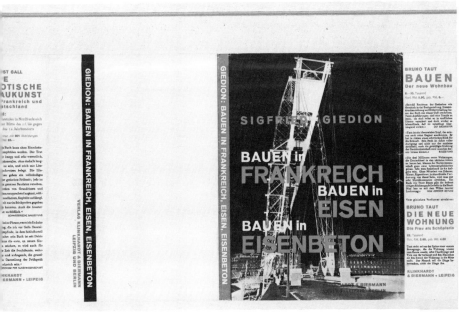

52. Book jacket for Sigfried Giedion's *Bauen in Frankreich, Bauen in Eisen und Eisenbeton*, 1928. 26.7 × 52.9 cm. Staatliche Museen, Preussischer Kulturbesitz, Kunstbibliothek, Berlin.

camera vision as modernist metaphor

extracted elements of architectural theories of space and construction from what one might think were exhausted Parisian subjects. Yet what is the tenor of Moholy's interpretation of these architectural monuments? Both images contain dark areas that partially obscure details. It is almost as if the architectural elements spring into life out of the darkness. Both also produce in the viewer a feeling of uncertainty and uneasiness in attempting to navigate their unfamiliar spaces.

Several of Moholy's photographs of Gropius and Meyer's new Dessau Bauhaus buildings likewise embody specific architectural principles that concerned Gropius at the time.[21] As a group, these buildings established an image of the school's style of architecture and helped shape the organization of the school. The master's houses also functioned as prototypes for simple, functional two-family dwellings. The buildings proclaimed the school's break with the arts-and-crafts tradition and with expressionist architecture. Because of his close relationship with his pedagogical mentor, Moholy must have been intimately acquainted with the theoretical bases for the new buildings. Of his known camera photographs, most of those taken at the Bauhaus are of the school's buildings. Since the majority of his photographs seem to have been taken elsewhere, the fact that we do have a group of photographs of the Bauhaus buildings suggests Moholy's preoccupation with the architectural principles the buildings represent.

The straight lines and right angles of the unornamented buildings, as well as the grids formed by the glass windows and their frames, paralleled the geometry of Moholy's paintings at the time and were ideally suited as subjects of his camera photographs. In *Bauhaus Balconies,* ca. 1926–1928, Moholy again subverts our expected experience of a building (fig. 53). By choosing a tilted angle for the upward view, he eliminated the ground and roof lines. In this view, taken from the west, of the new Bauhaus building's dormitory wing, the flat white areas of the wall, the dark panes of glass, and the reflections in the windows serve as compositional elements.[22] The repetition of the rectangular balconies and railings establishes a spatial recession toward the upper left of the picture. Because the figure stands on the railing rather than on the floor of the balcony, he seems to be rising up along the axis of the balconies. The figure's unstable position draws attention in a particularly dramatic way to the instability of the composition as a whole.

Bands of windows run counter to the rise of balconies; their reflections appear to pierce through the walls and continue behind them. This phenomenon embodies an underlying architectural principle of the Bauhaus buildings. Under the influence of Frank Lloyd Wright, known to Europeans both firsthand and through publication of his work in the German Wasmuth volumes of 1910 and 1911, horizontal bands of walling and fenestration became important design motifs. Gropius and Meyer had first used large areas of glass in a building facade in their brilliant designs for the steel-frame construction of the Fagus-Werk shoe last company in Leine in 1911–1912. In Moholy's photograph, the bands of glass windows and the reflections of the balconies in them produce

53. *Bauhaus Balconies (Bauhausbalkone in Dessau),* ca. 1926–1928. Gelatin-silver print, 37.2 × 27.4 cm. Bauhaus-Archiv, Berlin.

camera vision as modernist metaphor

a continuity of intersecting forms and in doing so become the central ordering device of the composition. The wall appears to be not the external skin of an architectural block but a thin freestanding plane. The photograph is a subtle lesson in Gropius's architectural values.

An instructive comparison can be made between *Bauhaus Balconies* and *House on Myasnicka Street,* 1924, by the Russian photographer Alexander Rodchenko, whose involvement with photography parallels Moholy's in many ways (fig. 54). Although Rodchenko's camera angle is more dizzying in its effect, the fragment of the building affords a larger, more comprehensible view. The series of balconies, the fire escape, and the roofline remain clearly visible. The light area of the sky contrasts with the darker brick facade and the dense black of the shadowed undersides of the balconies. Rodchenko's use of large gray and black tonal areas minimizes detail to produce a strong visual impact. This is not to say that his photograph makes no reference to the architecture, but clearly he and Moholy depict different architectural styles, each representing a specific set of values. The plainness and repetition of forms in Rodchenko's photograph contribute to an impression of order, sobriety, solidity. The opposition of the bright white walls and the reflecting glass of the Bauhaus buildings represents the essence of the Bauhaus architectural ethos.

Moholy's oblique angle and tilting of the rectangular grid of the building in *Bauhaus Balconies* indicate his adaptation of the "counter-compositions" of De Stijl artist and architect Theo van Doesburg, who had taken up residence in Weimar from 1921 to 1924 (fig. 55). After exposure to the diagonal axes of Russian painters such as Malevich and El Lissitzky, van Doesburg devised a program for a new "elementary (anti-static) art" that was a kind of protest against the strictly vertical-horizontal organization of Mondrian's paintings. He rotated the grids of his paintings 45 degrees on the diagonal. This shifting of the axis and the continuation of the forms to and past the picture frame characterize his "counter-compositions." Such an open arrangement with its feeling of centrifugal movement was soon adapted for building plans by van Doesburg and De Stijl architects Gerrit Rietveld and Cornelis van Eesteren, as well as by Gropius and Meyer for the innovative ground plan of the Bauhaus workshops at Dessau.

Although it is seldom seen in his paintings, which contain more complicated spatial configurations, Moholy often used the "counter-composition" in his photographs. An aerial view of the balcony and terrace of a master's house in his photograph *Dessau,* ca. 1926–1928, provides another example (fig. 56). While seeming artificially posed, the photograph is a study of tensions produced through the opposition of static forms and strong diagonal movement. With the scene shot at a skewed angle, the balcony and terrace form his characteristic planar recession away from the picture plane. The downward orientation of the standing woman's head at the center of the composition reinforces the descending movement.

54. Alexander Rodchenko, *House on Myasnicka Street*, 1924. Photograph courtesy of Alexander Lavrentjev, Moscow.

camera vision as modernist metaphor

Moholy enlivens this schema, counteracts its potential for stagnation in a pat formula, by indulging his interest in the interplay of light and shadow. Light patterns bind together the variously textured surfaces of the balcony tiles, grass, wall, and railing. Moholy again subverts the conventional hierarchies of the visual world by forcing our attention on textured areas of the composition. Specific textures no longer serve as attributes of objects; instead the textures and the light patterns, which cross boundaries to connect object to setting, become the unifying elements in this intensely optical art. In *Bauhaus Balconies* and *Dessau,* van Doesburg's two-dimensional counter-composition becomes a starting point for a three-dimensional conception of space based on the positioning of illuminated planes and objects.

In these photographs Moholy takes two very rigid systems, the counter-composition and the severe geometry of Bauhaus architecture, and turns them into lively, constantly fluctuating visual experiences. One might even say that he is directly denying and contradicting elements of the International Style. The straightforward, unadorned, planar architec-

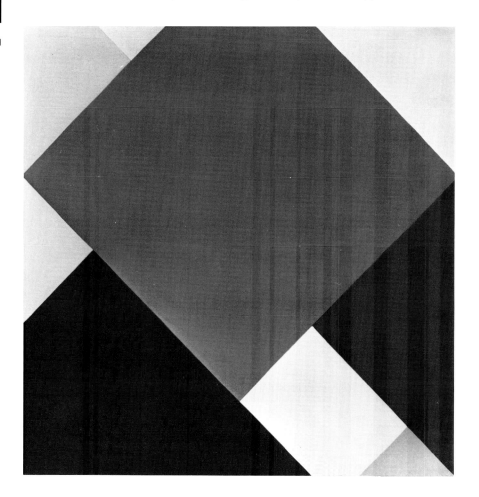

55. Theo van Doesburg, *Counter-Composition V,* 1924. Oil on canvas, 100 × 100 cm. Stedelijk Museum, Amsterdam.

56. *Dessau*, ca. 1926–1928. Gelatin-silver print, 24.9 × 18.6 cm. The Museum of Fine Arts, Houston.

camera vision as modernist metaphor

ture, meant to be easily read and "honest"—not concealing anything—becomes a confusing tangle of distorted geometric forms. Through his manipulation of light in *Bauhaus Balconies,* the white planes of the walls lose substance and become an equal counterpart to the blank wedge of sky in the upper right. The dark areas of the glazing become the substantial elements of the image. Moholy's intentions were very different from those of his wife Lucia, whom Gropius hired to make documentary photographs of his architecture. Even in one of her most abstract photographs, the emphasis is on the architectural details, here a cantilevered balcony, and she leaves in enough of the environment so that we do not lose our ground (fig. 57). Moholy, on the other hand, seems always obsessed with defying gravity. And in doing so, he offers a somewhat unstable and often mystifying view of the world.

Iconography of the Aerial View

In the new visual iconography of radical camera angles employed by Moholy as well as by Neue Sachlichkeit and Russian photographers, views from above and below came to take on a specific meaning. Although aerial photographs had been taken from balloons and kites in France as early as the 1850s, such views are predominantly phenomena of the twentieth century, the era of high-rise buildings and airplanes. Aerial views represented values associated with modern technological wonders: industrialization, the city, the conquest of speed and space. An important precedent for the abstracting aerial view of the 1920s was Alvin Langdon Coburn's well-known photograph *The Octopus,* taken in New York from the Metropolitan Tower onto Madison Square in 1912 (fig. 58).[23] Even though Coburn gave this photograph a title that assigned it a metaphorical reading, his later statement describes his interest in the abstracting potential of the distant aerial view for studying pure form. When people asked him about the photograph's subject, Coburn replied, "It is a composition or exercise in filling a rectangular space with curves and masses. Depending as it does more upon pattern than upon subject matter, this photograph was revolutionary in 1912."[24] Although Coburn made this statement a number of years later, similar observations had been made at the time by the English photographer Malcolm Arbuthnot, whom Coburn knew through his connections with the English vorticists. Arbuthnot's 1909 article "A Plea for Simplification and Study in Pictorial Work" addressed similar ideas on the uses of photography and was illustrated with a fragmentary view of stone steps entitled *A Study in Curves and Masses.*[25] These criteria for judging photographs shared by Coburn, Arbuthnot, and others represent the way in which many early twentieth-century photographers, in the fight for photography's parity with painting as a fine art, tried to show that photography shared the formalist concerns advanced by the critics Clive Bell and Roger Fry in the first years of this century.

By the mid-1920s the aerial view, a central design principle of suprematism, acquired specific relevance in Moholy's work. Malevich described aviation as the product of technology with the greatest impact

57. Lucia Moholy, *Bauhaus Building at Dessau: Balcony of Student Apartment*, ca. 1926–1927. Gelatin-silver print, 17.9 × 12.8 cm. Courtesy of the Busch-Reisinger Museum, Harvard University Art Museums. Gift of Walter Gropius.

camera vision as modernist metaphor

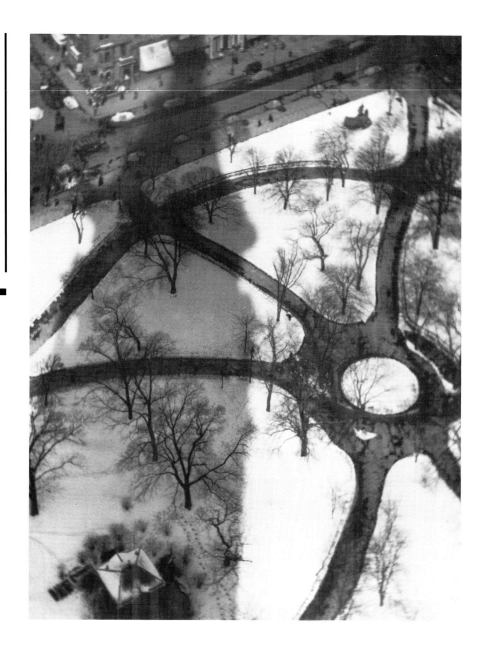

on modern culture. Photographs of airplanes flying and views taken from the cockpit illustrated what Malevich referred to as the "environment" or "reality" that "stimulated the Suprematist" in his Bauhaus book *The Non-Objective World*.[26] His more complicated suprematist works from 1915–1916 can be read as planar objects dropped from an airplane and pulled down by gravity. For Moholy, aerial photographs came to depict the modern world through a new and appropriate way of viewing, looking down on the cityscape where urban designers have organized geometric forms on a monumental scale.

In his article "Geradlinigkeit des Geistes—Umwege der Technik" (Directness of the Mind—Detours of Technology), published in the journal *Bauhaus,* Moholy discussed the relevance of the camera's eye to his concept of the New Vision. He stated that "man always desires to see more than the eyes are able to comprehend. . . . Working feverishly, mind and eye achieve new dimensions of seeing for which today photography and film already offer the foundation and the reality. The details for tomorrow. Today the training of vision."[27] The article was cleverly illustrated with three photographs from 1908 obtained from a Dr. Neubronner: an image of a pigeon with a camera tied around its neck and two aerial views taken by the pigeon (fig. 59).[28] The article's three other aerial photographs—of Gropius's newly constructed Bauhaus buildings in Dessau, of an airplane aloft, and a topographic view—reinforce Malevich's claim for the importance of the airplane, with its fresh perspectives on the world. In itself such a perspective stands for technological progress. The three aerial photographs were all taken by the firm Junkers & Co., which manufactured airplanes in Dessau.

In a series of photographs taken around 1928 from the Berlin *Funkturm,* or radio tower, devices already seen in Moholy's photographs of the Bauhaus reappear (figs. 60, 61). Disconcerting camera manipulations, strong contrasts of figure and ground, and architectural motifs engender an image that stands for the new urbanized, technological society. Erected in 1924 near the area in Berlin where Moholy would establish his atelier two years later, the *Funkturm* was in one sense Berlin's Eiffel Tower: a modern steel construction from which the energetic photographer could obtain views of the city below (fig. 62). Because of Moholy's interest in communication and the mass media, he undoubtedly saw the radio tower as a symbol of twentieth-century communication and the harbinger of the new collective society.

Rather than taking a more traditional panoramic view from the tower, Moholy used its height to transform the urban landscape into a powerful geometric design. In one of his untitled views from the *Funkturm,* Moholy provided little evidence of the natural landscape—no trees, grass, or earth (fig. 60). Sharp contrasts of light and shadow on the observation deck's roof and the white outdoor furniture below become abstracted forms in his geometric composition. Yet this is not a static, two-dimensional design. The circular area of pavement and the slightly angled orientation of the picture frame to the radio tower produce a swirling movement heightened by the diagonal rise of the tower up and out of

5

taube mit fotoapparat (1908) foto und klischee: dr. neubronner

taubenaufnahmen 1908 foto und klischee: dr. neubronner

moholy-nagy:

geradlinigkeit des geistes - umwege der technik

absehbare und unergründliche beziehungen entstehen gleicherweise unter kosmischer determination. die chemisch-fysisch-transzendenten einflüsse der wechselwirkenden beziehungen verdichten sich verschieden, je nach gesetzlichem ablauf. einmal zur blauen farbe, ein anderesmal zu einem aggregatzustand und ein drittes mal zur sublimation des geistes. das denken - als funktionelles ergebnis von körper und weltallbeziehungen - ist in seinen erscheinungen ein stetiges, ein immer von neuem entstehendes fänomen. geist ist immanente emanation menschlichen daseins.

unter dieser determination der kosmisch entstehenden beziehungen darf es nicht verwirrend scheinen, über eine identität menschlichen denkens aller zeiten zu reden. selbst die formalen variationen des denkens, die sogenannte „geistige haltung", sind in verschiedenen epochen zwangsläufig wiederkehrend. innerhalb dieser zwangsläufigkeit ist jede leistungsreihe von der zeitbedingten umwegigkeit technischer eroberungen abhängig. d. h. das gehirn arbeitet rascher als die ausführende hand. man kann diesen zustand schlagwortartig fassen: geradlinigkeit des geistes - umwege der technik. die „geradlinigkeit" ist nicht ein eindimensionales gerichtetsein auf das spannungsvolle, ökonomische, sublimierte allein, sondern vielmehr eine kosmische expansion, die nach jedem punkt hin den kürzesten weg nimmt.

„umwege der technik" bedeutet, daß praktisch alle wege, die man zur erreichung eines zieles einschlägt, länger und komplizierter sind, als sie - vom geiste aus gesehen - sein müßten. d. h. alles könnte besser als bisher gemacht werden, denn: die inspiration als anfang jeder tat - die geniale eingebung als zentrumbildende expansion - ist nur von zeit und umständen (auch technik) bedingte form des urgedankens.

ein beispiel: man wünscht immer mehr zu sehen als die augen fassen können. das fernrohr reicht bis zum nächsten dorf; das mikroskop in die spalten der zelle; der fernseher bis zum kap der guten hoffnung; die nächste station bei der des mond sein.

umwegigkeit der technik hier (heute erkennbar): das problem des fernsehens nach anderen planeten mit linsensystemen schaffen zu wollen, statt es z. b. durch elektrisch-magnetisch-fotografische reagenzen zu lösen. die konsequenz: alle kommenden observatorien werden unzulänglich sein, wenn sie auf traditionelle weise ausgerüstet werden.

um solche umwegigkeit auf ein minimum zu reduzieren, versucht man die eigene arbeit vom urgedanken her zu kontrollieren.

so kommt es, daß man manchmal von einer these besessen ist. sie gibt anlaß zur arbeit, mit ihr begründet man weitläufige konstellationen bis zu einer die ganze arbeit beherrschenden fixen idee.

man kann gegen diese herrschaft der idee gar nicht opponieren. denn: möge die basis noch so „launenhaft" scheinen, alles ist sinnvoll zur erhöhung der aktivität

da. ein arbeitsichernder wahn, der mit logisch-kausalen konsequenzen operiert.

das ist oft die genesis einer fruchtbringenden theorie. sie ist anregung und gleichzeitig kontrolle.

● ich war einige jahre von der wichtigkeit der „produktion-reproduktion"-these erfüllt. ich habe fast das ganze leben damit zu meistern gesucht. sie führte mich im einzelnen zu der analyse der reproduzierenden „instrumente", zu verständnis und vorschlägen mechanischer musik; andererseits brachte sie mir grundlegende erkenntnisse auf fotografischem gebiet.

● eine ergänzungsidee (vielleicht mehr als das, weil weniger mechanistisch, weil breit auslegbar) führt mich wieder zu optischen dingen: geradlinigkeit des geistes - umwege der technik.

● seitdem für mich das problem: malerei - foto - film in die fase des optisch gesetzmäßigen trat, erhellen sich mir die umwegigkeitsformen des uralten wunsches: farbige gestaltung als bannen von licht.

der immanente geist sucht: licht, licht! der umweg der technik findet: pigment. (ein zwischenstadium, das erst durch das licht leben gewinnt.) es ist ein verhängnis der menschheitsgeschichte, daß die geistigen emanationen zu falscher auswirkung verleitet werden. nämlich entgegen individueller elastizität und immer vorwärtsschreitender neigung des einzelnen richtet sich die menschliche gemeinschaft - als summe von individuen - nach der überlieferung angeblich unfehlbarer erfahrungen. angebliche unfehlbarkeiten verdichten sich zur feste existenz und die geheiligte existenz treibt zur eigenen rechtfertigung. das ist traditionsgebundenheit. geistige massenlähmung. zeitbedingte umwegigkeit.

das war auch das schicksal der pigmententdeckung. die erste verwendung heiligte den zufall, der im pigment eine art lichtlagerungsstätte, wenn auch in grobmateriell abtastbaren komplexen, gefunden hat. alle lichtgestaltung umwegt bis heute auf diesen spuren abendländischer malerei, obwohl seit der ersten laterna magica, seit der ersten camera obscura sich direkte wege des lichtbannens ergaben:

projektorisch-reflektorische spiele mit farbig flutendem licht, flüssiges, immaterielles schweben, durchsichtiger farbenfall von fluktuierenden garben, vibrieren des raumes mit schillernder lichtemulsion.

umwege der technik: von der manuellen darstellung zum grafischen stehbild, vom stehbild zur kinematografie, vom flächigen zum plastischen. vom stummen zum sprechenden. vom undurchdringlichen zum durchscheinenden. vom kontinuierlichen zum simultanen. vom pigment zum licht.

● mit fieber erarbeiten geist und auge die neuen dimensionen des sehens, die heute schon foto und film, plan und wirklichkeit bieten. die details für morgen. heute die übung des sehens.

geradlinigkeit des geistes - umwege der technik: auf der fotografischen ausstellung in frankfurt a. m. 1926 waren fotografien zu sehen, die durch brieftauben ausgeführt worden sind. für diesen zweck wurden um 1907 herum kleine fotografische apparate mit automatischer auslösung konstruiert, und das über hundert jahre nach montgolfiers erfindung! nach dem versuchen mit lenkbaren ballons, nach den versuchen lilienthals und der brüder wright. die kleinen wunderbaren fotografien: stadtaufnahmen, stark divergierende häuser, schienenstränge, plätze mit winzigen menschenfigürchen, eisbahn mit wimmelnden eisläufern, machen - als verahnung wichtiger verwendungsmöglichkeiten dieser art sichten - dem erfinder dr. neubronner (cronberg im taunus) ehre. und doch: was ist der liliputapparat und sein automatischer auslöser mit seiner zufallssicherheit gegenüber den apparaten, die - in den boden eines flugzeugs eingebaut - sicherheit selbst für kartografische institute bieten.

georg muche:

bildende kunst und industrieform

die enge verbindung moderner bildender kunst - insbesondere der malerei - mit der technischen entwicklung im 20.jahrhundert scheint nach einer außerordentlich bedeutungsvollen zeit schöpferischen austauschs auf geistig durchaus polar gelagerten gebieten mit überraschender konsequenz zur gegenseitigen abstoßung führen zu müssen.

die illusion, daß die bildende kunst in der schöpferischen art technischer formgestaltung aufzugehen hätte, zerschellt in dem augenblick, in dem sie die grenze der konkreten wirklichkeit erreicht. die mit imposant eindeutiger geste aus der künstlerischen utopie in das verheißene gebiet der technischen gestaltung herausgeführte abstrakte malerei scheint ganz plötzlich ihre vorausgesagte bedeutung als formbestimmendes element zu verlieren, weil die formgestaltung des mit technischen mitteln erzeugten industrieproduktes sich nach einer gesetzmäßigkeit vollzieht, die nicht von den bildenden künsten abgeleitet werden kann.

es zeigt sich, daß die technisch-industrielle entwicklungsfolge auch in bezug auf die formgestaltung absolut eigenartig ist.

der versuch, die technische produktion mit den bildnerischen gesetzen im sinne der abstrakten gestaltung zu durchdringen, hat zu einem neuen stil geführt, in dem das ornament als unzeitgemäße ausdrucksform vergangener handwerkskulturen keine anwendung findet, der aber trotzdem dekorativ bleibt. einen nur dekorativen stil glaubte man aber gerade vermeiden zu können, weil die besondere art der schöpferischen erforschung elementarer formgesetze durch die ab-

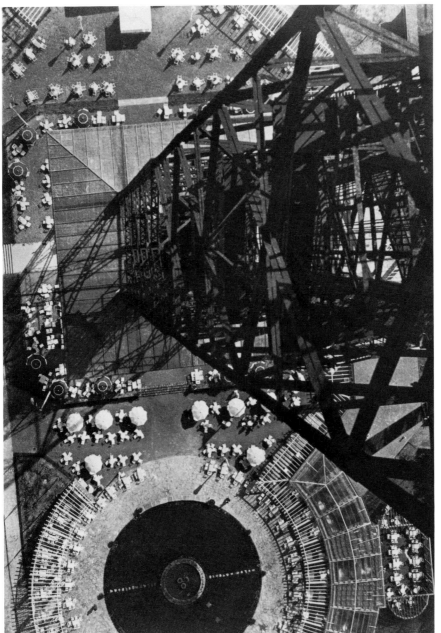

60. *Berlin Radio Tower,* ca. 1928. Gelatin-silver print, 36 × 25.5 cm. The Art Institute of Chicago, The Julien Levy Collection, Special Photography Acquisition Fund, 1979.84. Photograph courtesy of The Art Institute of Chicago.

camera vision as modernist metaphor

the picture plane. Moholy encourages us to appreciate an exciting new perspective on the dynamic urbanized world, as well as the simple beauty of technology. In a winter view Moholy eliminated the reference point of the tower, and the urban environment becomes less recognizable and more abstract (fig. 61). The strong contrast between the areas covered with snow and the dark lines of the pathways flatten the space. In its delicately balanced composition of textured surfaces devoid of human reference, the winter view from the *Funkturm* offers a subtle, if perhaps unintentional, comment on the sterile and alienating qualities of the built environment.

In a manner similar to that used in the *Funkturm* photographs, Moholy's mastery of his camera enabled him to highlight or obscure the details of the scene in his untitled photograph of a view down onto a section of a transporter bridge (*pont transbordeur*) in Marseilles, taken in 1929 (fig. 63). Here again Moholy was probably interested in the engineering feat of this movable "transporter" section of the bridge and saw the structure as an icon of modern construction. As Haus has pointed out, this bridge was photographed and discussed by Giedion in 1927 and was then photographed by a number of others, including Herbert Bayer, Germaine Krull, and Florence Henri.[29] Offering endless variations in the delineation of similar forms, the light picks out random elements in a row of dinghies extending from the upper corner down the left side of the picture. The heterogeneous character of the boats is balanced on the right by a vertical line of shadows cast by light passing through a balustrade. Cables radiating toward the top edge of the image, the coil

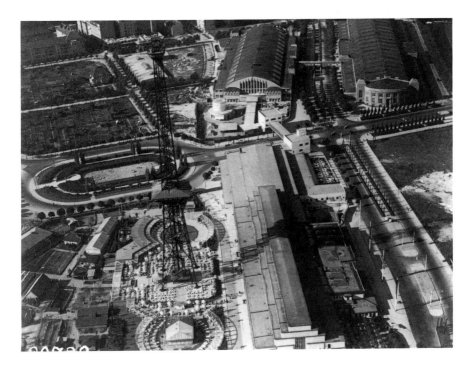

62. *The Funkturm, Berlin,* ca. 1930s. Photograph by Hansa Luftbild, GmbH, Berlin. Courtesy of Hattula Moholy-Nagy, Ann Arbor.

camera vision as modernist metaphor

63. *View from Pont Transbordeur, Marseilles (Aerial View of Cords Piled in a Circular Pattern)*, 1929. Gelatin-silver print, 29.5 × 22.1 cm. The Art Institute of Chicago, The Julien Levy Collection, Special Photography Acquisition Fund, 1979.85. Photograph courtesy of The Art Institute of Chicago.

of ropes in dead center, the curb of the walks along the edges of the bridge, and the strolling figure all enliven the contrasting areas of the sunlit dock and the dark water and shadows. Within the dominating light and dark areas, a rich assemblage of details and recognizable forms provides a feast for the eye. At the same time, however, we find ourselves straining to see glimpses of life. As with the *Funkturm* photographs, we wonder if this pictorial space is real or imagined. Its uncertainties as well as its visual delights hold the attention of the viewer.

The subject matter of Moholy's early camera photographs reveals his understanding of architecture, which clearly served as a springboard for his theoretical explanations of spatial relationships. He probed monuments, new buildings, and the urban environment with the camera's eye. Using devices of camera vision that in effect denaturalize his images, he was able to turn principles of spatial construction inside out. As a result, nothing, even the most rigid modernist designs, is ever static. Rather, in their ambiguousness his spaces are constantly changing, and because of this they offer a variety of often conflicting readings. Though he usually relied on strong formal relationships and high contrasts of light and dark, he was able to rise above mere designing with the camera by isolating complex relationships of forms without annihilating his subjects. Yet what do Moholy's distortions of reality, his snatches of the world emerging from his darkly printed images, really mean? Although they are on one hand playful—and Moholy was known to have had an exuberant, playful personality—one cannot but think they also reflect his own romantic view, at once joyous and tragic. An ever-present sense of anxiety pervades his intense passion for the built environment.

CHAPTER

THE EXPERIENCE OF MODERNITY

In an undated photograph from the mid-twenties entitled *At Coffee* (*Bei Mokka*), Moholy's techniques of the close-up, the counter-composition, cropping, and intense light set the stage for the social interaction (fig. 64). Rotated off its axis, the grid of the pavement lends the image the orientation of the counter-composition. Two pairs of feet form a right angle around a central patch of sunlight on the pavement that highlights and connects an array of details: a sock, shoe, trouser leg, coffee cups. In this way Moholy draws our attention equally from one clue to another rather than directing us toward a central focusing element. Through the fragments of this synecdochic image we can reconstruct a scene of the coffee ritual, that vehicle for social, intellectual, and artistic exchange.

The strength of *At Coffee* lies in the control, precision, and under-statement with which Moholy reveals the social relationship. The viewer is almost tricked into admiring the photograph's formal components alone—the unexpected angle of view, the richness of the details and textures. Yet it is what we do not see that haunts us. On one hand we savor the details of the sunny, friendly scene. The image could be read as autobiographical: Moholy's artistic growth in the early twenties re-sulted from his contacts with various artists from Russia, Holland, Hun-gary, and Germany, and many of these meetings undoubtedly took place, as witnesses attested, in the various cafés of Berlin. On the other hand, through his fragmentation of objects, and often through his use of an obstructed viewpoint or obscuring shadows, the photographer and the viewer are kept from entering the image and participating in the depicted event. The viewer feels detached, abandoned, isolated, unable to step into the scene. The image's provocative resistance to penetration itself becomes disconcerting and synecdochic: modern life is imaged as a series of fragments, juxtapositions, rather than as the smoothly flowing totality that was Moholy's highest goal for art.

Using techniques such as those seen in *At Coffee,* Moholy's photo-graphs, and his photomontages as well, break through the confines of radical formalism to become subtly nuanced psychological interpreta-tions of *Modernismus.* Through the camera lens he isolates aspects of modern life for our scrutiny and contemplation. In the case of photomon-tage, he recombines found photographic fragments to create his own subjective interpretation through new juxtapositions of ideas. His proc-ess is primarily one of dissecting reality and then rearranging its parts. The result, strangely enough for Moholy, is the opposite of the positivist, building spirit of constructivism, and it maintains ties to dada. By the second half of the 1920s, at a time when surrealism was developing, Moholy too was exploring the private and often disquieting areas of the modern condition.

Of the broad range of social issues covered by Moholy's photography, the discussion that follows will be primarily concerned with one he analyzed frequently: the process of redefining male and female roles at this time of cultural upheaval. His struggle to understand this issue is often directed toward the social phenomenon of the New Woman, that symbolic personification of sexual liberation, economic independence,

64. *At Coffee (Bei Mokka)*, n.d. Gelatin-silver print, 28.7 × 20.8 cm. The Museum of Fine Arts, Houston, Museum purchase with funds provided by Max and Isabell Herzstein.

and consumerism that dominated mass culture in the Weimar era. As Maud Lavin has recently described her, the New Woman "is best considered as a cumulative perception of female stereotypes, collected over time by women newly self-conscious of their modern status—and by their observers."[1] With very few exceptions, Moholy's photographs of people from the 1920s were of women, and through his pictorial strategies he set up an uncertain relationship with the newly working, sexually liberated women of his circle. Occasionally he photographed children, whom he placed in threatening situations. His photomontages, because they use found images of anonymous women, deal with more general issues of oppression—by men, the military, or the government. While they seem to be playful, personal interpretations of his subjects, Moholy was clearly intellectually and psychologically engaged with many of the primary social dilemmas of modern life.

Moholy's isolation and pictorial manipulation in his images of women often lead to an estrangement of the photographer and his subject, of viewer and viewed. This alienation occurs repeatedly in Moholy's work in the second half of the 1920s and must be seen as an important theme in his photographs. It is tempting to tie such a direction in his work to Moholy's circumstances at the time, his displacement from his homeland, his disintegrating marriage, and his ultimate departure from the Bauhaus. Curiously, Moholy applied essentially the same set of photographic techniques and formal devices to photographs he took of people as he used in his architectural photographs.

Ascona

In Moholy's photographs, it seems that the more difficult an image is to read, and hence the more frustrated the viewer, the more intensified its psychological effects become. In turn, the difficult images reveal the frustration of the photographer in his inability to identify or soothe troubling emotions. This condition is evident in the series of photographs Moholy took in 1926 while on a holiday in Ascona with fellow Bauhäusler Oskar Schlemmer and his family. In the first two decades of the century, this small fishing village in Switzerland became the home of the Nature Cure Sanitarium and the birthplace of an alternative intellectual movement whose participants ranged from D. H. Lawrence to Isadora Duncan. It was known as a place to escape from the malevolent aspects of industrial society, to participate in a kind of purifying nature cult, and to exchange radical ideas on the nature of society and art. By the twenties, the counterculture there was waning, but it maintained its identity as a place for the intelligentsia to escape and be renewed by the beautiful setting.

However, Moholy's photographs taken in Ascona were anything but peaceful. It is almost as if the relaxing atmosphere released his deeper anxieties about life. In a photograph of Lucia, one must struggle to "read" the photograph because the "worm's-eye" view and large areas of shadow disorient the viewer (fig. 65). The pension sign and the lettering down the corner of the building further confuse any readable sense of

65. *Lucia Moholy, Ascona,* ca. 1926. Gelatin-silver print, 34.8 × 25 cm. The Art Institute of Chicago, The Julien Levy Collection, Special Photography Acquisition Fund, 1979.90. Photograph courtesy of The Art Institute of Chicago.

perspective. The composition rotates around Lucia at the V formed by the intersection of two shafts of light. Though the central focus of the image, her head turns in the opposite direction into the shadows. The image thus creates a psychological tension by first highlighting and then withholding pertinent details about the subject.

The bizarre and unsettling photograph entitled *Ascona (In the Shade)* once again places the photographer/viewer in the role of a voyeur observing a mysterious, impenetrable world (fig. 66). Three bars of shadow radiating outward from the lower right corner provide the compositional structure. While these dark areas, which dominate the picture visually, form a barrier between the viewer and the two children, they also beckon the viewer to probe beneath them for the picture's subject. As the children seem locked in darkness, our attention moves to the tortured forms of a dismembered tree stump. He subverts one's sentimental associations with the joys of childhood while suggesting a sense of devastation, embodied in the tree stump. In several other photographs from his Ascona trip, a chain link fence and its shadows provide a visual homogeneity to the composition but psychologically imprison the young models (Schlemmer's children) or their dolls.[2] A dark shadow in the lower left of an untitled photograph presses toward the two naked dolls, one with legs missing, and heightens the picture's sensation of mystery and impending danger (fig. 67).

Because he frequently illustrated his writings with the Ascona photographs, Moholy evidently valued them for specific reasons. His captions for some of them minimize their emotional content in order to maintain the formalist, rationalist approach to photography that he advocated. From this distance it seems that Moholy carried on this charade for himself as much as for his audience. *Ascona (In the Shade),* one of three from this group in Roh's book of Moholy's photographs, had no caption or title at all.[3] Only in his caption for the photograph of the two dolls did Moholy, who had no children at the time, admit that "the organization of light and shade, the criss-crossing of the shadows, removes the toy into the realm of the fantastic."[4] Moving away from abstraction with these disconcerting, alienating, and often bizarre images, Moholy created some of his most powerful works. Yet rarely did he refer to his subject matter or to any psychological content. Both his theoretical writings and the captions he gave his most personal photographs continually stressed the organization of forms and the interplay of light and shadow. His photomontages are an exception to this rule; here through his titles Moholy directs us toward the personal, psychological, or social meanings.

Portraits

The tension between formalism and representation finds perhaps its most dramatic manifestation in Moholy's portraits. Few portraits from his German period survive either in the original or in printed reproduction; those that do are primarily of his first wife Lucia or of Ellen Frank, Gropius's sister-in-law who was Moholy's lover in the late 1920s. What

67. *Dolls*, 1926. Gelatin-silver print, 48.6 × 38.4 cm. George Eastman House, Rochester.

68. *Portrait of Lucia Moholy,* n.d. Gelatin-silver print, 29.2 × 21.6 cm. Photograph courtesy of Eugene Prakapas.

69. *Portrait of Lucia Moholy*, ca. 1926. Negative gelatin-silver print from positive transparency, 23.6 × 17.3 cm. The Museum of Modern Art, New York. Anonymous Gift.

interests us here are the decisions that Moholy incorporated into his picture making when he confronted his most intimate subjects. In two photographs from the mid-twenties, a positive and a negative close-up of Lucia, dramatic light patterns dominate the image (figs. 68, 69). It seems fitting for a portrait of his collaborator on photographic projects to emphasize the manipulation of light. However, the fragmentation of the face, the partial covering of the eyes and mouth, and the imprisoning bars of light imply a kind of oppressive manipulation and control enacted by the photographer. The negative print of the portrait offers a more somber view of her psyche. The mouth and an eye appear statuelike, cold and immovable, while the other eye is veiled by a jumble of white lines. Her face seems disfigured by the black shadow that passes over it.

Both positive and negative were illustrated in the Roh book, but not opposite each other.[5] The positive portrait's caption, "Peculiar lighting and leveling make the head appear slightly masked," only hints at a symbolic meaning. More telling is the location of the two photographs in the book. Moholy placed the positive photograph opposite a startling photomontage, *The Shattered Marriage (Die zerrüttete Ehe),* which will be discussed below (fig. 80). The negative photograph appeared next to a photomontage from 1927 entitled *Behind the Back of God* (fig. 70). In this photomontage a young female athlete appears to be jumping from an upper circle in which an African man is shooting something downward through a hollow pole. Her target is a group of figures gathered around a fireman's net. The young woman seems to be falling through empty space from one culture to another. While one photomontage evokes the devastation in the aftermath of an "explosive" relationship, the dark pensiveness of the other is related to sexism, racism, and oppression in general. At the time these photographs and photomontages were made, Moholy and Lucia were encountering marital difficulties; they separated in 1928 and were subsequently divorced.

The close examination of Moholy's portraits naturally leads to questions of their relationship to photographs by Lucia, who specialized in portrait photography. Lucia's *Florence Henri, Paris,* ca. 1926–1928, is typical of her style (fig. 71). In such large-format photographs, a roughly life-size head, shown either frontally or in profile, fills the picture plane. Moholy too experimented with a large format in a photograph of Ellen Frank taken around 1929, but the comparison indicates the strongly diverging artistic concerns of their portraits (fig. 72). While Lucia's have a strong graphic impact, Moholy maintained his interest in the open composition and diagonal movements produced by the oppositions of dark and light areas. Moholy's repertoire of more radical camera techniques, as well as the photograph's sheer size, distill Frank's facial features into a less static image. But at the same time, Ellen Frank's expression—the sideways glance of the one visible eye and the tensely pursed mouth—suggests anxiety and fear.

Lucia's portraits ultimately degenerate into formula. The variety of portraits Moholy made from 1925 to 1929 refute any such criticism of his work, and it would be erroneous to explain his use of the human face

70. *Behind the Back of God*, 1926. Rephotographed photomontage (*Fotoplastik*), 23.7 × 18.7 cm. Collection of the J. Paul Getty Museum, Malibu, California.

the experience of modernity

71. Lucia Moholy, *Florence Henri, Paris,* ca.1926–1928. Gelatin-silver print, 37.8 × 27.4 cm. The Sophie M. Friedman Fund. Courtesy, Museum of Fine Arts, Boston. Photograph Prakapas Gallery, La Jolla.

72. *Ellen Frank*, ca. 1929. Gelatin-silver print, 40 × 30 cm. Bauhaus-Archiv, Berlin.

the experience of modernity

as a device for the exploration of his formal principles. Nevertheless, certain stylistic consistencies exist. The heads are often photographed while his model is lying down, ensuring a shallow picture space. In a photograph of Lucia from 1925, her relaxed face stands out against a textured background of pebbles (fig. 73). Of her upper torso, which is cropped by the picture frame, only the slightest traces of the patterned straps of her sun dress remain. Even in this close-up view Moholy distances himself and the viewer from the subject. Her closed eyes allow little penetration of her thoughts, and Moholy further impedes contact by using a soft focus for her head and a sharper focus for the pebble background. In *Repose* a woman's head appears against a background of sand and brush, her eyes barely visible and her mouth strangely opened (fig. 74). The controlling, dominating presence of the man/photographer becomes more explicit in the dark shadow of his figure, which covers the woman's shoulder and masks her eyes. This provocative shadow, the triangle of kerchief at the throat, and the lowered bodice of the dress further suggest the sexual content.

This distancing of the viewer from an image of woman as sex object, either remote and out of reach or threatened by domination, gives way to a more intimate and moving depiction in a portrait of Ellen Frank (fig. 75). It reminds us not to categorize Moholy's work as traditional portraits or likenesses. The interaction between the photographer and his subject, the poser and the posed—the staging—isolates the image from reality. Here his principles of pictorial structure and camera manipulations combine to produce the quintessence of artifice. Again Moholy shifts an underlying composition format of the grid off-axis in the manner of the counter-composition. Frank's head tilts on a diagonal that runs perpendicular to a line of cord running across the top of her head. The light areas of her face and arms counter the dark areas of her hair and shadows to reinforce this perpendicular schema. The positioning of her face and the less sharply delineated arms and background isolate the head from her body and project it out from the picture plane. Stark lighting and this professional actress's make-up work together to minimize some details while heightening others. The curls of hair on her forehead echo the curves of her eyebrows, drawn on with a pencil. What we have in the end is an image recognizable as a beautiful woman's face that has been reduced to its formal components. Moholy seems to be reminding us that a photograph cannot be a window on the world or a trace of reality. It is a new and separate object, a product of a "new vision" of the modern condition.

The Nude

In his photographs of nudes, often made in positive/negative pairs, he injected the traditional study of the human figure with his newly analytical approach to subject matter. Some of the photographs of nudes were taken outside and can be said to reflect the interest of some, including Moholy and Lucia, in nudism as an aspect of the current health consciousness known as "physical culture."[6] However, others have a dis-

73. *Untitled (Lucia Moholy)*, 1925. Gelatin-silver print, 30.5 × 23.5 cm. Photograph courtesy of Jürgen Wilde, Cologne.

74. *Repose*, n.d. Gelatin-silver print, 36.8 × 27.1 cm. The Museum of Modern Art, New York. Anonymous Gift.

75. *Untitled (Portrait of Ellen Frank)*, 1930. Gelatin-silver print, 23.8 × 17.8 cm. Collection of Ellen Frank, Munich.

the experience of modernity

tinctly surrealist tone to them. In one such pair of nude photographs, a woman's body becomes a diagonal form positioned across the image (figs. 76, 77). Moholy confounds any normal impulse to appreciate the natural forms of the anatomy by distorting the figure's contours and plasticity. Light and shadow mask the delineation between the figure and the contrasting couch. The formal design and the gradual transitions between gray tones serve as an impediment to any naturalistic interpretation of the female body.

A fuller reading of the pair of images would see them in relation to the artistic tradition of reclining nudes. Displayed on a bed, whether by Titian, Goya, or Ingres, a reclining female nude was intended to invite male sexual fantasy. Manet's *Olympia* of 1863, of course, confronted this tradition of women represented as sexual objects and the realities of prostitution straight on. In photography, nineteenth-century images of the female nude were usually limited to "artistic" aids or outright pornography. In Moholy's pair of images, his shifting of the nudes 90 degrees toward the vertical challenges the notion of the inviting, reclining (horizontal) pose. And he omits the head and identity or individuality of the sitter. Instead of an enticing sex object, we have an image in which the line between design and reality is kept aggressively taut under the control/dominance of the photographer.

Regardless of the objectlike emphasis of the body, the soft focus, and the pearly grays, we are given enough details—a couch, a navel, a breast—all bathed in an unnatural light, to perceive a layer of sexual fantasy beneath his formal concerns. Once again, the power of the photograph lies not only in the eloquent design but in the play between design and reality. Far from the progressive theories of space-time and his utopian visions, this subject matter breaks free from the restrictions of Moholy's constructivist aesthetic. While the visual complexities of his camera photographs from the late 1920s demonstrate the increasing refinement of his eye and camera technique, an anxious psychological probing asserts itself. This aspect of his work becomes paramount in his photomontages.

The Photomontages

After his announcement of the death of representational art in *Malerei, Photographie, Film* and his creation of much abstract art—sculpture and painting as well as photograms—Moholy's increasing interest in photomontage comes as something of a surprise. Though it seems at odds with his constructivist aesthetic, he stands firmly in the center of the avant-garde's deep involvement with mass culture in Germany in the period from around 1922 to 1933. This development, which took place in other parts of Europe, in Russia, and in the United States as well, can be seen in the number of artists who began to work in photography and photomontage, in the proliferation of photo books and large-scale photography exhibits, and in the new developments in typography and advertising design. Of course, photomontage reaffirms Moholy's con-

tinuing emphasis on process and form, but it does so by the employment of figurative imagery.

In a further turnaround from his carefully enunciated aesthetic position, through photomontage Moholy challenged what he had earlier referred to as the "objectivity" of the camera image. By fragmenting and regrouping images, he first destroyed the supposed objective reality of a photograph and then reconstructed his own subjective reaction to his environment. In creating new contexts for the photographs (or fragments of photographs), he was consciously exploiting the variety of meanings and associations a photograph can have and thereby tapping the subjectivity of his viewers. With subjects ranging from his own psychological states to social matters and advertising material, his photomontages are at once his most imaginative works and, because of their often ambiguous and intensely personal content, his least accessible and most surreal.

In the past decade, several extensive and excellent studies of Moholy's photomontages have treated the complex historical issues behind his subject matter and the diverse sources for the "found" photographs he incorporated in his photomontages.[7] The analysis that follows will focus on the ways in which the photomontages, standing apart as they do, complement his work in other media by expanding into a wider range of issues related to *Modernismus.* They ultimately represent an underlying apprehension about social changes, particularly those involving the male and female roles, that were taking place at the time. The influence of the Berlin dadaists and the Russian constructivists is clear, but Moholy's aim was not the biting political satire of the former nor the dogmatic ideology of the latter. His photomontages are more ambiguous. They document his social anxieties, as well as his wit and his penchant for exploring fantastic realms of the imagination.

The *Fotoplastiken*

From photography's earliest days, collages of photographs and combination printing of negatives had been used to construct tableaux from separate camera images. In addition, as Moholy acknowledged in *Malerei, Photographie, Film,* advertising illustration, in its creative use of photomontage, offered a fresh source of inspiration for artists. Enamored as they were with the popular press, the Berlin dadaists recognized this potential of photomontage, and they transformed it from a commercial design method into a "new," antitraditional art procedure after the First World War. Their use of the term "photomontage," taken from the German words (borrowed from French) *montieren* (to assemble, set up, erect) and *Monteur* (engineer), was part of the conscious effort of the dada artists to identify themselves with the working class.

When Moholy first used photomontage in 1923, the influence of the Berlin dadaists was evident. His early photomontages also often indicate the same interest in form and construction seen in his collages and constructed reliefs of this period, when he was close to the Hanover dadaist Kurt Schwitters. The organization of separate forms for the con-

Moholy = Nagy 31

77. *Nude (Negative)*, 1931. Gelatin-silver print, 38 × 27 cm. The Jedermann Collection, N.A.

the experience of modernity

struction of a new object soon became his dominant strategy for piecing together his photographic units. As Roh described it, Moholy's photomontage technique was "not merely *applied photography* in the sense of literary reference to certain matters or to propaganda: it contains a complete forming principle in itself when well done."[8] Moholy made an effort to distance himself from the dadaists by referring to his works as *Fotoplastiken,* a term he first used in *Malerei, Photographie, Film* in captions for his own photomontages. As in neoplasticism, *Plastik* connotes the organizing of different parts into a synthetic image with an independent meaning.[9]

Few of the original montages for the *Fotoplastiken,* which numbered around fifty (excluding his commercial work), survive, but photographs of them that Lucia made for exhibition and publication purposes do exist. These photographs of the montages, which seem to be the works Moholy referred to as *Fotoplastiken,* suppress signs of the montaging process. The extant photomontages are valuable to us, however, for they reveal Moholy's use of pen and ink, watercolor washes, and colored pigments, as well as the fact that he collected his photographic material from a variety of magazines and newspapers. These found photographs conjured up associations for him independent of the original contexts, and their combination within a radically different setting lent the resulting image a new meaning. As photographs of the photomontages, the *Fotoplastiken* minimize process and discrepancies of material to offer a new seamless image. Moholy's captions expanded the meaning evoked by the grouping of images, and often they help in deciphering some of his more inscrutable *Fotoplastiken.*

Moholy and Dada Photomontage

In his 1928 article "Fotografie ist Lichtgestaltung," Moholy acknowledged the historical precedent and the irreverent provocations of dada photomontage. The influence of the dadaists, many of whom he knew well in his first years in Berlin, is most pronounced in Moholy's initial applications of the technique. Even though his formats were less haphazard than those of the dadaists, his imagery still consisted of fantastic images satirizing social conventions and dissecting a number of issues prominent in life at the time in Berlin. In *The Farewell (Der Abschied)* of 1924 he placed figures in a more comprehensible space, on a bridge with a train going underneath; and he structured the composition with his characteristic crossing diagonals (fig. 78). The image presents a parody, as Julie Saul has pointed out, of romance in modern society.[10] The dramatic, swooning gesture of the woman and the ingratiating stance of her suitor are stereotypes derived from popular mass media—films, magazines, and picture postcards—which we know were primary sources of images for dada photomontage. The two canine companions, whose poses mock those of the man and woman, offer a humorous twist. A similar theme is portrayed by Max Ernst in a photomontage from 1920. Derived from the saccharine postcards of the period, it shows a seated man dreaming about a courting couple (fig. 79). The role of the uncon-

78. *The Farewell (Der Abschied)*, 1924. Rephotographed photomontage (*Fotoplastik*), 33.4 × 25.4 cm. Collection of the J. Paul Getty Museum, Malibu, California.

79. Max Ernst, *Untitled*, 1920. Collage on postcard, 13.4 × 8.7 cm. Kunsthaus Zürich, Zurich.

scious with its sexual undertones dominates the Ernst piece; Moholy, likewise, is just beginning to exploit the possibilities of imaging sexual fantasies with photomontage.

On the other extreme, Moholy created a visual nightmare of marital conflict, which he was experiencing himself at the time, in *The Shattered Marriage (Die zerrüttete Ehe)* of 1925 (fig. 80). The union of marriage is "blown apart" by the bizarre crown of firecrackers perched on the head in the center.[11] This head combines a male and a female face; the latter is making a kind of grimace. The repetition of hands and eyes gives the whole image a surreal air. The conflict between the sexes is reinforced by the picture on the wall in which a man overpowers a woman, either verbally, physically, or sexually (the slipping strap of the reclining woman suggesting the latter). Moholy transforms a melodramatic view of marriage into a violent nightmare. This juxtaposition of *trompe-l'œil* space and the bizarre, imaginary creature made of photographs lends the nightmare a realism similar to that pursued by the surrealists. The effect anticipates that of Magritte, Tanguy, and Dalí in their illusionistic, hyper-realistic paintings of the second half of the 1920s and the 1930s.

The setting in *The Shattered Marriage* reveals the direction in which the pictorial structure of Moholy's photomontages was moving in 1925. The figure, confined by parallel planes closing in from the left and right, is further compressed by the dark rectangular shapes in the foreground. Planes and boxes are rendered with pen and ink and washes, a technique used frequently in works by Hausmann, Grosz, and Ernst of around 1920; the organization of the space bears direct resemblance to an untitled photomontage by Ernst (fig. 81). However, Moholy turns the walls and the foreground into a series of planes set at various angles to define his space, in the manner of modernist architecture, rather than creating a box in which to place his grotesque figure. Lusk has pointed out similarities between these planes and the moving partitions for theater stage sets proposed by Kurt Schmidt and Oskar Schlemmer at the Bauhaus.[12]

In its montage of disparate images, *The Shattered Marriage* creates a grotesque figure reminiscent of Höch's work from several years earlier, and it is apparent that Moholy's frequent contacts with Höch had an impact on his subject matter and sources for photographs. Höch fondly recalled her friendship with Moholy:

László Moholy-Nagy also remained a close comrade for me until his departure from Germany. Together we watched the first elaborate documentary films, saw Nurmi race, and heard the first jazz concerts. And every now and then he would have a spare chocolate for me, something that was very rare at the time. He was always generous, even though he often quarreled with the other men.[13]

As we will see, Moholy's persistent questioning of social mores, especially those pertaining to the New Woman, through his use of images of women culled from mass media reflects Höch's work in the 1920s.

80. *The Shattered Marriage (Die zerrüttete Ehe),* 1925. Rephotographed photomontage (*Fotoplastik*), 18.1 × 12.7 cm. Collection of the J. Paul Getty Museum, Malibu, California.

154.

max ernst

81. Max Ernst, *Untitled*, 1922. Collage, gouache, and pencil on paper, 17.5 × 13.5 cm. Kunsthaus Zürich, Zurich.

the experience of modernity

By 1928 Moholy made it clear that he desired to distance his work from what he saw as the dadaists' self-conscious presentation of unreal images and their blatant display of process. "Dadaist photomontage," he said, "in its unruliness, in its big leaps, was mostly too individualistic to be understood quickly." The synthesis of images and ideas, he continued, would allow for a unification of concept that could be "amusing, moving, despairing, satirical, visionary, revolutionary, etc."[14] To achieve such an end Moholy began to arrange the forms of his photomontages on a constructivist-inspired substructure, thus avoiding randomness and chaos. Nevertheless, the personal, obscure, or ambiguous content of his photomontages contradicts the theory he developed around them. His satirical subject matter and recurring themes of sexual exploitation, conjured up as they were from the most fantasy-laden corners of his imagination, is closer to dada in origin than he would have liked to admit.

Constructivism and Photomontage

In "Fotografie ist Lichtgestaltung" (Photography Is Manipulation of Light) of 1928 Moholy did not specifically mention the Russian constructivists in his detailed discussion of photomontage. It is true that he differed from the Russians in his use of photomontage. As Gustav Klutsis, the foremost Russian practitioner of photomontage, insisted, "One must not think that photomontage is the expressive composition of photographs. It always includes a political slogan, color, and graphic elements."[15] However, despite his silence on the subject, it is obvious that Moholy's photomontages, both in their compositions and their use of color, depend upon the Russian constructivists' example.

We have already seen formal elements as crucial determinants in Moholy's paintings from the mid-1920s. The linear structure connecting geometric forms against a light background in a constructivist painting such as *Composition A XX,* ca. 1924–1926, reemerges in the photomontages (fig. 82). These linear structures solved a specific problem inherent in photomontage visually and theoretically in a way that distinguishes his from other works of the period. The "found" photographs from the printed media that provide the material for photomontages necessarily varied in size. Many dadaists exploited these size differences for the resulting visual disjuncture, making them a pictorial equivalent for the collapse of contemporary social institutions. Moholy, on the other hand, as a constructivist painter and a positivist needed to build up, to construct, each new work. From his earliest photomontages, he allowed the size of the photo fragments to determine where they should be in space, with larger figures in the foreground and smaller ones in the distance. As we have seen, at first Moholy, like Hausmann, Grosz, and Ernst, drew a setting for the placement of figures. Soon, however, he came to use lines to connect images and to integrate the diversity of sizes visually into a unified whole. In this way he could avoid using explicit settings, which could seem too naturalistic, in order to inspire our contemplation of various abstract ideas.

82. *Composition A XX*, 1924. Oil on canvas, 136 × 115.5 cm. Photography Musée National d'Art Moderne, Centre Georges Pompidou, Paris.

The tendency to connect images through a linear structure appears early in his photomontages, as evidenced in the widely reproduced *Militarism,* 1924 (fig. 83). The organization of images helps to establish the hierarchies of power and subordination that are the central theme of this image. In the foreground two blacks administer aid to a third, who seems to have collapsed, while a third looks away toward the other figures in the background. An army officer watches running athletes, whose hockey sticks look like clubs. A single curved line connects the series of tanks approaching from the upper left to the strewn bodies that become larger toward the figures in the foreground. Although it might first appear that the use of these lines to join images of different sizes derives from traditional perspective, in fact Moholy's source more likely was El Lissitzky's *Prouns,* in which lines, his "axes of projection," were used both to anchor objects and to indicate their positions and movements in space. Avoiding a specific setting, which would be too naturalistic, Moholy exploited such a structure to create an organization of ideas that is both intellectual and affecting.

A subtext of *Militarism* explores the horrors of German colonialism. Such an overtly political statement seems at odds with the utopian nature of his constructivist ethos. Not active politically, Moholy was generally not motivated, as were the dadaists and Russian constructivists, to attack specific social institutions and their leaders or to spread Communist propaganda. He was driven by more personal, humanitarian instincts to produce a number of strange and haunting images that present suggestive dichotomies of meaning—freedom/subordination, joy/suffering, sensuality/sexual aggression—as in his juxtapositions of athletes with black victims of colonial imperialism in *Militarism.* Höch also frequently used images from African tribal cultures in her photomontages and scrapbooks of images cut from the mass media. However, while Moholy employs such disparate symbols of civilization as military power and organized sport against victimized Africans, Höch's photomontages, as Lavin has pointed out, more often isolated general stereotypes, like the romantic views of Gauguin, of the pure and simple beauty of primitive cultures.[16]

Moholy draws a parallel between racist and sexual oppression in another work, his photomontage entitled *In the Name of the Law (Massenpsychose),* 1927 (fig. 84). In the uppermost of three cylinders stands an army guard. Outside the center cylinder a man plays pool; his phallic billiard cue points toward a circle of women in bathing suits submissively bending over. Below the group of women is a drawing of a standing male figure, his body an anatomical chart of the circulatory system and his hat a referent to civilized society. This composite biological-social man stands in the line of fire of a female sharpshooter squatting on top of the largest cylinder. Below her a group of Africans huddle in a circle, a configuration that echoes the group of women above. We have the New Woman of the 1920s in the markswoman and in the female athletes. One takes power, while the others take part in a social ritual, the new rage for sports and "physical culture" that is implicitly compared to the

83. *Militarism (Militarismus)*, 1924. Rephotographed photomontage (*Fotoplastik*), 17.9 × 12.8 cm. Collection of the J. Paul Getty Museum, Malibu, California.

84. *In the Name of the Law (Massenpsychose)*, 1927. Black ink, graphite, and collage of half-tone reproductions of photographs on cream board, 64.5 × 49.3 cm. George Eastman House, Rochester.

tribal ritual of the group of blacks. Although the figures are divided into three groups, it is their overlapping in terms of subject and meaning that creates the overall theme of empowerment, victimization, and the battle between the sexes. The angst aroused by these ideas is underscored by the inscription "*Massenpsychose*" in the lower left corner.

Moholy similarly heightens the theme of conflict between the sexes through his presentation of the figures and choice of title in *Rape of the Sabines (Raub der Sabinerinnen)* (fig. 85). As in *The Shattered Marriage,* a couple is a combination of chopped-off fragments of a male and female. Both sets of legs seem to dance; the woman appears to be stuck in a handclasp with a male figure represented only by an arm and a hat. Once again we see a parallel with work of Höch, who frequently created androgynous figures in her photomontages.[17] These images address issues of sexual stereotyping, cross dressing, and androgyny that were currently of concern in Weimar culture. As we shall see in another photomontage, *A Chick Remains a Chick,* Moholy uses lines to connect the photo fragments and to amplify the struggle between the male-female figure on the right and a group of athletes engaged in a tug-of-war at the lower left. The struggle of modern men and women, identified as such by their clothes, updates the theme often painted in Western art and epitomized by Poussin's *Rape of the Sabine Women* from the 1630s. Poussin's image of writhing bodies dramatically represents the way in which the abduction of women was used—is still used—as a sign of power over the enemy. Moholy's version identifies the struggle within our society: the idea of physically overpowering women as a sign of masculine superiority.

Moholy further pursues the opposing themes of freedom and subordination in his *Dream of Girls' Boarding School (Traum des Mädchenpensionats),* 1925 (fig. 86). The system of lines and overlapping forms that unifies the various images on the picture plane demonstrates again his reliance on the pictorial structure established in his paintings. An arc-shaped plane isolates two dancers in patterned leotards. Behind them rows of schoolgirls dressed in uniform, four leaping male athletes, and a lone dog exist on separate planes receding into space; yet they are related to the two acrobatic dancers by their orientation toward them and by the lines connecting them. The rigid H-shaped formation of the schoolgirls provides a witty contrast to the freedom of the male figures and the gymnastic grace of the dancers. Here pictorial form amplifies the image's content: structure becomes equated with the sexual isolation of a girls' boarding school, while the movements of the figures seem to imply that nothing can restrict the budding adolescents. This combination of *Sportkultur* and regimentation had appeared earlier in a more blatantly sexual photomontage entitled *Chute,* 1923 (fig. 87), in which a row of girls, made by repetitions of the same cluster of young girls in sport attire, zooms down a slide with their legs spread toward the viewer. The young girls are controlled through uniforms and organized sports, though the ability to restrict their sexual activities in this era of emancipation remains an open question.

85. *Rape of the Sabines (Raub der Sabinerinnen)*, 1927. Rephotographed photomontage (*Fotoplastik*), 21.1 × 15.7 cm. Collection of the J. Paul Getty Museum, Malibu, California.

86. *The Girls' Boarding School; Dream of Girls' Boarding School (Das Mädchenpensionat; Traum des Mädchenpensionats),* 1925. Graphite, gray wash, and collage of half-tone reproductions of photographs on cream paper, 48 × 30.8 cm. Museum Folkwang, Essen.

87. *Chute*, 1923. Airbrush, pen and ink, and collage of half-tone and gravure reproductions of photographs, 6 × 4.9 cm. The Museum of Modern Art, New York, Gift of Sibyl Moholy-Nagy.

Moholy's allusions to sexual mores become uncharacteristically derogatory and overtly sexist in the 1925 photomontage *A Chick Remains a Chick; Poeticizing of Sirens (Huhn bleibt Huhn; Sirenenverdichtung)* (fig. 88). This is described on the verso as a film poster, Moholy later stated that his film script of this title was inspired by the photomontage.[18] An X ray of a chicken, first published in *Malerei, Photographie, Film,* is tied to a female athlete wielding a stick. The appendages of each are circled, and the connecting lines drawn between them resemble pulleys; the lines establish a tension between the opposing images of a nubile woman and the seemingly dead apparition of a chicken. Behind the taut lines are a group of chicks hatching from eggs, another female athlete leaping over a line, and in the furthest plane a woman golfer taking a swing. Thus the lines are used to unify the figures visually, as well as to highlight the contrasting concepts.

The demeaning appellation for a woman, "chick" (*Huhn*), alludes to fertility and to the idea of the New Woman as sexually liberated. In the film script this theme is further developed into a misogynist's nightmare in which a man, bombarded with eggs, is pursued by a woman, who marries and then divorces him. In the end her aggression apparently receives its just reward: chased by eggshells, she is transformed into a china hen. Such zany subject matter is decidedly surrealist in its orientation toward the bizarre and unexpected, the sexual and sexist. If Moholy had mustered the resources, both creative and financial, to realize this film, it surely would have been comparable to some of the most fantastic visions of surrealist film in France and Germany.

Moholy's attitude toward women as represented in his photomontages is conflicted and ambiguous. Using images of the New Woman as athlete and sharpshooter, he often turns her newfound signs of independence into aggression, ritualized behavior, or a threat to men. Within the context of his polemic, the recurring and contradictory messages of the sexual imagery in these photomontages are a bit baffling. Such subject matter can be seen as part of a more general trend in dada and surrealism at the time. More importantly, these photomontages reflect Moholy's struggle to understand the crisis of modernity, in which women's liberation could simultaneously be seen as a sign of progress and a constant threat to society. It is also difficult not to read these subjects as part of Moholy's own psychobiography, with the conflict he must have experienced between his formal, old-world background and the sexual liberation of the 1920s in Berlin; and by all accounts he was a gentleman who charmed many women.

Photomontage and Film

The inscription "Filmplakat," or film poster, on the back of *A Chick Remains a Chick, Rape of the Sabines,* and *Love Your Neighbor* (fig. 89) implies that these dramatic, violent scenes of sexual conflict were ideas Moholy had for film projects that were never realized. Moholy seems to have used photomontage either as a way to study a film concept or as an inspiration for a future film. Photomontage was also

connected to film in other, more subtle ways. The joining of visually disparate images allows a depiction of events happening concurrently. By the mid-1920s the notion of simultaneity, growing out of cubist and futurist practices, came to represent for many artists the dynamism of the new urban society. Moholy first used photomontage (and his "typo-photo") in the storyboard for the second version of his film script *Dynamic of the Metropolis,* published in 1925, discussed in the next chapter (see fig. 98). Photomontage seemed the perfect vehicle for capturing the fast pace of contemporary life through superimpositions of images that could be viewed repeatedly and would be accessible to the viewer. Moholy was aware that such repetition and superimposition of photographic fragments were central principles in the montage theory of the Russian film makers Lev Kuleshov, Dziga Vertov, and Sergei Eisenstein. In addition, Moholy was undoubtedly interested in film as an exciting form of mass entertainment. He was able to bring these different aspects of film—simultaneity, disjuncture, rapid pacing—to heighten the psychological implications of his exploration of the New Woman.

Several of Moholy's photomontages of 1925 utilized devices of repetition and montage to achieve results associated with contemporary film. In *Love Your Neighbor; Murder on the Railway Line (Liebe deinen Nächsten; Mord auf den Schienen),* one of Moholy's most striking photomontages both visually and thematically, the format resembles Moholy's diagram for a "poly-cinema." This he described as a simultaneous projection of films on different subjects, and he reproduced a diagram of it in *Malerei, Photographie, Film* (fig. 90).[19] He speculated on the possibility of showing overlapping films of several people's lives. In effect

88. *A Chick Remains a Chick; Poeticizing of Sirens (Huhn bleibt Huhn; Sirenenverdichtung),* 1925. Rephotographed photomontage *(Fotoplastik)* with letters printed on in red ink, 11 × 16.4 cm. Collection of the J. Paul Getty Museum, Malibu, California.

89. *Love Your Neighbor; Murder on the Railway Line (Liebe deinen Nächsten; Mord auf den Schienen)*, 1925. Rephotographed photomontage (*Fotoplastik*), 37.8 × 27.2 cm. Collection of the J. Paul Getty Museum, Malibu, California.

90. *Poly-Cinema.* Illustration from *Malerei, Photographie, Film* (Munich, 1925), p. 34.

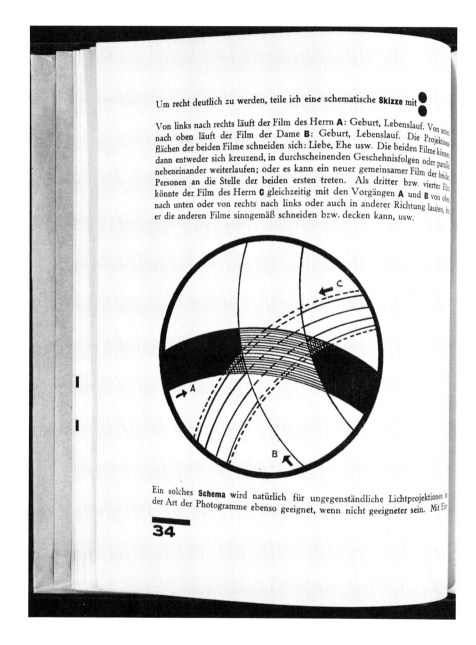

Um recht deutlich zu werden, teile ich eine schematische **Skizze** mit

Von links nach rechts läuft der Film des Herrn **A**: Geburt, Lebenslauf. Von unten nach oben läuft der Film der Dame **B**: Geburt, Lebenslauf. Die Projektionsflächen der beiden Filme schneiden sich: Liebe, Ehe usw. Die beiden Filme können dann entweder sich kreuzend, in durchscheinenden Geschehnisfolgen oder parallel nebeneinander weiterlaufen; oder es kann ein neuer gemeinsamer Film der beiden Personen an die Stelle der beiden ersten treten. Als dritter bzw. vierter Film könnte der Film des Herrn **C** gleichzeitig mit den Vorgängen **A** und **B** von oben nach unten oder von rechts nach links oder auch in anderer Richtung laufen, bis er die anderen Filme sinngemäß schneiden bzw. decken kann, usw.

Ein solches **Schema** wird natürlich für ungegenständliche Lichtprojektionen in der Art der Photogramme ebenso geeignet, wenn nicht geeigneter sein. Mit Ein-

34

Moholy tries out this idea in several photomontages, the subjects of which expose his intense emotions as his marriage to Lucia was disintegrating. The experience of the coexistence and implicit relationship of separate events was also his goal in *Love Your Neighbor.* A woman sits in the center of a circle aiming a rifle at another woman, who stands outside the circle exercising. Other fragments of photographs provide the setting, a deserted railway station at night. The overlapping circles, some segments of which contain photographs, organize the composition.

The resulting mood of isolation and impending violence similarly infuses a related photomontage, entitled *Jealousy (Eifersucht)* or *The Fool,* 1925, and its comparison to *Love Your Neighbor* provides clues to their meaning (fig. 91). Through his formal procedures Moholy again gives an extra dimension of time to the sense of suspended action in a photograph. The photomontage is divided into two planes, the irregular shapes of which suggest a recession toward the upper right. He combines another image of a markswoman with three versions of a photograph of himself taken by Lucia that were each printed or altered in a different way (fig. 92).[20] Moholy cut out his figure from a negative printing of Lucia's photograph, and this white silhouette finds its reversal in the drawn white plane with a black silhouette of Moholy in the frontal plane. The addition of a woman's legs coming out the bottom of the white silhouette and the placement of the actual cut-out image of Moholy to the side make this likeness of himself seem an illusion that is overshadowed by the woman's jealousy. This is the most obvious instance of autobiographical subject matter in his photomontages. The general theme of jealousy, conflict, disrupted relationships appears repeatedly and would seem to reflect his own marital problems at the time; we can sense Moholy's use of photomontage, of arranging and constructing images, as a way of dealing with psychological stress.

While his photomontages often suggested ideas for film scripts, he also derived imagery from actual contemporary films. In *City Lights (Die Lichter der Stadt),* ca. 1928, for example, Moholy focused on the image of Charlie Chaplin's little tramp as the social outcast who finds himself in all kinds of unusual and comic situations (fig. 93). Chaplin, because of his film techniques, his political stance, and the more general *Amerikanismus* in Germany at the time, was particularly popular among the avant-garde. The photograph of Chaplin Moholy used here actually came from his 1928 film *The Circus,* but Moholy uses the image nevertheless to illustrate the "city lights" theme.[21] Moholy has combined photographs of Chaplin and two fat women in bathing suits with a geometric structure that resembles beams of light taken from his painting *Construction* of 1922 (fig. 37). Chaplin appears as a kind of peeping Tom, looking up at the legs of two inaccessible women who are comically lacking in sex appeal. Moholy evidently found photomontage useful for exploring filmic qualities of simultaneity, rupture, and juncture that served as a paradigm for the rhythms and conflicts of urban life.

Moholy's photomontages produced in the 1920s provided him a way to explore figurative subject matter through the inherently analytical

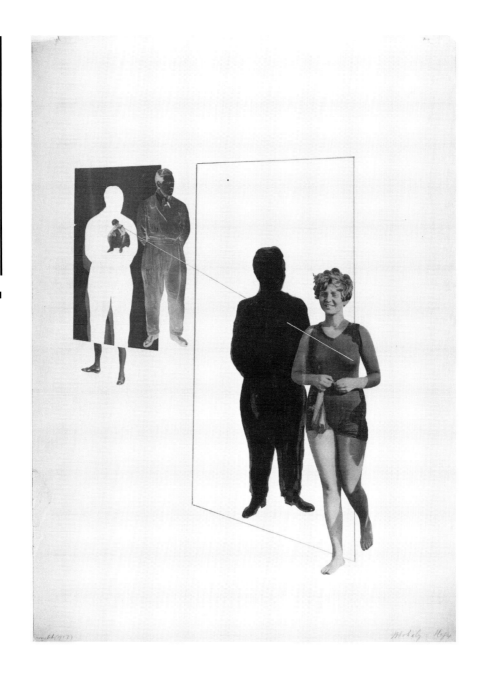

91. *Jealousy: The Fool (Eifersucht)*, 1925. Collage of photographs with drawn elements, 63.8 × 56.1 cm. George Eastman House, Rochester.

92. Lucia Moholy, *László Moholy-Nagy at the Dessau Bauhaus*, ca. 1925. Collection of Hattula Moholy-Nagy, Ann Arbor.

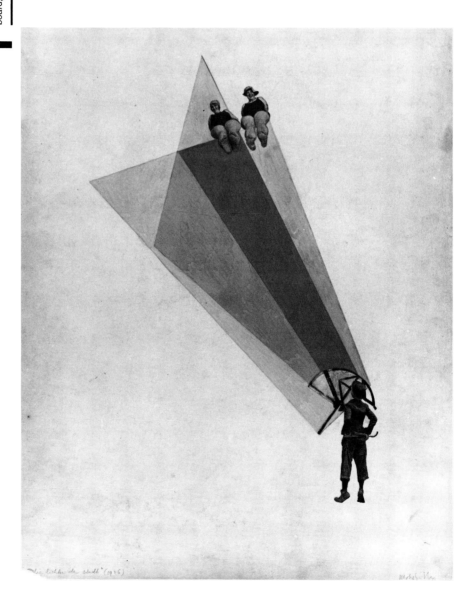

93. *City Lights (Die Lichter der Stadt)*, ca. 1928. Graphite, tempera, tusche, and collage of half-tone reproductions of photographs on gray board, 61 × 50 cm. Bauhaus-Archiv, Berlin.

means of his constructivist compositions. The dichotomy between these works and his constructivist art may at first seem puzzling. The fact that he reproduced only a few of his *Fotoplastiken* (thus keeping most of his works private) shows that perhaps he also felt this discrepancy. However, we sense that in Moholy's work there is some of the same mixture of dada destruction and constructivist rebuilding that characterized the two sides of van Doesburg's career as a dada poet and De Stijl architect. In these works he lays claims to a territory dominated by his rival in photogram production, Man Ray, for Moholy's works too enter the realm of surrealism. Most importantly, the themes of uncertainty, anxiety, or even, to use his own term, *Massenpsychose* underlying his groupings of photographs of modern men and women lifted from the mass media reveal better than anything his own unstable footing in his romantic vision of the modern industrial world.

CHAPTER

THE BAUHAUS BOOKS

In the fall of 1923 Moholy and Gropius embarked upon a project that would become one of the important legacies of the school, a series of books called the *Bauhausbücher,* or Bauhaus Books. "Our goal," Moholy wrote to Rodchenko in 1923, "is to give a summary of all that is contemporary."[1] Moholy sent Rodchenko an outline of possible titles that indicates his intention to cover a wide range of subjects. The list of 30 "brochures" begins with a work on constructivism by Rodchenko and ends with one on "utopia." In between are proposed volumes on topics ranging from science, economics, politics, and religion to current developments in European and Russian art, architecture, and theater. Moholy and Gropius gradually transformed this original sketch into a series concentrating on the art, architecture, and design of the modern movement as well as several volumes on the teaching at the Bauhaus. Most important for this study, Moholy's own two Bauhaus Books focused on the ways in which photography and light itself were media invaluable for design education and unsurpassed in creative potential for interpreting the modern world.

In this impressive publishing venture, originally projected to contain 50 titles, 14 individual volumes were published, a number in several editions, between 1925 and 1931.[2] As general editor of the series, Moholy was largely responsible for the choice of authors and the design of the book jackets, bindings, and typography.[3] He conducted the correspondence with the architects and artists who wrote the books, and he selected and obtained the illustrative material and photographs. Mo-

94. *14 Bauhaus Books.* Cover design for an eight-page prospectus of the Albert Langen Verlag, 1929. 15 × 21 cm. Staatliche Museen Preussischer Kulturbesitz, Kunstbibliothek, Berlin.

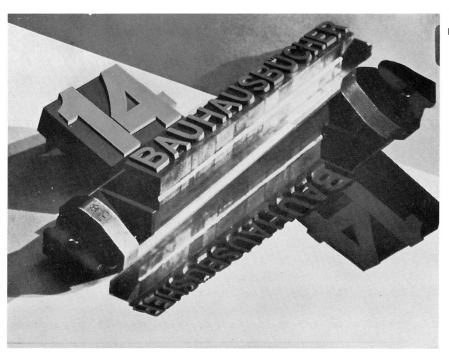

holy's influence is also evident in the very fact that the texts were so lavishly illustrated. A letter to van Doesburg on 12 March 1924 demonstrates his predilection: in formally inviting van Doesburg to become a contributor, Moholy wrote that the "Büchlein" could either be 16 pages of text with 30 pages of illustrations, or 48 pages of text, but that the former would be better.[4] While reflecting Moholy's own interests, as a group the Bauhaus Books offer an unparalleled sequence of lavishly illustrated documents on the aesthetics of art, architecture, and design in the 1920s inside and outside the Bauhaus.

Though ostensibly a primer of contemporary movements, the *Bauhausbücher* had a grander aim: to provide nothing less than the theoretical background for the development of a new visual culture. The orientation of the series was described in a brochure of 1927 (fig. 95):

The publication of the Bauhaus Books is motivated by the recognition that all areas of design are interrelated. These books deal with problems of art, science, and technology, and for the specialist of today they attempt to furnish information about the complex problems, working methods, and research results in various areas of design, thereby providing the individual with a criterion for his own studies and with progress made in other areas. In order to be able to tackle a task of this magnitude the editors have enlisted the cooperation of the most knowledgeable experts from various countries who are trying to integrate their specialized work with the totality of phenomena of the modern world.[5]

The selection of titles, both published and unpublished (fig. 96), sheds light on the modern art movements and recent architectural developments, and on the artists and the architects that nourished the school's philosophy and program.

As was the case with the *Buch neuer Künstler,* the series began with cubism, thereby ignoring any earlier historical influences.[6] Again the importance of Russian art and De Stijl is evident. The series included a book by Malevich and requests (turned down) for ones from both Rodchenko and Lissitzky, as well as volumes by Piet Mondrian, J. J. P. Oud, and van Doesburg.[7] With nine by members of the Bauhaus faculty, the *Bauhausbücher* additionally serve as an important set of documents on the teaching methodology and the products of the Bauhaus at Dessau from 1925 to 1928, the year Gropius and Moholy resigned. Moholy was the coauthor with Oskar Schlemmer and Farkas Molnár of *Die Bühne im Bauhaus* (The Theater of the Bauhaus) (1925). Two of the nine books were by Moholy alone: his seminal *Malerei, Photographie, Film* (Painting, Photography, Film) of 1925 and a summary of his teaching of the preliminary course, *Von Material zu Arkitecktur* (From Material to Architecture) of 1929. Both volumes demonstrate the central role of what he defined as the light media—photography, film, light displays—in his aesthetic. For this reason, and because these important monuments of

1920s art theory have not received extensive analysis in the past, it is important to devote the ensuing discussion to them.

Malerei, Photographie, Film

Malerei, Photographie, Film, the first book on photography and film by an established member of the avant-garde and Moholy's most important theoretical statement, led in the flood of books on photography that appeared in Germany in the second half of the 1920s.[8] But *Malerei, Photographie, Film* differs greatly from the later picture books and treatises on photography because of the context in which it was written. Although he incorporated several previously published articles into the book, Moholy now emphasized the ways in which photography and film could be relevant to the pedagogical methods and utilitarian projects of the Bauhaus.[9] His obvious enthusiasm and unfaltering conviction make up for his occasional lapses in logic or lucidity. And his creative approach to the film media's artistic possibilities, evident in his proposals for projects and his selection of illustrations, extended the book's implications beyond the realm of mere art education to the most advanced art experimentation of the time. It is curious that this original, handsome, and influential book has received only cursory treatment in the past.[10]

Moholy begins by defining what he thinks the purpose of art should be, and in doing so he attempts to justify the authority he thinks photography should hold in the field of "optical creation." His text covers a number of controversial and farsighted issues, such as the relationship between painting and photography, the social benefits of mass-produced art, and the creative and educational potentials of the camera. The illustrations that follow the text do more than merely complement it. With only one exception (one of his own paintings juxtaposed to one of his photograms of similar composition), the illustrations consist only of photographs, stills from films, and a storyboard for one of Moholy's proposed film projects. These images provide an outline of the ways in which photography could offer exciting new challenges to expand the frontiers of vision.

The book also makes a strong statement through its design, beginning with its binding and the typography of its jacket. We cannot overlook the importance of his characteristic attractive packaging for the dissemination of his ideas. As a way of emphasizing the major role experimental photography had on his aesthetic program, Moholy placed his own photograms on the dust jacket (fig. 97). On the front, Moholy's name, the title, and "Bauhausbücher" were printed in white and gray capital letters justified to the left. For the binding of all the books, Moholy chose a yellow linen that set off the red of the lettering and the horizontal and vertical bars of his cover design.[11] In the text he used bold black horizontal and vertical bars, titles, subtitles, Roman and Arabic numerals, bullets, and bold type to orchestrate the flow and emphases of the text. His final manipulation of the reader comes on the text's last page, where in bold type accompanied by a large arrow he directed "Noch einmal, noch einmal, das Ganze noch einmal durchlesen!" (Once again, once

IM VERLAG

ALBERT LANGEN MÜNCHEN

erscheinen die

BAUHAUSBÜCHER

SCHRIFTLEITUNG:

WALTER GROPIUS und L. MOHOLY-NAGY

Die Herausgabe der Bauhausbücher geschieht von der Erkenntnis aus, daß alle Gestaltungsgebiete des Lebens miteinander eng verknüpft sind. Die Bücher behandeln künstlerische, wissenschaftliche und technische Fragen und versuchen, den in ihrer Spezialarbeit gebundenen heutigen Menschen über die Problemstellung, die Arbeitsführung und die Arbeitsergebnisse verschiedener Gestaltungsgebiete Aufschluß zu geben und dadurch einen Vergleichsmaßstab für ihre eigenen Kenntnisse und den Fortschritt in anderen Arbeitszweigen zu schaffen. Um eine Aufgabe von diesem Ausmaße bewältigen zu können, haben die Herausgeber bestorientierte Fachleute verschiedener Länder, die ihre Spezialarbeit in die Gesamtheit heutiger Lebenserscheinungen einzugliedern bestrebt sind, für die Mitarbeit gewonnen.

SOEBEN IST DIE ERSTE SERIE ERSCHIENEN

8 BAUHAUSBÜCHER

			Abbildungen	**PREIS**	
				steif brosch.	i. Leinen geb.
1	**Walter Gropius,**	INTERNATIONALE ARCHITEKTUR. Auswahl der besten neuzeitlichen Architektur-Werke.	101	Mk. 5	Mk. 7
2	**Paul Klee,**	PÄDAGOGISCHES SKIZZENBUCH. Aus seinem Unterricht am Bauhaus mit von ihm selbst gezeichneten Textillustrationen.	87	Mk. 6	Mk. 8
3	**Ein Versuchshaus des Bauhauses.**	Neue Wohnkultur; neue Techniken des Hausbaues.	61	Mk. 5	Mk. 7
4	**Die Bühne im Bauhaus.**	Theoretisches und Praktisches aus einer modernen Theaterwerkstatt.	42 3 Farbtafeln	Mk. 5	Mk. 7
5	**Piet Mondrian,**	NEUE GESTALTUNG. Forderungen der neuen Gestaltung für alle Gebiete künstlerischen Schaffens.		Mk. 3	Mk. 5
6	**Theo van Doesburg,**	GRUNDBEGRIFFE DER NEUEN GESTALTENDEN KUNST. Versuch einer neuen Ästhetik.	32	Mk. 5	Mk. 7
7	**Neue Arbeiten der Bauhauswerkstätten.**	Praktische Beispiele neuzeitlicher Wohnungseinrichtung.	107 4 Farbtafeln	Mk. 6	Mk. 8
8	**L. Moholy.Nagy,**	MALEREI, PHOTOGRAPHIE, FILM. Apologie der Photographie, zugleich grundlegende Erkenntnis abstrakter und gegenständlicher Malerei.	102	Mk. 7	Mk. 9

Die Reihe wird in schneller Folge fortgesetzt.

IN VORBEREITUNG:

BAUHAUSBÜCHER

W. Kandinsky:	Punkt, Linie, Fläche
	Violett (Bühnenstück)
Kurt Schwitters:	Merz–Buch
Heinrich Jacoby:	Schöpferische Musikerziehung
J. J. P. Oud (Holland):	Die holländische Architektur
George Antheil (Amerika):	Musico–mechanico
Albert Gleizes (Frankreich)	Kubismus
F. T. Marinetti und	
Prampolini (Italien):	Futurismus
Fritz Wichert:	Expressionismus
Tristan Tzara:	Dadaismus
L. Kassák und E. Kállai	
(Ungarn):	Die MA–Gruppe
T. v. Doesburg (Holland):	Die Stijlgruppe
Carel Telge (Prag):	Tschechische Kunst
Louis Lozowick (Amerika):	Amerikanische Architektur
Walter Gropius:	Neue Architekturdarstellung ● Das flache Dach ● Montierbare Typenbauten ● Die Bauhausneubauten in Dessau
Mies van der Rohe:	Über Architektur
Le Corbusier-Saugnier (Frankreich):	Über Architektur
Knud Lönberg-Holm (Dänemark):	Über Architektur
Friedrich Kiesler (Österreich):	Neue Formen der Demonstration Die Raumstadt
Jane Heap (Amerika):	Die neue Welt
G. Muche und R. Paulick:	Das Metalltypenhaus
Mart Stam	Das „ABC" vom Bauen
Adolf Behne:	Kunst, Handwerk und Industrie
Max Burchartz:	Plastik der Gestaltungen
Martin Schäfer:	Konstruktive Biologie
Reklame und Typographie des Bauhauses	
L. Moholy-Nagy:	Aufbau der Gestaltungen
Paul Klee:	Bildnerische Mechanik
Oskar Schlemmer:	Bühnenelemente
Joost Schmidt:	Bildermagazin der Zeit I
Die neuen künstlichen Materialien	

Die BAUHAUSBÜCHER sind zu beziehen einzeln oder in Serien durch jede Buchhandlung oder direkt vom

VERLAG

ALBERT LANGEN

MÜNCHEN Hubertusstr. 27

BAUHAUSDRUCK MOHOLY DIN C5

Bestellkarte liegt diesem Prospekt bei.

BAUHAUS-ARCHIV

96. Brochure for Bauhaus Books in preparation, 1927. 23 × 16 cm. Photograph courtesy of the Bauhaus-Archiv, Berlin.

the bauhaus books

again, read through the whole essay once again). The result of Moholy's new typographical design, particularly the bars and the bold type, may today seem heavy-handed. On the other hand, it gives the book its punch, a striking dynamic look that matched the tenor of his artistic pronouncements. In 1925, both its content and its design were a radical departure from previous books on art theory.

Moholy claimed that he gathered material for *Malerei, Photographie, Film* during the summer of 1924, a little more than a year after he joined the Bauhaus.[12] His expansion of several earlier essays into a more comprehensive theory of art reveals the influence of Gropius and the Bauhaus on the development of his theory and pedagogy. Yet *Malerei, Photographie, Film*, and *Von Material zu Architektur* as well, can be readily distinguished from the pedagogical statements of other Bauhaus teachers because of Moholy's emphasis on the film media. "This book is the apologia for photography," he began.[13] From this first sentence to the end of the book he insistently built up his position that photography, as a technological medium, was "one of the most important factors in the dawn of a new life."[14]

Moholy originally entitled his first Bauhaus Book *Film und Photographie,* a title that Gropius continued to use until the time it was printed.[15] The ultimate insertion of "Malerei" (painting) in the title faces the issue of the relationship of painting to photography and film; the title change is also symptomatic of an odd paradox in Moholy's career. Regardless of his exaltation of the film media's creative potential and his innovative contributions in this area, he himself could never abandon painting. Thus in this first, and least convincing, section of the book, he attempted to redefine the relationship between painting and photogra-

97. Book jacket for *Malerei, Fotografie, Film* (second edition, Munich, 1927). 23.6 × 38.9 cm. Staatliche Museen Preussischer Kulturbesitz, Kunstbibliothek, Berlin.

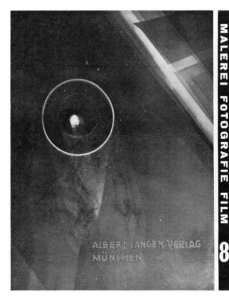
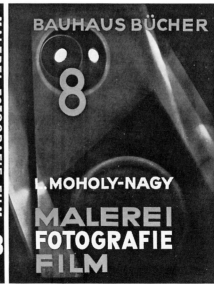

phy in order to defend his own abstract painting while proclaiming that photography held the greatest potential for the future.

Moholy felt the purpose of painting had been obscured by its traditionally representational function. Then photography entered. Its very invention, Moholy argued, demanded that the "missions" of the various media be redefined and clarified. Photography, through its "mechanical means of representation," could now fulfill painting's old narrative functions, that is, documenting reality. Now, Moholy maintained, the interplay of color, plane, and space, with the further implications of movement and time, had become the primary goals of modern painting. Then his argument becomes contradictory and confusing. Following abstract painting's lead, he said, photography too could break away from reportage and narration to study various formal issues. Because he saw the field of color photography as still in its infancy, he defined painting as the medium for exploring color relationships and photography for monochromatic contrasts.

Moholy's argument is flawed on several accounts. His view that photography had freed painting to turn to abstraction was based on a very limited understanding of photography's first 80 years. The photograph, he said, had been limited to a "reproduction (copy) of nature in conformity with the rules of perspective. Every period with a distinctive style of painting since then has had an imitative photographic manner derived from the painterly trend of the moment."[16] His knowledge of photography's beginnings seems to have been based on a limited exposure to early documentary photographs (he refers to a historical collection in Munich that illustrates his point).[17] Had he been more familiar with the range of creative image-making in nineteenth-century photography, Moholy might have needed to find another way to justify his abstract painting. Nevertheless, while his approach to photography might be seen as typically modernist in that he sought to avoid traditional conventions of pictorial construction and Renaissance perspective, his own work shows that he did so to achieve a new kind of gravity-free space more in tune with the era of theoretical physics.

The case Moholy built for photography's importance went beyond aesthetic issues to include farsighted hypotheses on the social impact technology would have on art. In the section entitled "Domestic Pinacotheca," Moholy declared that art for art's sake, or the notion of individual, subjective art works created for an elite, was unsuitable under current social conditions. Technology he saw as a force for the formation of an egalitarian society. Mass production made commodities widely available and raised the standard of living. "Painterly methods of representation suggestive of past times and past ideologies shall disappear," Moholy declared, "and their place be taken by mechanical means of representation and their as yet unpredictable possibilities of extension."[18] Therefore, machine printing and technical processes for mass production—such as spray guns, enameling, stenciling—could make art affordable for everyone, not just elite patrons. The new art could be stored in drawers and cabinets—an updating of the *Kunstkammer*—and brought out to study.[19]

He even envisioned our current mania for collecting and copying videos when he talked of storing "film spools for private cinematographs in a cupboard in our home."[20] In the age of mechanical reproduction, Moholy said, art would cease to be decoration for the bourgeoisie; it would instead educate and expand everyone's awareness.[21] Moholy was in effect proposing a predecessor of Malraux's "museum without walls." Everyman could have a home picture gallery and be improved by it.

In the first section of the book Moholy may have struggled to defend theoretically his own abstract painting and photograms, but once he established the "mission" of current painting his creativity seemed unleashed, and he moved on to his main interest. The rest of the book is devoted to photography, film, and light displays. Again and again he demonstrates an almost prophetic ability to visualize future possibilities. Only until photography could successfully satisfy what Moholy saw as a basic human need to experience color relationships would painting still be a viable art form. "Profoundly pertinent, therefore, to the problem of easel painting is the most urgent question: is it right today, in the age of moving reflected light phenomena and of film, to continue to cultivate the static individual painting as a color composition."[22] He demonstrates how photography could lead the way by outlining its uses. Ultimately the most important medium was light itself, which would reach its highest realization when set into motion, either in film or moving light displays.

Particularly in the second edition of the book, he expanded upon his views on the artistic applications of photography's supposed objectivity. He explained that photographs present truthful representations of optical phenomena. Moholy's faith in the camera's ability to record the phenomena of nature in a scientific, objective way now strikes us as a reversion to nineteenth-century positivism, especially odd in light of his radical manipulation of his subjects in his own photographs. Today this notion of the camera as a "transparent eye" is obsolete; if the machine is a mindless eye, the photographer who must operate it is not. The very selection of the medium, the process of operation, the viewpoint, and choice of subject matter make every photograph a subjective statement. In addition, Moholy's argument for a photograph's objectivity is undermined by the way in which he removed photographs from their original contexts, stripped them of their intended meanings, and commented only on their formal qualities in his captions. As confusing and undeveloped as this part of his argument is, it is important not to see Moholy's descriptions of photography as "representing in an objective, mechanical manner" as merely an archaism in his theory.[23] His attempts to define photography's objectivity coincide with a general movement among the avant-garde to discover an objective, "pure" art in a reaction against the subjectivity of expressionist painting.

Even his definition of truth needs to be put into the context of his desire to use a scientific model as the basis for visual exploration. Photography, he felt, could be truthful because it records optical phenomena and can be verified through science. His description of the photogram shows his awareness of the growing field of optics. "The light is allowed to fall onto

a screen (photographic plate, light-sensitive paper) through objects with different coefficients of refraction or to be deflected from its original path by various contrivances."[24] And as he looked to science as his model, he was struck by that discipline's exemplary and promising use of photography. Through advances in phototechnology such as high-speed, micro-, and X-ray photography, "the camera can either complete or supplement our optical instrument, the eye."[25] Photography can help us see aspects of nature we cannot observe with the naked eye. Although the recording of such phenomena obviously intrigued Moholy, he regarded the new scientific photography as only a "visual encyclopedic achievement," a merely technical advance.[26] What he advocated was the application of the techniques of scientific photography according to the premise that we saw first in his 1922 article "Produktion-Reproduktion": in order to make photography "productive"—creative, useful, and constructive—rather than "reproductive," the artist must exploit the characteristics inherent to the medium.

Moholy himself was at his most creative when he speculated on ways in which light could be manipulated to produce new kinds of abstract art in film and light displays ("light architecture").[27] In the section on "Static and Kinetic Optical Composition," he described how to use new products of technology, which he labeled "optical apparatus"—the spotlight, reflector, and electric sign—to make moving compositions.[28] In a brilliant project proposal, Moholy borrowed lighting devices from the cityscape to create metaphors for the movement, dynamism, and simultaneity of the constantly changing urban environment. In another proposal, he described his idea of "poly-cinema" in which several films, each about a separate person, overlap where their lives intersect (fig. 90). This kind of overlapping and then separating of film projections could also be applied, he said, to abstract film. He could even foresee the development of television when he suggested the future possibility of the "radio-projected newspaper." His descriptions, often quite detailed, of proposed light displays and film projects served to broaden general awareness of these experimental art forms.

One of his own ideas for a film project, entitled *Dynamic of the Metropolis,* appeared in the form of a film script at the end of *Malerei, Photographie, Film* (fig. 98). Moholy prefaced the film script with a description of his intentions:

Dynamic of the Metropolis is not to teach, nor to moralize, nor to tell a story; its effect is meant to be *purely* visual. The elements of the visual have not in this film an absolute logical connection with one another; their photographic visual relationships, nevertheless, make them knit together into a vital association of events in space and time and bring the viewer actively into the dynamic of the city.[29]

As the title implies, Moholy hoped to construct a paradigm for the vibrant simultaneity of sensory experience in the urban environment that he had described in his section on "Simultaneous or Poly-cinema." Central to

these investigations was Moholy's concept of the "filmic," wherein the potentials of the camera are combined with the dynamics of movement.

As the second of two versions, the first having been published in *Ma* the previous September, the film script *Dynamic of the Metropolis* bears the indelible stamp of Moholy's Bauhaus typographic style and his exuberant use of all forms of photography.[30] The film script's novel combination of photographs, typographical layout, and symbols graphically illustrates not only his intentions for film but also what he called "typophoto," visually striking combinations of photographs and text. Dividing the pages into sections with black horizontal and vertical bars, he produced a diverse array of staccato rhythms.[31] He further encouraged a sense of rupture by the use of the word "tempo" placed in different directions and sizes with varying frequency on each page. Moholy never produced a film directly from the script, although his films *Berlin Still Life* and *The Old Port of Marseilles* carry out many of these ideas. What survives instead is a storyboard that is a visual montage of ideas. Moholy transformed the disjointed, nonnarrative form of dada poetry into a hyperactive montage of urban images that were meant to assault the senses. Such techniques for representing the energy and simultaneity of events in the metropolis has affinities with Dziga Vertov's aggressive montage technique that reached its apex in his masterpiece *Man with a Movie Camera* of 1929.

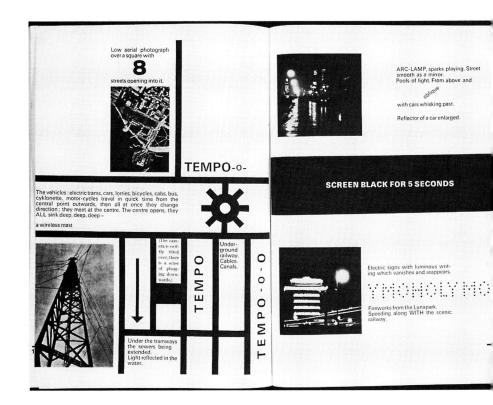

As was the case with *Buch neuer Künstler*, Moholy did not interweave photographs into the text of *Malerei, Photographie, Film*. Instead, the placing of one hundred illustrations in a second section of the book substantiates his proposal that photography could be used independently of verbal commentary to explore artistic principles. To achieve this goal, he organized the illustrations by type, with scientific photographs apparently providing him with the greatest range of technical possibilities. Moholy expressed this idea in a note preceding the illustrations: "I have placed the illustrative material separately following the text because continuity in the illustrations will make the problems raised in the text VISUALLY clear [emphasis Moholy's]."[32] He gathered the photographic material from his usual eclectic, nonart sources (news services, periodicals, newspapers, and film companies), as well as from individual artists. Moholy's ability to make striking visual statements with photographs supports the ideas on the education of perception laid out in the preceding text.

For Moholy, the scientific photographs pointed to a new way of seeing the world and, in the process, evoked a sense of amazement about hitherto unseen aspects of it. However, this new seeing for Moholy is something very visual, formal, and abstract. His captions emphasize how light could be used creatively to produce formal and spatial relationships (an illustration of birds in flight has the caption "The wonder of

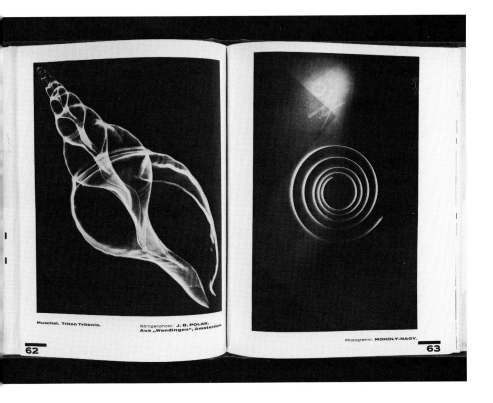

Muschel. Triton Tritonis.

Röntgenphoto: **J. B. POLAK.**
Aus „Wendingen", Amsterdam.

Photogramm: **MOHOLY-NAGY.**

62

63

99. Illustrations from *Malerei, Photographie, Film* (Munich, 1925): shell and photogram.

the bauhaus books

light-dark [contrasts])."[33] He further demonstrated the formal properties of photographs by placing his own photograms opposite X-ray photographs of shells, both images containing white forms floating in a black void (fig. 99). In later editions he added the explanatory caption "Contrasting relationships between black and white with the finest transitions of gray."[34] He placed one of these photograms opposite his painting K_x, in which a circle and several overlapping bars float in an infinite white space (fig. 100). In equating the three types of image—photograph, photogram, and painting—he seemed to be suggesting that the relationship of light and dark forms floating in an infinite space is more important than the object pictured.

Unfortunately for our understanding of his work, this kind of aesthetic focus in his selection of photographs has long determined the way in which his own photographs have been received. One wonders why he would have defined these photographs, which he found so visually and intellectually stimulating, in such a narrow formalist manner. Was it to make them relevant to the kind of discussion of design issues that might be part of his *Vorkurs?* Or was he not used to discussing these works in more subjective terms, or not willing to do so? If Moholy was trying to develop a public image of himself as constructivist pedagogue, a more personal interpretation would not have been appropriate. We find out the most about Moholy between his layers of logic, in what he does *not* say, and through his own photographs.

Some of Moholy's original boldness and innovation was modified in the second edition published in 1927. He drew attention away from his

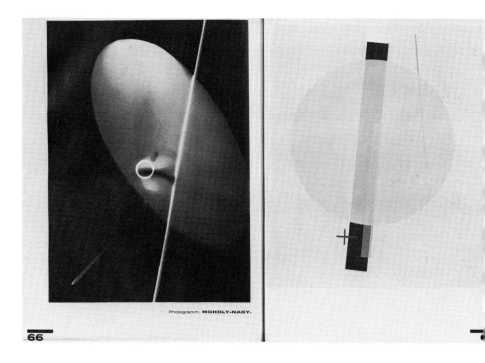

100. Illustrations from *Malerei, Photographie, Film* (Munich, 1925): photogram and Moholy's painting K_x.

argument for the great promise and artistic applicability of photography by expanding his discussion of the purpose of nonobjective painting. Apparently he also thought twice about allowing the photographs to speak for themselves, adding more captions, but captions that still stressed the formalist concerns informing his selection. These changes in the second edition indicate his struggle between his interests in abstract painting and in photography. His fresh enthusiasm for photography of 1924 had subsided into something more pedagogical, the additional captions justifying photography's potential use in teaching visual awareness.

The theoretical shift of Moholy's emphasis in artistic discourse "from pigment to light," coupled with the visually exciting diversity of its illustrations, made *Malerei, Photographie, Film* an important milestone in his career. The visual impact of the book's typography, layout, and illustrations helped define the new look of Bauhaus publications. In the world of photography, the influence of the book was wide ranging. His method of assimilating photographs from different sources into the realm of aesthetics became a commonly accepted organizing strategy in photography books and exhibitions in Germany in the late 1920s, as will be discussed in the next chapter. The illustrations themselves, with their encyclopedic scope and variety, made *Malerei, Photographie, Film* the inspiration for a whole new genre of photography book.[35]

Von Material zu Architektur

Even though *Malerei, Photographie, Film* was surely Moholy's most important theoretical work on photography and film, it has never received the attention commanded by *Von Material zu Architektur,* the third Bauhaus Book devoted to a master's course of instruction (fig. 101).[36] Published as it was a year after Moholy and Gropius left the Bauhaus, this book has a peculiar importance since it describes the Bauhaus program as it was (or was meant to be) at the height of Gropius's regime. If any of Gropius's Bauhaus ideal survived under Hannes Meyer, little of it was left after Meyer was ousted in 1930. Moholy's pedagogical method once again belies the degree to which his own education was founded on mass culture—in the era of the machine and Einstein's theory of relativity—rather than historical tradition. But the unique character of *Von Material zu Architektur* depends on more than the novel methodology of Moholy's preliminary course at the Bauhaus. The real innovations can be found in Moholy's proposals for the use of light (photography, film, and "light displays") as an essential medium in design education. This interest in light, as we have seen, can also be found in his experimental photograms and photographs, as well as his paintings at the time. And the copious illustrations are often inventive, unorthodox, brilliant, and witty to a degree that surpasses even those of *Malerei, Photographie, Film.*

Originally to be entitled *Von Kunst zu Leben* (From Art to Life), the book's final title reflects a more pragmatic attitude that emphasizes architectural education. Following an initial chapter on "Pedagogical

Questions," the three sections of *Von Material zu Architektur* treat "Material (Surface Treatment, Painting)," "Volume (Sculpture)," and "Space (Architecture)." With this format Moholy expands and reinterprets the methodologies of two other Bauhaus teachers, Kandinsky and Klee. Paul Klee's *Pädagogisches Skizzenbuch* and Kandinsky's *Punkt und Linie zu Fläche* both analyzed the evolution of a point into a line and a plane; Klee also included an analysis of volume and space. Basically limiting his discussions to abstract art of the twentieth century, Moholy made his customary reverential bow to cubism before moving on to such movements as suprematism, constructivism, and neoplasticism. The artists Picasso, Rodchenko, Le Corbusier, and Mart Stam figure prominently in the text. The only major reference to nineteenth-century work is to the Eiffel Tower, that landmark and symbol of industrial engineering. What primarily interests us here is how Moholy concluded each section with an analysis of the ways light could be used as a medium by exploiting the reflective properties of materials, light projections, and photography.

The introductory section of *Von Material zu Architektur* presents the basic premises not only of the book but, in its attempt to integrate technology into pedagogy, of the entire Bauhaus of Gropius. It is this integration that distinguishes Moholy's work from that of the other Bauhaus masters, supporting the declaration of Gropius in 1923: "The Bauhaus believes the machine to be our modern medium of design and seeks to come to terms with it."[37] The first task of the machine, according to Gropius and Moholy, was to improve general living conditions through mass production. However, Moholy emphasized, this was to be motivated by a sense of social responsibility rather than economic greed: "Not the product, but man, is the end in view." A rise in the standard of living could be achieved "by a purposeful observation and a rational

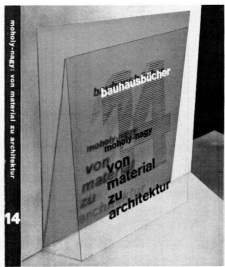

101. Book jacket for *Von Material zu Architektur* (Munich, 1929). Photograph courtesy of the Bauhaus-Archiv, Berlin

safeguarding of organic, biologically conditioned factors—through art, science, technology, education, politics."[38]

As developed by Itten (and carried on by Albers and Moholy), the *Vorkurs* stressed analyses of the properties of materials, such as strength, flexibility, and texture. To these Moholy added inquiries into the ways materials reflected and absorbed light. And while Itten emphasized natural materials, Moholy focused on industrial ones. Moholy's students even explored tactile sensations with an actual machine, one of the first illustrations of the book (fig. 102). This interest in tactile sensations is an element lingering from Itten's *Vorkurs* that Moholy gradually replaced with a more "scientific" approach. Unrestricted by traditional art education, Moholy utilized a novel selection of photographs to substantiate his points. One of the finest examples illustrates texture first by a negative photograph of a cat (his own photograph), and then by the outrageous juxtaposition of photographs of a wrinkled, 130-year-old man and a moldy, rotten apple (fig. 103).

In the section on "Volume (Sculpture)" Moholy delineated five "stages," classified according to the treatment of materials, in which to achieve volume in sculpture. The fifth stage, devoted to kinetic sculpture, ends with a discussion of the use of light to create "virtual volume," or sculptural volume without mass. Quoting extensively from their "Realistic Manifesto" of 1920, Moholy revealed his debt to the Russian sculptors Naum Gabo and Antoine Pevsner. He embraced their aims: "to deny volume as a spatial form of expression, . . . to eliminate (physical) mass as a plastic element. . . . To incorporate our experience of the world in the forms of space and time: this is the single goal of our creative art." This goal of art in general precisely sums up the achievement of his photograms. Moholy extended their theory by suggesting the use of light to render space, time, and movement in a nonstatic art: "Light—as time-spatial energy and its projection—is an outstanding aid in propelling kinetic sculpture, and in attaining virtual volume."[39] Such experiments with "virtual volume" defy traditional views of a sculpture's relationship to the space around it and the concept of volume. In theory, they are the predecessors of the hologram and virtual reality.

Moholy was at his most inventive when he described the urban environment at night, with its advertising signs, traffic and car lights, and radio tower beacons, as an inspiration for the artist to use light as a medium. He proposed various ways to manipulate light through displays in the open air and indoors, utilizing film and color organs. Some of these possibilities he had presented earlier in "Produktion-Reproduktion" and *Malerei, Photographie, Film*. He continued to develop new schemes for outdoor light displays, such as "projection onto clouds or other gaseous backgrounds through which one can walk, drive, fly, etc.," that must have originally seemed fantastic. Of course, Moholy was not the first to derive inspiration for his art from the urban environment. The avant-garde art of the 1920s was rife with references to the effects of urbanism: dynamism, simultaneity of experiences, claustrophobic space, geometric architectural form. Such ideas can be found in proposals by several

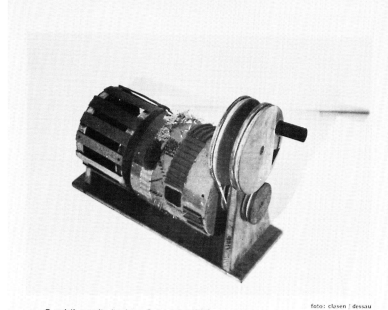

foto: clasen / dessau

abb. 5 rudolf marwitz (bauhaus, 2. semester 1926)
drehbare tasttrommel mit verschiedenen in sich zeilenweise abgestuften kontrastierenden tastwerten

die form der tasttafel wurde bei keiner aufgabe vorgeschrieben. das einzige kriterium war, daß die zur darstellung gelangenden werte deutlich, doch in knappster weise erfaßt werden. diese forderung führte bei den einzelnen zu grundverschiedenen lösungen.
unter den vielen abgelieferten arbeiten war keine einzige, die nicht eine individuelle erfindung aufwies. das war nicht etwa das ergebnis einer langen vorbereitung. die arbeiten entstanden alle nach den ersten stunden.

4 moholy-nagy

25

Russian artists for outdoor projections of propaganda films and news-reels or the indoor light experiments at the Bauhaus. These sources clearly fed Moholy's fertile imagination, resulting in projects so farsighted that they were not realized by others until decades later.[40] Just as Moholy appropriated scientific photography for aesthetic ends, he would also use urban lighting and advertising techniques to postulate new art forms created with light.

Moholy devoted the final section of the book to "Space (Architecture)." His definition of space, borrowed from physics and also fundamental to Lissitzky's theory of the *Proun,* sums up the aesthetic core of the modern movement in architecture. "Space is the relation between the positions of bodies (volumes)."[41] He explains this principle through commentary on photographs of a series of buildings. An interior of a house by the Swiss architect Le Corbusier shows how movement through space is directed by the planar organization of walls, windows, and doors. He uses Frank Lloyd Wright's Robie House of 1906 as an example of the merging of the interior of a building with the exterior space around it. As seen in a photograph by Lux Feininger, the facade of Gropius's Bauhaus *Werkstätten* (workshops) in Dessau demonstrates the manner in which glass replaced the wall mass to make the connection between interior and exterior (fig. 104).

These photographs, however, are more than illustrations of architectural concepts. They also introduce and illustrate Moholy's proposal that

abb. 22 textur. das fell einer katze. (negativ) foto: moholy-nagy

40

abb. 23 textur
ein 130 jähriger amerikaner von minnesota

im grunde ist diese fotografie eine zeitraffer-aufnahme der epidermiswandlung: eine flug-zeugaufnahme der zeit.

foto: weltspiegel

abb. 24 textur
ein fauler, mit pilzen besetzter apfel

foto: haus und garten

l. moholy-nagy

41

103. Illustration from *Von Material zu Architektur:* photographs illustrating textures.

foto: lux feininger

abb. 193 walter gropius 1926
das bauhaus in dessau

innen und außen durchdringen einander in der spiegelung der fenster. das auseinanderhalten der beiden ist nicht mehr möglich. die masse der wand, woran alles „außen" bisher zerbrach, hat sich aufgelöst und läßt die umgebung in das gebäude fließen.

221

192.

foto: krajewsky

abb. 199 o. firle 1928
fahrstuhlschacht

228

105. Illustration from *Von Material zu Architektur:* view up an elevator shaft. Photograph by Krajewsky.

the bauhaus books

photography, like architecture, can define space or challenge our understanding of it. The photograph of the Bauhaus cited above communicates little information about the actual appearance of the building. Instead, the skewed angle of vision transforms the structure of the building into an abstract, geometric composition. The base of the wall and the window grid emphasize the rotation of the composition or the tilting of its vertical axis. This device, coupled with the reflection in the glass wall of another part of the building, creates an ambiguous construction of space. Moholy used a view up the shaft of an elevator to illustrate how people can perceive space "through the sense of equilibrium produced by circles, curves, windings (spiral stairways)" (fig. 105).[42] The Eiffel Tower, which Moholy labeled as on the borderline between architecture and sculpture, he illustrated in the first edition with an aerial view and in later editions with a photograph looking up through the interior.[43] As with the image of the elevator shaft, the later Eiffel Tower photograph uses the structure of the tower and the perspective of the camera lens to simulate movement through a space by means of light.

Moholy's practice of using photographs to explain his theories served several purposes. As he offered new "technological" solutions for design problems, he was in effect defending the value of photography. In his section on space, one of his photograms demonstrated how a projection of light on a photosensitive material could create a constructivist sense of space (fig. 41). In an audacious judgment he found this photogram more effective than one of Malevich's paintings, *White on White* (1918), because the pure form, color, and emotion that the painting's image consciously tried to evoke was blemished, he said, by the subjective imprint of the artist's hand. Because of the invention of film, he explained, artists had become concerned with problems of "projection, motion, interpretation of color, and light." "Photography is doubtless a bridge," Moholy stated, for solving these problems.[44]

Von Material zu Architektur reveals important aspects of the Bauhaus program and Moholy's relationship to it at the time of his departure. As discussed earlier, the basic structure of the *Vorkurs* was not developed by Moholy alone; it owed much to the original formulation of Itten and to the more rationalist orientation of Josef Albers. In addition, inquiries into the progression from point to plane, or to volume in space, were being explored at the Bauhaus by Kandinsky and Klee. However, Moholy's proposed course of instruction replaced their deductive logic with a semblance of scientific method. He emphasized technology and industrial materials, the urban environment, and, in accord with Gropius's vision, portrayed architecture as the goal of all the arts. Within this framework he brilliantly interwove the issue central to his own artistic endeavors: the creation of forms and space (ultimately adding motion and time) by means of light. Due to Moholy's favored position with Gropius and the publication of *Malerei, Photographie, Film,* masters such as Schlemmer earlier had expressed fears that photography would become more important than painting at the school.[45]

Although many experimented at the Bauhaus with photography and light projections, the curriculum did not include courses in these subjects until after Moholy's departure, when Meyer hired Walter Peterhans to set up a photography course in 1929. There were two factors in particular that may account for this delay in establishing a photography course. First, Moholy himself was not a professional photographer; in fact, he rarely, if ever, processed his own photographs. Gropius would hardly have hired a professional photographer (like Peterhans) to teach a photography course as long as Moholy was still there. Second, Moholy had to prove that, in the context of a school of art and design (Gropius, as noted above, did not establish the architecture department until shortly before he resigned), photography had relevance to the curriculum.[46] This is essentially what Moholy set out to do in *Von Material zu Architektur.* Later, at the Institute of Design, an American version of the Bauhaus founded in Chicago in 1937, Moholy made photography one of five areas for specialization after the completion of the preliminary course. He described the fourth area for study in the 1938 and later English editions of *Von Material zu Architektur,* entitled *The New Vision,* as "Light (photography, motion picture, light display, advertising art)."[47] Therefore, not until a decade after *Von Material zu Architektur* was written was Moholy able to make his proposals for the artistic uses of light, photography, and film an established part of a curriculum.

Since these proposals were not realized while he was at the Bauhaus, nor did he teach courses in photography there, it is unclear what influence his theories had at the time on students at the school. Nevertheless, the evident exuberance, the newness, of Moholy's work must have helped to inspire the intense exploration of photography that developed at the school, resulting in Moholy's creation of a section on Bauhaus photographers in the *Film und Foto* exhibition held in Stuttgart in 1929. Recent publications on "Bauhaus photography" demonstrate that there was not really a definable style of Bauhaus photography, that Bauhaus photographers, in fact, incorporated many photographic tendencies of the twenties into their work.[48] However, the photographs by the Bauhäusler are marked by diversity, by an energetic exploration of the iconography of camera vision, and by the use of photography in typographical design, advertising, and architectural rendering. This experimentation and its pragmatic applications fulfilled many of Moholy's goals for photography and characterize his own work as well.

CHAPTER

8

THE NEW VISION,
LANGUAGE
OF MODERNISM

By the late twenties, Moholy's position of leadership in the New Photography movement in Germany was firmly established, due in no small part to his previous tenure at the Bauhaus. From that vantage point he became a spokesman for two often diverging sets of ideals: Gropius's aspirations for the school's role in designing for a more powerful, and humane, industrial Germany; and the Russian formalists' search for a visual language that would have pragmatic applications in a new Communist society. Moholy's reconciliation of these views, though often fraught with contradictions, produced what is arguably one of the most important bodies of work in the theory of photography and modernist art education to appear in the 1920s. He was able to publish his theoretical writings and reproduce a number of his photographs in his books *Malerei, Photographie, Film* and *Von Material zu Architektur,* as well as in several articles in the journal *Bauhaus,* which he edited with Gropius. Outside the Bauhaus, Moholy's photographs gained exposure in a variety of publications, and he lectured widely.[1] The apex of his influence on German photography came through his substantial role in the organization of the *Film und Foto* exhibition, held in Stuttgart in 1929. As a result of these activities, the synthesis of his writing and work that he named the New Vision became internationally renowned.

The New Vision and Russian Formalism

In 1922 Moholy laid the foundation for his concept of a New Vision in his article "Produktion-Reproduktion." There he stated that art's purpose was to enable people to live to their greatest potential through sensory stimulation. Three years later in *Malerei, Photographie, Film,* he explored the ways photography might be a prime agent for such releases of creative energy in the modern technological era. Moholy's notion of a visual language, which appeared repeatedly in his writings, was based on two assumptions, both of which parallel developments in Russia.[2] The first, that the purpose of art is to expand awareness by stimulating the senses, echoes principles of Russian formalism, an outgrowth of futurism applied initially to poetry and then to film and photography. The second was a belief in the ability of the "objective" eye of the camera to see more than the human eye, a notion expressed in Vertov's concept of "kino-eye."

I recognize that making such connections to Russian formalism has its dangers, for an exact chronology and pattern of transmission for artistic developments is difficult to establish. This is due in part to the fact that in the early 1920s, when Berlin became an extremely active cultural center, artists from many countries mingled freely and exchanged ideas. Within this milieu, Moholy and his Hungarian compatriots were in constant contact with their Russian counterparts. Thus, even if he did not actually meet the Russian formalists or read their writings, he would have learned of their work through his circle of colleagues. However, it is very probable that he met several of the Russian formalists, since he was a part of the same intellectual circle in Berlin. I feel that the similarities between Moholy's thinking and Russian formalism is so strong

that discussion of the latter gives a fuller picture of Moholy's theoretical development.

The language of seeing that comprises Moholy's New Vision offers a number of striking parallels to the structuralist approach of the Russian literary critic Viktor Shklovsky, who directed his formalist practice toward an attack on human complacency, our blind acceptance of the world around us. In his essay on Tolstoy, "Art as Technique," from 1917 Shklovsky urged that art should provoke and challenge the viewer, for only in its very difficulty could art promote growth and reverse an individual's propensity to repetitious actions and thus stagnation.[3] Shklovsky's method involved a process he called *ostranenie,* defamiliarization or "making strange," in which the viewer is forced to see a known object, institution, or what have you, in a new way, from a new perspective. Shklovsky's strategy for "making strange" depended upon reducing an art form to its unique characteristics and then re-viewing the world in a way that emphasizes the essential forms of the discipline. Through the provocations of artistic form and the resulting growth of individual awareness, people would first be liberated and then mobilized by a heightening of their collective consciousness. Thus, defamiliarization became associated with revolutionary struggle.

It is important to keep in mind that because Shklovsky's approach ultimately favored the process of making art over defining the object, its effectiveness for ideological communication is questionable. Therefore, in the visual arts at least, formalist techniques had to be modified and adapted to create the kind of eye-catching graphic designs that became the trademark of agit-prop art. After the Russian Revolution, it became clear that visual rather than written forms of communication would be more effective in educating a proletariat that was largely illiterate. Since painting was viewed as a bourgeois institution inappropriate for the new proletarian culture, alternative means of communication were needed. From the first Lenin provided the answer: "History is written very well through the lens. It is clearer and understandable. No painter is able to depict on canvas what the camera sees."[4] He directed his Commissar for Education, Anatoly Lunacharsky, to focus attention on film and photography.

In 1918, Dziga Vertov applied his experiences with futurist sound recordings and word montage experiments to the editing of government newsreels. The following year Vertov declared the death of archaic "fictive" film and the birth of a new kind of cinema. 'In his essay "WE: Variant of a Manifesto" published in 1922, Vertov rejected the idea of the synthesis of the arts, the turn-of-the-century *Gesamtkunstwerk,* and instead advocated (as did Moholy in *Malerei, Photographie, Film*) the integration of art and life, the *Gesamtwerk*.[5] A medium (in Vertov's case film) should be "cleansed" of "foreign matter"—that is, extraneous tendencies gleaned from music, literature, theater. In keeping with principles of formalism and the constructivists' emphasis on *faktura,* cinema should discover its own laws and rhythms, exploit its own materials. Vertov distilled film's essential characteristics to two elements, the rep-

resentation of the rhythms and movements of life and the kind of new "seeing" offered by the camera lens. The first of these refers not just to the moving film but to the pacing of connections between objects and events made by the editor—Vertov, it must be remembered, was an editor, not a cameraman—as well as to the movements of the subject. Vertov further proclaimed that film should focus on the beauty of machines, "propelled and driving," in order to inspire the worker to become dedicated to the assembly line.[6]

As part of this constructivist technomania, wherein the perfect machine rises above the foibles of mortals, Vertov found the camera lens superior to the human eye in its ability to see objects differently and to range more widely. His "kino-eye" could analyze "the chaos of visual phenomena," could see the world from new unknown perspectives: "Kino-eye has the possibility of making the invisible visible, the unclear clear, the hidden manifest, the disguised overt, the acted nonacted; making falsehood into truth."[7] Through his most famous film *Man with a Movie Camera* of 1929, Vertov canonized his lexicon of the various techniques and deeper vision of the camera. Based on Vertov's concept of kino-eye, the term "photo-eye" became widely used in the late 1920s to refer to the specific qualities of camera vision.

In the film media, the emphasis on technique and process and the cult of defamiliarization and newness first developed in the Soviet cinema. For Soviet photography the situation was different. From the time of the Revolution both Lenin and Lunacharsky called for the use of photography as well as cinema for the education of the masses, and as a result a core of peasant and worker photo reporters came into being. However, experimental photography did not begin to flourish until the establishment of the New Economic Policy (NEP), a kind of capitalist liberalization of the economy meant to stimulate economic growth in 1921. The Soviet illustrated press, a forum that served as a catalyst for the new photography, did not appear until several years later, and in 1923 the State Academy reopened its department of photography. But the real changes in Soviet photography came after 1928 when the Bureau of Agitation and Propaganda realized that there was a pressing need for photojournalists that could only be filled through the training of more photographers. It will come as no surprise to those who know the fate of modernism under Stalin that the few photographers who were experimenting with formalism in photography were passed over in favor of the new "factographers," photographers supplying raw information on Communist society to the people.

We have seen how Moholy expressed his ideas on the superiority of the camera lens to the eye in *Malerei, Photography, Film*. By the early 1930s he could articulate more precisely his concept. In his essay "A New Instrument of Vision," said to have been written in 1932, he stated:

In photography we possess an extraordinary instrument for reproduction. But photography is much more than that. Today it is in a fair way to bringing (optically) something entirely new into the world. The

specific elements of photography can be isolated from their attendant complications, not only theoretically, but tangibly, and in their manifest reality. . . . Photography, then, imparts a heightened, or (in so far as our eyes are concerned) increased, power of sight in terms of time and space. A plain, matter-of-fact enumeration of the specific photographic elements—purely technical, not artistic, elements—will be enough to enable us to divine the power latent in them, and prognosticate to what they lead.[8]

He went on to offer yet another list of eight types of photographic vision: abstract seeing, exact seeing, rapid seeing, slow seeing, intensified seeing, penetrative seeing (radiography), simultaneous seeing, and distorted seeing.[9] What he had explored almost intuitively in his frenetic proposals and selection of photographs in *Malerei, Photographie, Film* now coalesced into a more focused and systematic theory. What is pertinent to this comparison with Russian theoretical developments is his methodology, which developed over a decade from the limiting definition of photography's characteristics in his article "Produktion-Reproduktion" to his indices of types of camera vision.

The origins of Moholy's positions in Russian formalism and Vertov's film theory are easily discernible. In keeping with Shklovsky's formulation, Moholy stressed that the camera forces the spectator to see in unusual ways, and hence a "new vision" of the world can be created. This is possible through a variety of techniques that he indexed in his writings, including radical cropping, exaggeration of light-dark contrasts, enlargement, and the presentation of unorthodox viewing angles. To disorient the viewer accustomed to a picture space based on Renaissance perspective, he recommended aerial and "worm's-eye" views, rotation of the camera to the diagonal, and elimination of the horizon line. The formalist emphasis on technique and process to "lay bare the artfulness of the object," to show its essence, became the core of Moholy's position. Thus a photograph by Moholy of a building would point both to the artfulness of the camera's technique and to the architectural practice by which the building came into being.

Rodchenko and Moholy

When Osip Brik, a leading spokesman for formalism, expressed the need for a theory of the art of photography in 1926, he singled out Rodchenko's experiments as the most progressive.[10] Because of the obvious parallels in Rodchenko's and Moholy's careers, it is worthwhile to take a closer look at the work of Russia's most prominent formalist (in the Shklovskian sense of the term) photographer. Although they never met, they corresponded, they discussed each other's work in print, and, it should be noted, there were inscribed copies of Moholy's *Malerei, Photographie, Film* in Rodchenko's personal library.[11] After the Revolution, Rodchenko had concentrated his efforts on the materials of painting, executing his textured *Black on Black* paintings of 1918. But by the time of the radical *5 × 5 = 25* exhibition of 1921, where he exhibited

his triptych of three monochrome canvases of yellow, red, and blue, Rodchenko had committed himself to production art, focusing on its practical applications for graphic design. This led him to two important series of collaborations that began in 1922: with Vertov making tests and captions for his Kinopravda newsreels and with Vladimir Mayakovsky matching graphics and photomontages to the poet's slogans. Familiar with the photomontages of the Russian productivist Gustav Klutsis and the German dadaists (Mayakovsky brought photomontages by Hausmann, Heartfield, and Höch back to Moscow after his 1921 trip to Berlin), Rodchenko first depended upon photographs taken by others in his own applications of the technique. As he later explained, the demands of the montaging process, which required photographs varying in size, lighting, and viewpoint, made him soon realize the expediency of taking the necessary photographs himself, and he started to do so in 1923.

Once Rodchenko took up the camera, he began to experiment with principles basic to film theory. The very first issue of *Kinofot,* a periodical edited by Alexei Gan on constructivist cinema that began publication in 1922, contained Vertov's article "WE" and had a drawing by Rodchenko on the cover. Rodchenko's drawing can be interpreted as schematically illustrating Vertov's interest in applying basic constructivist principles of spatial movement to film. Officially on the staff of the periodical, Rodchenko on several occasions used photomontage for the cover; this practice asserted the connections between montage and editing in film and photomontage.[12] These techniques created conglomerations of images that were meant to represent the multiplicity of stimuli in modern urban life. Likewise, Rodchenko's continued experiments with the photographic series gave photography the cinema's capacity to show more than one image, hence to construct a composite view. In his article "Against the Synthetic Portrait, for the Snapshot" of 1928, Rodchenko discussed the importance of using photography to "crystallize man not by a single 'synthetic' portrait, but by a whole lot of snapshots taken at different times and in different conditions."[13] His photojournalism of the late 1920s and 1930s also utilized groupings of photographs in his magazine layouts. The constantly changing focus of the different images provided the kind of analytical seeing essential to Vertov's goals for film. Basic to both Rodchenko's and Vertov's theory was the belief in the objective credibility of the camera and its ability to expose various truths about the new state to the masses.

An important example of Rodchenko's "objective propaganda" was his Myasnicka Street apartment house photographs from 1924, a series of analytical views in which his employment of *ostranenie* (defamiliarization) produces a powerful visual impact (fig. 54). The building is an example of the latest modern construction of the 1920s (which in the Soviet Union was often built of brick rather than concrete). Rodchenko's camera utilizes photographic elements of cropping, high contrast, and dizzying angles of view. The placement of the "estranged" building fragments against a neutral sky and the strong contrasts of light and dark abstracts the forms and emphasizes the formal composition.

A precise chronology of Rodchenko's work is crucial for establishing the originality and independence of Moholy's own contribution to the development of a theory of photography. It is clear that Moholy's work of 1921–1922, including his use of industrial materials and the medium of the linocut, reveals an indebtedness to Rodchenko's work of several years before. Moholy would have seen this work in photographs circulating in Berlin as well as in the *Erste russische Kunstausstellung.* Gropius too undoubtedly saw Rodchenko's work at that time, and it is probably no coincidence that he hired Moholy, a prominent constructivist in Berlin at the time (albeit in the "Western" vein), to serve in a position similar to the one Rodchenko held teaching the basic course and heading the metal workshop from 1920 to 1931 at VKhUTEMAS (The Higher State Artistic and Technical Workshops), the Russian counterpart of the Bauhaus. Moholy and Rodchenko began working with photomontage and the camera simultaneously, but for the first few years (1922–1925) their works in these media were not published with the exception of Rodchenko's photomontages for Majakovsky's *Pro Eto (About This)* in 1922. Moholy, unlike Rodchenko, published a number of articles and a major book (*Malerei, Photographie, Film*) on photography between 1922 and 1925. Save for one article concerning the use of photomontage for illustration purposes in 1926, Rodchenko did not publish theoretical essays on photography until his association with *Novyi Lef* in 1927–1928.[14]

While we know from their publications and correspondence that Rodchenko and Moholy were familiar with each other's work, Moholy's knowledge of Shklovsky's ideas is equally likely. (The connections between Rodchenko and Shklovsky are not difficult to establish: they were friends who moved in the same circle with Brik, Mayakovsky, and Vertov, and they were both on the board of *Novyi Lef.*) Moholy must have gained access to Shklovsky's ideas, and possibly even to Shklovsky himself, through visits by members of the formalist group—Brik, Mayakovsky, and Shklovsky—to Berlin in 1921–1923. These visits would not have passed unnoticed by Moholy because of his close associations with a number of Russian artists (Puni and Lissitzky, for example) then living in Berlin. At this time, as seen in his 1922 "Produktion-Reproduktion," Shklovsky's emphasis on form and technique and on the expanding of perception as a goal of art became integral parts of Moholy's developing theory of the New Vision. In addition, the formalist critic's codification of a medium's formal attributes became an organizing strategy in Moholy's discussions and presentations of photography.

Thus, while Shklovsky reduced poetry or prose to basic linguistic units and the film maker Vertov formulated a vocabulary of film techniques, Moholy developed a lexicon for photographic vision. I think it is important to stress here that formalist theory was applied to film by Vertov before others did the same for photography in the Soviet Union. Moholy took the latter on as his special mission in 1922. It seems evident that *before* such theoretical work was written and published by Rodchenko and his Russian colleagues, Moholy began to develop and publish a new theory

of photography on the formalist/constructivist model. And to his credit, he was able to make Russian formalism pertinent to the curriculum at the Bauhaus and, on a larger scale, to the experimental art of the avant-garde in the West.

The *Film und Foto* Exhibition

In the second half of the 1920s, when the industrialization of Weimar Germany and the commercial photo industry were booming, a series of large, popular photography and film exhibitions were held around Germany. Moholy exhibited his photographs in several of them. He also played a major role in the planning and selection of photographers for the most important of these, the *Film und Foto* exhibition (referred to as *Fifo*) organized by the Deutscher Werkbund in 1929.[15] Moholy's precise role in the selection and organization of the almost one thousand photographs in *Fifo* is unclear, but his influence seems to have been substantial. The exhibition was initiated by Gustav Stotz, the managing director of the Württemberg section of the Deutscher Werkbund, and had a selection committee that consisted of the prominent art historian Hans Hildebrandt, the architect Bernhard Pankok, and the graphic designer Jan Tschichold. In the Stuttgart catalogue, Moholy appeared as Germany's representative in the list of collaborators, along with the photographers Edward Steichen and Edward Weston for the United States, Piet Zwart for Holland, El Lissitzky for Russia, the architectural historian Sigfried Giedion for Switzerland, and Hans Richter for the film program.[16]

Undoubtedly it was Moholy's ties through Gropius to the Werkbund that provided him with the opportunity to select the German works and design the title page of the prospectus for the exhibition (fig. 106). In what can only be called an act of unabashed self-promotion, Moholy devoted an entire gallery to his own work (97 photograms, photographs, and photomontages). Herbert Bayer had 26 photographs and an undesignated number of photomontages in the exhibition, and Hans Finsler was represented by 37 photographs, but most of the over one hundred photographers who participated in the exhibition were represented by under ten works each. Through this traveling exhibition, Moholy's photographic work and theories received important exposure, and several books containing his work were published as a result.

While *Kunstphotographie* was self-consciously subjective and antitechnological, Germany's new photography in the *Fifo* exhibition stressed objective exploration of the medium's technical means. Although we know precisely the film program of the exhibition, the catalogue containing the list of photographers gives only a rough idea of which works were included. There are, however, a few published photographs of the installation, such as those selected by Werner Gräff for the book entitled *Es kommt der neue Fotograf!* With the encouragement of Stotz, Gräff edited this book of photographs (the exhibition catalogue was not illustrated) to accompany the exhibition when it traveled.[17] Two other important books of 1929 document the photographs in the exhibition: Franz Roh

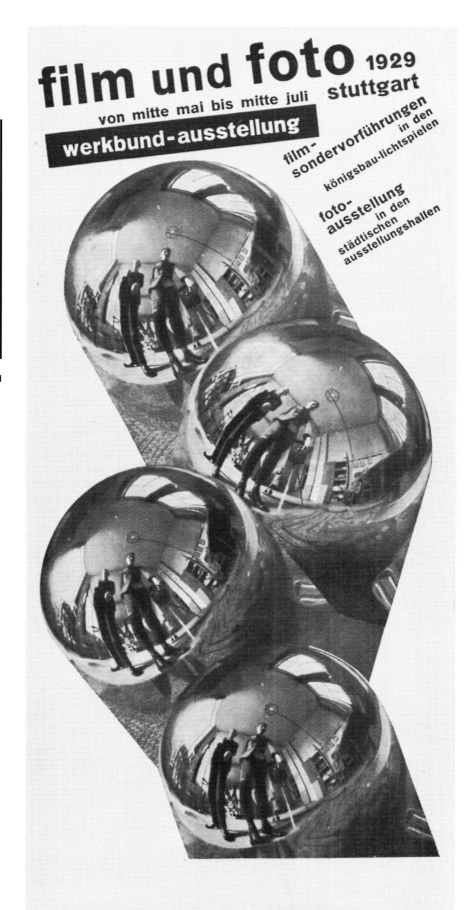

and Jan Tschichold's *Foto-Auge/Oeil et photo/Photo-Eye* and Roh's *László Moholy-Nagy: 60 Fotos.*

The first exhibition room, by far the largest and one through which every visitor had to pass, contained a group of photographs that, according to the catalogue, were collected and installed by "Professor" Moholy-Nagy of Berlin (he had left the Bauhaus in 1928). The selection seems to have been made from the photo history collection of Erich Stenger, a professor of photo chemistry in Berlin, and from newspapers, scientific and popular journals, as well as the work of other photographers. Stenger's collection formed the historical section in several other large photography exhibitions—in Berlin in 1925, in Frankfurt in 1926, and the 1928 *Pressa* exhibition. Thus, the Stenger collection seems to have become an accepted, if not preordained, introduction for every large photography exhibition. This requirement, however, did not restrict Moholy. He used Room 1 to combine a historical survey of photographic techniques taken from Stenger's collection with a second section of photographs illustrating the typology of his New Vision. From correspondence between Moholy and Stenger, it is evident that this second section included many photographs from Moholy's personal collection gathered primarily for *Malerei, Photographie, Film* five years earlier.[18]

Moholy outlined his intentions for Room 1 thus:

The emphasis is on presenting photographic elements. Controlling these elements can lead to a synthetic photographic achievement. These elements are essentially: the possibility of creating unadulterated documents, stationary and kinetically moving forms in variable light intensities; plus new vision, enlargements, microscopic images, X-rays, mechanical distortions of reality, direct light manipulations (photograms), and simultaneous projections of which photomontages are a preliminary stage.[19]

The photographs Moholy described here represent the diversity of means available for visual exploration—such as odd viewpoints, enlargements, montage, and light manipulations—rather than a conventional historical survey. In a photograph of the installation of Room 1 (fig. 107), we can see a group of portraits on the left, works by Moholy including his photomontages *Das Mädchenpensionat* (fig. 86), *Die Pneumatik,* and *Huhn bleibt Huhn* (fig. 88) to the left of the door, and on the right scientific X-ray photographs of the human body.

This emphasis on technique informed Roh's essay entitled "Mechanism and Expression" that served as the introduction to *Foto-Auge.* The book's title alluded to Moholy's New (camera) Vision, as well as the kino-eye of Vertov, while the photographs were selected almost exclusively from the works of German photographers whom Moholy chose for the *Film und Foto* exhibition. In his essay Roh codified the diverse forms of "expression" possible through technical processes, and in doing so followed Moholy's methodology for the installation of the first gallery of the exhibition and probably the other galleries as well. This same orientation can be found in Roh's introductory essay to *Moholy-Nagy:*

60 Fotos, where his praise for Moholy's versatility in photography was based on the variety of techniques the Hungarian used.

In *Fifo,* as in his other endeavors, Moholy juxtaposed photographs by amateurs and professionals, anonymous and known, without making a distinction between "art" and nonart. A precedent for this can be found in *Malerei, Photographie, Film,* where he rarely used captions and the few he did use stressed visual elements rather than subject matter or original context. By removing photos from their intended contexts and stripping them of their original purposes, Moholy illustrated his concept of the New Vision as a visual language.

Moholy's inclusiveness may seem at first refreshingly nonelitist, and the photographs' heterogeneity must have provided for an exciting visual experience. His organization of photographs according to formal devices, however, raises another issue. Was this a Duchampian move, in which Moholy made all the photographs "art" by placing them in the exhibition setting? His publication of his own photographs suggests that it was. He did not reproduce them in periodicals for the masses, but in art, architecture, and photography journals. And the fact that he analyzed his works in terms of form and technique rather than subject matter further defines them as artistic endeavors. But in another, very important way, Moholy diverges from the Duchamp's practice. Rather than parodying the traditional definition of art, he can be seen as actually expanding art's definition to include a boundless array of visual possibilities, motivated by his formalist (here again I am referring to formalism on the Russian model) search for a basic language of seeing.

107. View of Room 1, *Film und Foto* exhibition, Stuttgart, 1929. From Württembergischer Kunstverein, *Film und Foto der zwanziger Jahre* (Stuttgart, 1979), p. 191.

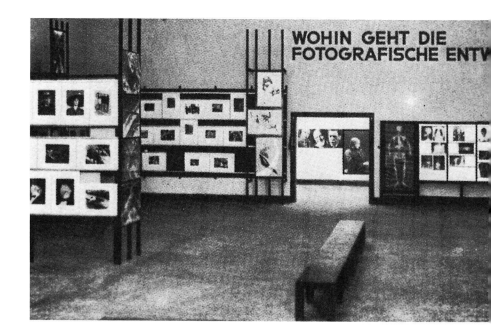

With either interpretation, as in the case of Shklovsky's formalism, we are still left with a difficult dilemma. A work of art resists being read solely in terms of formal elements and techniques, since the objects or forms themselves have associative or signifying values. Even Moholy's photograms and his most radical formalist photographs provide ample evidence for this assertion. Today the definition of modernism has gone beyond a stress on purely formal elements to incorporate the ways in which new techniques, media, and subject matter reflect modern life. As we have seen, Moholy's selection of photographs for exhibitions, and his own photographs through their visual form and metaphorical allusion, represent a complex reaction to the experience of modernity conditioned by his background and artistic milieu.

CHAPTER **9** EXILE

In many ways the colossal *Film and Foto* exhibition of 1929 can be seen as a turning point for the New Photography and for Moholy's concept of the New Vision as well. Shklovsky's proposition "Art is a way of experiencing the artfulness of an object; the object is not important" now seems an appropriate description of the new photography seen at *Fifo*.[1] This characterization and the very size and popularity of the exhibition together indicate that the period of radical experimentation was coming to a close; formalist photography had become stylish and mainstream. Moholy's more holistic concept of the New Vision as a language of seeing by which to analyze the modern condition degenerated, as Benjamin said, into "fetishism of the creative."[2] In turn, the radical manipulations of the image—odd angles of view, sharp tonal contrasts, radical cropping, and the like—came to serve the ends of capitalism through their exploitation in advertising.

Although many of these techniques had appeared in advertising previously, in the late 1920s the intense competition in selling new mass-produced products called for the use of novel devices by professional photographers to capture the attention of the mass audience. The more radical and eye-catching the photograph, the more attention could be attracted to the product. Moholy himself was part of this phenomenon, since he opened a commercial studio and took on a number of advertising commissions in order to support himself after he left the Bauhaus in 1928. His commercial photography is also inextricably connected to mass culture in Weimar. The list of his clients—including a department store, a chic fashion magazine, a book publisher, and an airline—indicates his involvement with the latest in contemporary life.[3] Because of their popularity and applicability, Moholy's ideas on photography's potential uses and his own implementation of them helped to establish the new cutting edge for graphic designers. In the profusion of images in the mass media at the time and since, it has become increasingly difficult to identify the individual struggles of Moholy and others of the avant-garde to redefine radically the nature of image making in the 1920s.

In the Soviet Union, the new photography—I use the term here in its most generic sense—also found broader application outside of the artistic sphere as a means of communication. However, the conditions in the USSR were very different from those in Germany. For the Russians, the aim of photography was not "to charm or persuade," Benjamin said, "but to experiment and instruct."[4] That is, Russian photography was not used to trick people into buying commodities; instead it would be used to teach, to disseminate the philosophy of the new Communist society. In both countries the new photography was put to the service of the social order, for one Communism and the other capitalism. We must remember, though, that Benjamin's analysis of Soviet photography in 1933 was based on the new photojournalism that developed after 1928 rather than on Rodchenko's radical formalism.

Rodchenko's approach to photography came under intense criticism in the late 1920s. In a series of articles published in *Novyi Lef* and *Sovetskoe foto,* he was accused of being a formalist aesthete rather than a

political photographer committed to furthering the goals of the Soviet revolution. And to make matters worse, it was said, his irrelevant approach to photography merely copied the formalist ways of that bourgeois artist in the West, Moholy-Nagy.[5] Such criticism disturbed Rodchenko, and after avidly defending his formalist procedures, he eventually retreated from the debate and for a time even left Moscow. One result of this departure was his great photo essay "The White Sea Canal," published in the periodical *USSR in Construction* in 1933. In truth, he was devoted to "factography," but his genius could not be trammeled by set pictorial formulae for photoreportage. Having chosen photography as his profession and the publication of the Soviet Union's progress as his cause, Rodchenko devoted much of the rest of his life to photojournalism.

Bauhaus and productivist ideals had both stressed the exploration of various media and techniques, but neither Moholy nor Rodchenko was able to continue working in an environment in which experimentation and discovery were the primary goals of art. From the time Moholy left the Bauhaus in 1928 until his departure from Germany in 1933, he relegated photography primarily to his commercial work while continuing to explore light as an artistic material in his painting and sculpture. He moved into a new apartment house established for singles near the *Funkturm* (he and Lucia had separated), set up a commercial studio on Friedrichstrasse in the Charlottenburg section of Berlin, and hired an assistant, his compatriot György Kepes. Moholy's commercial endeavors were focused primarily on his use of photomontage for advertising design. He also continued various art projects, exhibited and sold his photographs, wrote articles for German, Hungarian, and Dutch periodicals, and worked on stage designs for Erwin Piscator's opera. His stay in Berlin was shortened by the Nazis' increasing control of the arts, and like many artists he left Germany, emigrating to Amsterdam in 1933 and then London in 1934. The first move was undoubtedly facilitated by his close connection to the artists of the De Stijl group and those associated with the avant-garde journal *i 10,* for which he became the photography editor. There he worked for the periodical *International Textiles.* In London he continued in commercial design and landed several photography projects, such as his illustrations for the books *The Street Markets of London* and *Eton Portrait.* The photographs in these books, however, seem illustrative and conventional in comparison to his work from the 1920s.

It was not until he assumed the position as the director of the New Bauhaus in Chicago in 1937 (upon the recommendation of Gropius) that he was able to concentrate once again on photography as a means for expanding visual education. Photography held a prominent place in his curriculum, and he continued to work on his own experimental photography. During the decade before his untimely death from leukemia in 1946, Moholy was repeatedly in demand in Europe and the United States to give lectures and write articles on photography and film. He chose photographs dating mainly from his German period for exhibition

and reproduction. He also remained true to his earlier ideas about the potential and importance of his New Vision, the need for everyone everywhere to be visually literate. He was able to balance his teaching, artistic experiments, and commercial work, thus addressing the integration of art and life he sought.

There is little doubt that expediency had a large role in Moholy's moving back and forth between commercial and experimental photography. This was not contrary to his program, however, for his visual explorations were meant to provide a basis for better visual communication in the real world. And having chosen to live in various capitalist societies, he called on photography's usefulness for commercial advertising. The very flexibility of photography (and of Moholy too) enabled him to make the most of his continuous experience of exile, and he could therefore support himself and his family (by the mid-1930s he was married to Sibyl Pietzsch and had two daughters) after he was forced to leave Germany. His experience in Germany was that of a displaced Hungarian artist, but his great hunger for art and life enabled him to embrace new experiences outside his homeland enthusiastically.

Moholy's great gifts as a teacher enabled him not merely to support himself, but to continue developing his theory and work within a context of greater intellectual freedom. While the fates of many artists in Hungary, Germany, and Russia were determined by their governments' programs, Moholy and other members of the Bauhaus, because they were teachers, were able to make their homes and reestablish their careers in other countries. The Bauhaus masters were more fortunate than many other professionals, who often found it difficult to make a new start in another country. In the United States, foreign doctors, lawyers, and architects, for example, had to hurdle great obstacles, often in the middle or late in their careers, to undertake the further education in American schools and to complete the internships required to obtain legal certification. The success and subsequent influence of a number of Bauhaus faculty is tied to their affiliation with various reputable institutions, such as Harvard's Graduate School of Design for Gropius, the New Bauhaus for Moholy, and Black Mountain and Yale for Albers. Gropius was able to use Harvard as the base for his program and to form The Architects Collaborative with established American architects. Sadly, many less fortunate but very talented and similarly displaced architects and artists spent the final decades of their lives during and after the Nazi era unable to regain a footing in the art world.

Over the past half-century Moholy's work in photography has been shrouded in controversy, and Moholy himself was partially responsible for the view that his photography was limited by an emphasis on technique and form. On the surface, this often seemed to be the orientation of his writings. In his camera photographs especially, Moholy's powerful and striking compositions, his inventive juxtapositions of forms, textures, and tones, make it hard not to see his works as narrowly formalist objects. Yet they demonstrate that he was able to transcend his own polemic, as original and insightful as it often was. Examination of his

subject matter points to his intense involvement with problems of modernization in every aspect of Weimar culture, whether social, economic, political, or technological. His photograms allude to theories of the space-time continuum, while the built environment dominates his camera photographs. His photomontages juxtapose images to scrutinize the clashes of social forces in the uncertain postwar world.

Perhaps Moholy's most profound insights deal with the impact photography would have on popular culture, but here too there are contradictions between his theory and his practice. As we have seen, for example, his views on the mass media's potential for raising consciousness on a broad scale often bear little relation to his own work. Nevertheless, Moholy recognized the cultural importance of illustrations in periodical literature and lobbied to improve their quality. "Modern illustrated magazines are still lagging behind, considering their enormous potential!" he exclaimed. "And to think what they could and must achieve in the field of education and culture."[6] Yet, no matter how powerfully he presented it in print, he himself did not actively pursue the practical implications of his conviction that photography could transform popular culture into an enlightened mass culture. Moholy may have hoped his own works would be available to everyone, but in fact they were not published in the sort of periodical literature that would be seen by the masses. Ultimately the photography he advocated was reserved for visual arts education, not for a more widespread expansion of social consciousness.

Curiously, one of the many irreconcilable inconsistencies in Moholy's work involves his own identity as an artist. From the time he left Berlin he seems to have preferred painting over photography. Even though his writings on painting were few, we can sense an underlying desire on his part to be seen first and foremost as a serious painter. In the 1920s his advocacy of photography and film had stemmed from his interest in experimenting with new "technological" media. In *Malerei, Photographie, Film* he declared easel painting dead (as the Russian constructivists had before him); and he reaffirmed Gropius's position that architecture was the end goal of all the arts. In his article "Ismus oder Kunst" of 1926, written no doubt in response to Arp and Lissitzky's recent book *Kunstismen,* Moholy said that "the common aim of all the Isms, from naturalism to constructivism, is the constant, subconscious struggle to conquer the primary, autonomous, purely *painterly* means of creation [my emphasis]."[7] By the time of the 1927 edition of *Malerei, Fotografie, Film* he seemed to be recanting his earlier prophecies on the death of easel painting and the rise of photography as the medium of the future.

In a lengthy letter published in *Telehor* in 1936, Moholy attempted to justify his move away from photography and film back to painting: "Since it is impossible at the present to realize our dreams of the fullest development of optical technique (light architecture), we are forced to retain the medium of easel painting for the time being."[8] Moholy blamed this situation on the lack of financial support from industry and private patrons. But the evidence is unequivocal: even his descriptions of photography and film as "painting with light" demonstrate his inability to

reconcile his theory, in which the film media dominate, with his desire to be known as a painter. Perhaps most illuminating is the self-deprecating assessment Moholy offered to Beaumont Newhall in 1946, the year of his death:

If I could print like Strand and make negatives like Weston, I'd be a good photographer. But I am a painter. I am not a good technician. I began with the idea that my photographs could be printed by any corner drugstore, and still have something to say and be good. I wanted to open up the field, to show the possibilities.[9]

Despite the seeming discrepancies between his theory and work and the number of movements to which various works seem to belong, Moholy's oeuvre occupies a well-defined space within the Berlin avant-garde of the 1920s. Elements from Hungarian Activism, dada, constructivism, surrealism, Russian formalism all played a role in shaping his aesthetic. Yet his career points out the dangers in trying to categorize the continuously evolving work of an artist or a period. In addition, it is necessary to understand the model of formalist or modernist photography in order to read the history of Moholy's reception critically. Rather than relating Moholy's work to this programmatic aesthetic modernism, we need to expand the definition of modernism, as have the critics David Bathrick and Andreas Huyssen, to encompass "the experience of modernity," the impact of modernization on all areas of life. Supporting their call "to challenge the confining Anglo-American canonization of high modernism to which most of German and Austrian modernism simply does not fit," this study has attempted to contextualize Moholy, to make him a part of a dynamic moment in history rather than to set him apart and canonize him.[10] In this context we can see his career not as groping and unfocused, but as representing the mood of questioning and experimentation, the very plurality, of the modern experience.

Like many other avant-garde artists in Weimar Germany, Moholy struggled to create an art that addressed the issues of industrialization and urbanization in a positive and constructive way. His search involved experimentation with a variety of industrial materials and procedures and his formulation of proposals for realizing a new visual culture. This new culture was not to be nationalistic; he hoped to develop a new kind of visual language that could be understood by all people everywhere. Moholy shared this dream of *Gemeinschaft,* an international cooperative community, with many members of the European and Russian avant-garde, but his ideals were most closely tied to those of other Hungarian exiles, whether Communist, liberal, or avant-garde. One can easily understand how these Hungarians, whose families had withstood the continual changes in boundaries and rule in the Austro-Hungarian Empire, would want to transcend politics to create a new world order.

Thus, Moholy's New Vision should not be seen merely as the basis for stylish photographs and provocative advertising, or as the spearhead for an elitist view of the aesthetic photograph promoted especially in the United States for decades after the age of Stieglitz. Instead, it is impor-

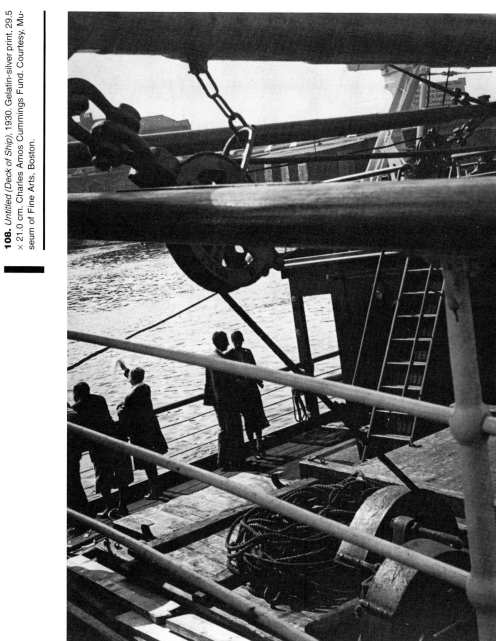

108. *Untitled (Deck of Ship)*, 1930. Gelatin-silver print, 29.5 × 21.0 cm. Charles Amos Cummings Fund. Courtesy, Museum of Fine Arts, Boston.

tant to understand how he represents the spirit of his times. For this I have tried to interpret his work and intentions in light of his specific circumstances as an exiled artist in Weimar Germany. If we see his photographic theories and works as cultural documents, what aspects of Weimar culture was Moholy, as an outsider, showing us, how does he interpret them, and by what means does he get his message across?

Something of an underlying ambivalence or even anxiety about change, as well as a sense of closure for an era, can be found in one of his most moving photographs, *Untitled (Deck of Ship)* (fig. 108). Taken on a trip with Ellen Frank to Rügen Island off the north coast of Germany in 1930, the photograph offers a sophisticated application of the New Vision. Moholy has created a complicated ordering of space without the radical, decontextualizing cropping and odd angles of view of his Paris photographs from five years earlier. Structural elements of the ship's deck form a linear network that binds together dark and light areas but separates the viewer from the people on deck. At the same time, the myriad lines of railing, cables, ladders, and planks produce staccato rhythms of their own.

But as is true of his best work, *Shipboard View* is more than a richly textured visual experience; it also offers a deeper understanding of Moholy's life as an exiled artist. Through the barrier of railing and equipment, we see four figures silhouetted against the water: two on the right engaged in conversation, one on the left leaning over the railing looking out, and a stout woman waving. These anonymous people, their faces either turned away or obscured in shadow, Moholy held at a distance. Watching from afar we witness the scene and are touched by the woman waving her handkerchief. Moholy depicts a bittersweet departure, a life transition of which he would have known many in his career as a displaced Hungarian artist. Regardless of his positive attitude and vibrant spirit, he stopped once again to reflect, by means of the camera, on the meaning of his life and the nature of an era.

1 Reading and Misreading Moholy

1. Walter Benjamin, "A Short History of Photography," in David Mellor, ed., *Germany: The New Photography 1927–1933* (London, 1978), p. 74. Benjamin also quoted this sentence, citing Moholy by name, in "New Things about Plants" (1928), a review of Karl Blossfeldt's book *Urformen der Kunst,* in Mellor, ibid., p. 20. Moholy made such a statement a number of times. For example, "The illiteracy of the future will be ignorance of photography," in "Die Photographie in der Reklame," *Photographische Korrespondenz* 63 (September 1927), p. 259, English translation by Joel Agee in Christopher Phillips, *Photography in the Modern Era: European Documents and Critical Writings, 1913–1940* (New York, 1989), p. 90. "The illiterate of the future will be the person ignorant of the use of the camera as well as of the pen," in "Fotografie ist Lichtgestaltung," *Bauhaus* 2 (1928), p. 5, English translation in Krisztina Passuth, *Moholy-Nagy* (Budapest, 1982; London, 1985), p. 3.

2. Beaumont Newhall, *Focus* (Boston, 1993), p. 47. Newhall reported that when he was first given money to buy photographs ($1,000 from David McAlpin), he went to the Delphic Studios in New York and spent half of the money buying all the photographs in Moholy's one-man show there. (Ibid., p. 58.) He also related this story to the author in an interview in Sante Fe in October 1981. Moholy's photography exhibition was held at the Delphic Studios in 1931, but Newhall started at the Modern, first as the librarian, in 1935. Despite the confusion of the dates, it does seem that Newhall's first purchase was of the group of photographs that had been exhibited earlier in the show. Newhall also stated that Moholy was a very important influence on Newhall's own photography. (Ibid., p. 251.)

3. The Museum of Modern Art, *Photography 1839–1937* (New York, 1937), exhibition catalogue by Beaumont Newhall. Newhall expanded this into his *History of Photography* (New York, 1949) that has since undergone numerous reprintings. Newhall's curatorial practices are examined in depth in Christopher Phillips, "The Judgment Seat of Photography," *October* 22 (Fall 1982), pp. 27–63.

4. Even though Moholy's art received little notice in the press while he worked in Hungary from 1917 through 1919, his early support in Berlin came from the Hungarian Kállai. Kállai had first made contacts in Hungary with the artists and writers centered around the periodical *Ma* (Today) in 1919 but formed closer ties with the expatriates in Berlin, his primary home from 1920 to 1935. He wrote extensively for Hungarian periodicals and was also a contributor to German publications such as *Das Kunstblatt, Cicerone,* and *Die Form*; he edited the *Jahrbuch der jungen Kunst,* the fifth volume of which was devoted to Moholy. His German articles and a book on Hungarian modern art, *Neue Malerei in Ungarn* (Leipzig, 1925), helped to make Hungarian artists better known in the West. He was thus a supporter of some importance for Moholy.

5. Review by Ernő Kállai (under the name Péter Mátyás), first published in *Horizont* 2 (Vienna, 1921); republished in *Ma* 9 (September 1921), p. 119; English trans. in Passuth, *Moholy-Nagy,* p. 412.

6. Ernst Kállai, "Ladislaus Moholy-Nagy," in *Jahrbuch der jungen Kunst* 5 (Leipzig, 1924); English trans. in Passuth, *Moholy-Nagy,* pp. 415–419.

7. Ernst Kállai, "Malerei und Photographie," *i 10: Internationale Revue* 4 (1927), pp. 148–157. Responses by Kandinsky, Kassák, Mondrian, the art

historian Will Grohmann, and Moholy in "Diskussion über Ernst Kállai's Artikel 'Malerei und Fotografie,'" *i 10*, 6 (1927), pp. 227–240. Malevich's response was not printed, but his letter to Moholy on Kállai's article is reprinted in Passuth, *Moholy-Nagy,* pp. 396–397.

8. Moholy-Nagy and Alfréd Kemény, "Dynamisch-konstruktives Kraftsystem," *Der Sturm* 13 (December 1922), p. 186.

9. Kemény and Schmidt seem to have equated Malevich's spiritually based abstraction, suprematism, with constructivism in general.

10. Review by Paul F. Schmidt in *Das Kunstblatt* (March 1924); Alfréd Kemény, "Bemerkungen," *Das Kunstblatt* 6 (1924). Quoted in Passuth, *Moholy-Nagy,* pp. 394–395.

11. See, for example, Lissitzky's favorable review of Moholy's 1922 Der Sturm exhibition, in contrast to the more critical letter to his wife dated 15 September 1925, in Sophie Lissitzky-Küppers, *El Lissitzky: Life, Letters, Texts* (London, 1974), pp. 66–67, 345.

12. Fedorov-Davydov's foreword is reprinted in Passuth, *Moholy-Nagy,* pp. 418–422. The cover and title page of the Russian edition are illustrated on p. 374, figs. 245, 246.

13. Sibyl Moholy-Nagy, *Moholy-Nagy: Experiment in Totality* (Cambridge, 1969), and Richard Kostelanetz, ed., *Moholy-Nagy* (New York, 1970).

14. Hattula Moholy-Nagy expressed her mother's lack of recognition of the importance of Moholy's work in photography in written comments to this author, 25 November 1992. Sibyl's lack of appreciation of his photography also resulted in the loss of most of the original negatives and photograms Moholy created after he came to the United States.

15. Similarly photography received minimal treatment in Joseph Harris Caton, *The Utopian Vision of Moholy-Nagy* (Ann Arbor, 1984), and Steven A. Mansbach, *Visions of Totality: László Moholy-Nagy, Theo van Doesburg, and El Lissitzky* (Ann Arbor, 1980).

16. Herbert Molderings, "Urbanism and Technological Utopianism: Thoughts on the Photography of Neue Sachlichkeit and the Bauhaus," (1978), in Mellor, *Germany: The New Photography,* p. 94.

17. Walter Benjamin, "The Author as Producer." Translated by John Heckman in *New Left Review* 62 (July–August 1970), p. 90. Benjamin is referring here to the general approach to photography at the time that is epitomized by Albert Renger-Patzsch's book *Die Welt ist Schön* (Munich, 1928).

18. Abigail Solomon-Godeau, "The Armed Vision Disarmed: Radical Formalism from Weapon to Style," *Afterimage* 10 (January 1983), pp. 9–14.

19. For example, Rosalind Krauss used the term "New Vision" in referring to such a broad range of photographs in her article "Jump over the Bauhaus," *October* 15 (Winter 1980), pp. 102–110. Also more recently, Maria Morris Hambourg and Christopher Phillips appropriated the term without reference to its origins in their exhibition catalogue *The New Vision: Photography between the Wars,* Metropolitan Museum of Art (New York, 1989).

2 From Berlin to the Bauhaus

1. Although little is known about his family and youth, it is possible to sketch out Moholy's beginnings in Hungary before he emigrated to Berlin in late January of 1920. For information on his early years in Hungary, see Krisztina Passuth, "Début of László Moholy-Nagy," *Acta Historiae Artium* 19 (Buda-

pest, 1973), pp. 125–142; László Péter, "The Young Years of Moholy-Nagy," *New Hungarian Quarterly* 13 (Summer 1972), pp. 62–72; and Júlia Szabó, "The Beginnings of László Moholy-Nagy," *New Hungarian Quarterly* 16 (Spring 1975), pp. 187–193. László Moholy-Nagy was born in Bácsborsod, a small village in southern Hungary, on 20 July 1895, to Karolina Stern and Lipót Weisz. (Information that his mother's name was "Stern" and not "Stein" comes from Moholy's daughter, Hattula Moholy-Nagy, who viewed his mother's and brother Akos's death certificates.) It is known that Moholy's father came from a middle-class family; see Krisztina Passuth, *Moholy-Nagy* (London, 1985), p. 13. After his father's departure for the United States in 1897 and subsequent disappearance, László and his two brothers moved with their mother to Mohol (now in Yugoslavia). By 1906 they were living in Szeged with his maternal uncle, Dr. Gusztav Nagy, whose name they adopted. It is unclear why Moholy and his brothers changed their name; Moholy's daughter implies that their father, Lipót Weisz, was *persona non grata,* and the name change might have emphasized their disassociation from him. By 1919 László had added Moholy, perhaps to distinguish the commonly occurring name Nagy by identifying it with an area of Hungary associated with his relatives.

2. Sibyl Moholy-Nagy stated that Moholy was reportedly refused membership in the Communist party after the Hungarian revolution on class grounds and because he fought on the side of the monarchy during the war: *Moholy-Nagy: Experiment in Totality* (Cambridge, 1969), p. 13. It is possible that when her biography of Moholy was first published in 1950, she did not want to say that he was a Communist due to the political climate in the United States. It should be noted here that the left-wing treatise "Constructivism and the Proletariat" that appeared first in Sibyl Moholy-Nagy, *Moholy-Nagy,* pp. 19–21, and then in Richard Kostelanetz, ed., *Moholy-Nagy* (New York, 1970), pp. 185–186, was not by Moholy, though it has often been quoted as evidence of his political leanings. It was written by Egon Egelien and originally appeared in *Ma* (May 1923), unpaginated. I am indebted to Winfried Nerdinger for first pointing this out to me. His brother Jenő Nagy remembered that Moholy's views were "progressive" and that virtually anyone who wished to join the party could. Jenő had joined and he believed Moholy must have also. "Reminiscences of Jenő Nagy," an interview by Passuth dated 25 October 1975, in Passuth, *Moholy-Nagy,* pp. 385–386.

3. Moholy commented on his time in Vienna in a letter to Iván Hevesy dated 5 April 1920. English translation in Passuth, *Moholy-Nagy,* p. 388.

4. Picabia had exhibited in the "Erste Internationale Dada-Messe" in Berlin, June-August 1920. Since Moholy arrived in Berlin in early 1920, he probably saw the dada fair in Berlin that summer. Moholy could also have seen Picabia's work in periodicals such as *Dada 3* and Picabia's own *391.*

5. Moholy-Nagy, *The New Vision and Abstract of an Artist* (New York, 1946), p. 70.

6. R. Hausmann, Hans Arp, Ivan Puni, and L. Moholy-Nagy, "Aufruf zur elementaren Kunst—an die Künstler der Welt!," *De Stijl* 4 (October 1921), p. 156. English translation in Passuth, *Moholy-Nagy,* p. 286.

7. Van Doesburg's relationship with Moholy is crucial but problematic. Despite later reports to the contrary, the Moholys and the van Doesburgs maintained a close friendship in the early twenties and socialized with each

other often in Berlin and Weimar. (From an interview by the author with Lucia Moholy, 7 July 1981.)

8. Nikolai Tarabukin, *Ot mol'berta k mashine* (Moscow, 1923). French translation edited by André B. Nakov, *Le Dernier tableau: 1. Du chevalet à la machine. 2. Pour une théorie de la peinture* (Paris, 1972). English translation of excerpts in Francis Frascina and Charles Harrison, *Modern Art and Modernism: A Critical Anthology* (Cambridge, 1982), pp. 135–142.

9. In 1921 *Ma* published an album of six prints by Bortnyik with a foreword by Kassák entitled "Bildarchitektur" (Picture Architecture). Kassák then published his foreword in Hungarian ("Képarchitektúra") with his own series of works entitled *Bildarchitektur,* in *Ma* (March 1922), pp. 52–54. Kassák's theory of *Képarchitektúra* centered on the medium of constructed reliefs (though two-dimensional works were also made), a kind of synthesis of architecture and painting that was a nonmimetic object unto itself. For a recent discussion of *Képarchitektúra,* see Oliver A. I. Botar, "Constructed Reliefs in the Art of the Hungarian Avant-Garde: Kassák, Bortnyik, Uitz, and Moholy-Nagy, 1921–1926," *The Structurist* 25/26 (1985/86), pp. 87–95. English translation of Kassák's essay "Képarchitektúra" in *The Structurist* 25/26 (1985/86), pp. 96–98. Moholy also became interested in collage and constructed reliefs around 1921 at the time he shared a studio in Berlin with Kurt Schwitters. Although Botar dates Moholy's reliefs to ca. 1920, 1921 seems a more likely date when comparing his process of constructing and building up an image to his work in other media.

10. See Paul Scheerbart, *Glasarchitektur* (Berlin, 1914). The historical precedents and the adoption of crystal glass imagery by the expressionist architects are discussed in Rosemarie Haag Bletter, "The Interpretation of the Glass Dream—Expressionist Architecture and the History of the Crystal Metaphor," *Journal of the Society of Architectural Historians* (March 1981), pp. 20–43.

11. Moholy had also participated in a group show in October 1920 organized by Fritz Gurlitt that included work by Walter Dexel, Ralf Votmer, and Joseph Nemes Lampérth.

12. Moholy-Nagy, *The New Vision and Abstract of an Artist,* p. 71. It must be kept in mind that this criticism of Kandinsky was written nearly 20 years after Moholy and Kandinsky had taught at the Bauhaus together. In the late 1910s and 1920s there was considerable criticism of Kandinsky's work by Russian constructivists. Their rational, economical approach to pictorial construction differed from Kandinsky's intuitive compositions of forms conveying emotional and spiritual content. Kandinsky's dislike of Moholy is reflected in the choice of Bauhäusler Herbert Bayer to design Kandinsky's *Punkt und Linie zu Fläche,* one of the few Bauhaus books not designed by Moholy.

13. Moholy and Alfréd Kemény, "Dynamisch-konstruktives Kraftsystem," *Der Sturm* 13 (December 1922), p. 186. English translation in Passuth, *Moholy-Nagy,* p. 290.

14. It was not until the construction of his *Light-Space Modulator* in 1930 that he was finally able to achieve actual motion through the use of a motor, something Gabo had done as early as 1920 with his sculpture *Standing Wave.*

15. Hattula Moholy-Nagy believes there are two other *Telephone Pictures* that she has seen.

16. Lucia Moholy, *Marginalien zu Moholy-Nagy: Moholy-Nagy, Marginal Notes* (Krefeld, 1972), p. 75. Moholy described the creation of the *Telephonbilder* in *The New Vision and Abstract of an Artist,* pp. 73–74.

17. *The New Vision and Abstract of an Artist,* pp. 73–74; Lucia Moholy, *Marginalien,* p. 76.

18. When there are two or three prints from the same negative, they invariably show differences in cropping and printing. Andreas Haus states that Moholy had one series of 10 photograms produced in an edition of 20 copies. However, Haus does not give a reference for this information, and I have not found evidence that any of these photograms exist in such large quantities. Andreas Haus, *Moholy-Nagy: Photographs and Photograms* (New York, 1980), cat. no. 118, p. 75.

19. For the English translation of Lissitzky's Der Sturm review, see Lissitzky-Küppers, *El Lissitzky,* p. 341. His later, critical comments are in a letter to his wife, dated 15 September 1925; see ibid., pp. 66–67.

20. Konstantin Umanskii, *Neue Kunst in Russland 1914–1919* (Munich, 1920).

21. Uitz published an article on Russian art and a translation of "The Program of the First Working Group of Constructivists" and "The Realistic Manifesto" in *Egység* (Unity), the Hungarian magazine he edited, in 1922. See Christina Lodder, *Russian Constructivism* (New Haven, 1983), pp. 234–236.

22. The Soviet writer Il'ya Ehrenburg noted that at the Romanisches Cafe "the Hungarian painter Moholy-Nagy argued with Lissitzky about constructivism." Il'ya Ehrenburg, *Men, Years, Life* (London, 1963), vol. 3, p. 13.

23. Botar, "Constructed Reliefs," pp. 93–94.

24. Hans Richter, "Begegnungen in Berlin," in Deutsche Gesellschaft für Bildende Kunst und Akademie der Künste, *Avant-Garde Osteuropa 1910– 1930,* exhibition catalogue (Berlin, 1967), p. 18.

25. Manfredo Tafuri, *The Sphere and the Labyrinth* (Cambridge, 1990), p. 145. Tafuri offers a detailed overview of Berlin's international avant-garde, their associations and impact, on pp. 119–148.

26. Theo van Doesburg, "Der Wille zum Stil: Neugestaltung von Leben, Kunst, und Technique," *De Stijl* 2 (February 1922), pp. 23–32; and *De Stijl* 3 (March 1922), pp. 33–41.

27. On the KURI group see Steven A. Mansbach, "Constructivism and Accommodation in the Hungarian Avant-garde," *Art Journal* 49 (Spring 1990), p. 14. Also, Éva Bajkay-Rosch, "Die KURI-Gruppe," in Hubertus Gassner, ed., *Wechselwirkungen: Ungarische Avantgarde in der Weimarer Republik,* exhibition catalogue, Neue Galerie, Kassel (Marburg, 1986), pp. 260–266, and Farkas Molnár et al., "KURI Manifest," ibid, pp. 266–268.

28. Van Doesburg was a vocal critic of Gropius's Bauhaus program, and probably for this reason he was not a candidate.

29. Walter Gropius in his preface to Moholy-Nagy, *The New Vision and Abstract of an Artist,* p. 5.

30. "Az új tartalom és as új forma problémájáról," *Akasztott Ember* (1922), p. 3; English translation in Passuth, *Moholy-Nagy,* pp. 287–288.

31. Citroen, quoted in Sibyl Moholy-Nagy, *Moholy-Nagy: Experiment in Totality,* p. 35.

32. Lyonel Feininger, in a letter to Julia Feininger dated 1 August 1923 in the Feininger Archive, Harvard University Art Museums (Busch-Reisinger

Museum). Quoted in Hans M. Wingler, *The Bauhaus: Weimar, Dessau, Berlin, Chicago* (Cambridge, 1979), p. 69.

33. Schlemmer also referred to Moholy as Gropius's "faithful drummer boy and teeth-chatterer." Quoted in *The Letters and Diaries of Oskar Schlemmer* (Middletown, 1972), edited by Tut Schlemmer, pp. 184, 228.

34. Feininger, in a letter to Julia Feininger, 12 March 1925, Feininger Archive. Quoted in Wingler, *The Bauhaus*, p. 97.

35. Walter Gropius, "Programm des Staatlichen Bauhauses in Weimar" (Weimar, 1919); translated into English in Wingler, *The Bauhaus*, p. 31.

36. Marcel Franciscono, *Walter Gropius and the Creation of the Bauhaus in Weimar* (Urbana, 1971), p. 21.

37. Walter Gropius, "Idee und Aufbau des Staatlichen Bauhaus in Weimar," in *Staatliches Bauhaus in Weimar: 1919–1923* (Weimar, 1923), 12 pages; translated as "The Theory and Organization of the Bauhaus," in Herbert Bayer, Ise Gropius, and Walter Gropius, eds., *Bauhaus: 1919–1928,* reprint of the 1938 exhibition catalogue, The Museum of Modern Art (New York, 1975), pp. 20–29.

38. Marianne Brandt in Eckhardt Neumann, ed., *Bauhaus and Bauhaus People* (New York, 1970), p. 98.

39. Wilhelm Wagenfeld, for one, said Moholy's paintings offered inspriation for the famous glass lamp that he designed with Karl Jucker. See "Das Staatliche Bauhaus—die Jahre in Weimar," *Form* 37 (March), pp. 17–19.

40. Information on its fabrication and materials are recorded in Institut für Auslandsbeziehungen, *Bauhaus* (Stuttgart, 1975), p. 99, cat. no. 160. Kassák too made three-dimensional models of his *Képarchitektúra* studies around 1923. See Esther Levinger, "Lajos Kassák, *Ma,* and the New Artist, 1915–1925," ill. p. 83.

41. Both students at the time, Bayer and Schmidt designed a sans serif typeface for the Bauhaus exhibition. After the move to Dessau, a new department of typography, advertising, and exhibition design was headed by Bayer from 1925 to 1928 and then by Schmidt from 1928 to 1932. Schmidt taught lettering from 1925 onward.

42. "Die neue Typographie," in *Staatliches Bauhaus in Weimar,* p. 41. English translation in Kostelanetz, *Moholy-Nagy,* p. 75. Moholy's initiation into the field of typography undoubtedly came through van Doesburg, who consistantly covered developments in this area in the journal *De Stijl* beginning with the fourth volume in 1921. Van Doesburg published his own innovative designs and articles on work by others, and probably most importantly devoted an issue to a reprinting of El Lissitzky's children's book "The Story of Two Squares" in 1922. This book, even in its slightly muted *De Stijl* form, provided a bold example of the way in which typography could play a primary role in the presentation of content. See El Lissitzky, "Van twee kwadraten," *De Stijl* 5 (1922).

43. Feininger, in a letter to Julia Feininger, 9 March 1925, Feininger Archive. Quoted in Gillian Naylor, *The Bauhaus Reassessed* (New York, 1985), p. 102.

44. Winfried Nerdinger, *Walter Gropius* (Cambridge, 1985), p. 108.

45. Lyonel Feininger, in a letter to Julia Feininger, 29 June 1928, Feininger Archive. Quoted in Wingler, *The Bauhaus*, p. 141.

3 Production/Reproduction

1. Work on the book had begun by February 1922; Kassák finished his introduction in May, the month of the epoch-making issue of *Ma*. It was published in September 1922 in Vienna in both Hungarian and German; Moholy and Kassák had also hoped to print it in English in America. Éva Körner, "Nachwort," in the reprint of *Buch neuer Künstler* (Budapest, 1977), unpaginated. Published in Hungarian as *Új művészek könyve*.

2. "Produktion-Reproduktion," *De Stijl* 5 (July 1922), pp. 98–100. English translation by Frederic Samson in Andreas Haus, *Moholy-Nagy: Photographs and Photograms* (New York, 1980), pp. 46–47.

3. Letter from Moholy to Hevesy, 26 May 1921. Private collection, Budapest. Quoted in Krisztina Passuth, "Début of László Moholy-Nagy," *Acta Historiae Artium* 19 (1973), p. 131. Passuth uses the date 1922, but this Archipenko issue was dated 1921.

4. Compare Hans Arp and El Lissitzky, *Die Kunstismen* (Zurich, 1925); and Amédée Ozenfant and Charles-Édouard Jeanneret (Le Corbusier), *La Peinture moderne* (Paris, 1925).

5. Walter Gropius had included these silos in his article on engineering published in the Werkbund *Jahrbuch* in 1913. Walter Gropius, "Die Entwicklung moderner Industriebaukunst," *Jahrbuch des Deutschen Werkbundes* 2 (1913), pp. 17–22.

6. The AEG consciously developed an image that promoted the firm as a symbol of industrial power. To achieve this end, they were enlightened enough to employ important architects and designers. The architect Peter Behrens, a founding member of the Deutscher Werkbund in 1907, became the artistic director of AEG the same year. See Tilmann Buddensieg, *Industrialkultur: Peter Behrens and the AEG, 1907–1914* (Cambridge, 1984).

7. Lucia Moholy, *Marginalien,* p. 59. Lucia first described the inception of the ideas that led to their work with the photogram in her article "Das Bauhaus-Bild," *Werk* 55 (June 1968), pp. 397–402. Lucia and Moholy were, in fact, not the first to experiment with recording light manipulations on photographic film; similar techniques were employed by the dadaists Christian Schad in 1918 and Man Ray in late 1921, as will be discussed in chapter 4 below.

8. For claims of the earlier 1920 date see Richard Kostelanetz, ed., *Moholy-Nagy,* p. xv; and Moholy-Nagy (New York, 1970), *Vision in Motion* (published posthumously in Chicago, 1947), in a footnote on p. 187.

9. Reportedly, Moholy's German was not flawless, but like most Hungarians he had studied German in school and knew it well. Lucia, on the other hand, was a native German speaker.

10. Lissitzky in a letter to his wife, dated 19 September 1925, in Sophie Lissitzky-Küppers, *El Lissitzky: Life, Letters, Texts* (Greenwich, 1968), p. 66.

11. From an interview by the author with Lucia Moholy, 7 July 1981.

12. See Lucia Moholy, *Marginalien,* p. 61. On the collaboration of Lucia and Moholy, see Rolf Sachsse, *Lucia Moholy* (Düsseldorf, 1985), pp. 6–13.

13. "Produktion-Reproduktion," pp. 99–100. English translation in Haus, *Moholy-Nagy,* p. 47.

14. Albert Renger-Patzsch, "Ziele," *Das deutsche Lichtbild* (1927), p. 18.

15. Ute Eskildsen discusses this contrast in the approaches of Renger-Patzsch and Moholy in her essay "Innovative Photography between the

Wars," in San Francisco Museum of Modern Art, *Avant-garde Photography in Germany 1919–1939* (San Francisco, 1980), pp. 40–41.

16. Lucia confirmed the existence of these friendships in her interview with the author, 7 July 1981.

17. Van Doesburg, "The Will to Style," in Joost Baljeu, *Theo van Doesburg* (New York, 1974), pp. 125–126.

18. "Produktion-Reproduktion," p. 100. English translation in Haus, *Moholy-Nagy,* p. 47.

19. Moholy-Nagy, *Materei, Photographie, Film* (Munich, 1925), p. 27. English translation by Janet Seligmann as *Painting, Photography, Film* (Cambridge, 1969), p. 33.

20. The term "plastic," used in the title and text of his article, refers to the process of forming a composition. The idea of "plasticity" was prevalent at the time, having appeared in the writings of Malevich, Lissitzky, Mondrian, and others. In general it refers to the emphasis on form in a work of art. Although Moholy's original German text is lost (the article was reportedly translated into English by the American artist Louis Lozowick), his term "plastic" undoubtedly derives both from the German word *Plastik,* meaning sculpture, and De Stijl's "neoplasticism," their new art of form-giving creation. Louis Lozowick was a Russian-born American artist who lived in Europe, mainly Berlin, from 1920 to 1924 and who worked for the American periodical *Broom.* Lissitzky stated that Lozowick translated Moholy's article. (Sophie Lissitzky-Küppers, *El Lissitzky,* p. 67.) Lucia Moholy has said that Moholy's use of *Plastik* in *Fotoplastik,* the name Moholy gave to his photomontages, did allude to neoplasticism. (Lucia Moholy, *Marginalien,* p. 70.) The origin of the Dutch term is itself problematical, but most certainly it is associated with the German word *Gestalt.* Three years after the *Broom* article appeared, Moholy expanded its thesis in his article "Fotografie ist Lichtgestaltung," *Bauhaus* 2 (1928), pp. 2–9. Moholy's usage refers to the process by which the photographer creates form through light and the photographic medium.

4 Light: Medium and Message

1. Max Kozloff, "Moholy the Aerialist," in his *Photography and Fascination* (Danbury, 1979), p. 127.

2. Moholy first used the term "photogram" in *Malerei, Photographie, Film* (Munich, 1925).

3. This process was undertaken frequently by Lucia Moholy, his wife at the time, and by Moholy in the late 1930s. In 1937 Moholy had around a dozen of his photograms from the 1920s photographed and prints made.

4. Wedgwood's experiments were described by Sir Humphrey Davy in "An Account of a Method of Copying Paintings on Glass and Making Profiles by the Agency of Light upon Silver Nitrate Invented by T. Wedgwood with Observations by H. Davy," *Journal of the Royal Institute* 1 (1802), pp. 170–174.

5. Talbot's title refers to the use of photography to "draw with light." Moholy, as a constructivist, discussed *creating* forms with light.

6. I am indebted to Beaumont Newhall for providing me with a photocopy of Lindner's book.

7. Maria Morris Hambourg and Christopher Phillips, *The New Vision: Photography between the Wars,* exhibition catalogue, Metropolitan Museum of Art (New York, 1989), figs. 99–103.

8. Lucia Moholy, *Marginalien zu Moholy-Nagy* (Krefeld, 1972), pp. 59–64.

9. Ibid., p. 61.

10. Moholy-Nagy, "Light—A Medium of Plastic Expression," *Broom* 4 (March 1923), p. 283.

11. Photograms similarly organized can be seen in Andreas Haus, *Moholy-Nagy: Photographs and Photograms* (New York, 1980), nos. 108, 110, 112. See also Hight, *Moholy-Nagy: Photography and Film in Weimar Germany,* exhibition catalogue, Wellesley College Museum (Wellesley, 1985), for information on the dimensions, printing, references, and inscriptions of the photograms, camera photographs, and photomontages discussed in chapters 4, 5, and 6 of this book.

12. Schad's description of this moment in his career can be found in "Relative Realitäten, Errinerungen um Walter Serner" in Walter Serner, *Die Tigerin* (Munich, 1971), p. 248. Quoted in Von der Heydt-Museum, *Schadographien 1918–1975; Photogramme von Christian Schad* (Wuppertal, 1975), unpaginated.

13. This description of Schad's working process is from an interview with Inge Bondi, "Renaissance of the Schadograph," *Printletter* 2 (March/April 1976), pp. 3, 10.

14. Herta Wescher, *Die Collage: Geschichte eines künstlerischen Ausdrucksmittels* (Cologne, 1968), p. 133.

15. Similar variations in texture were made with a lithographic crayon in Moholy's prints of 1923, as seen, for example, in his portfolio of lithographs *Konstruktionen,* published by the Kestner-Gesellschaft (Hanover, 1923). Lissitzky's *Proun* portfolio, also published by the Kestner-Gesellschaft, offers an even more elaborate (and thus more costly) use of *faktura* in printmaking through the addition of colored papers glued onto the prints.

16. For example, two of the photograms for *Les Champs délicieux,* with their geometric shapes created out of paper or cardboard, could easily be mistaken for Moholy's constructivist photograms.

17. See National Museum of American Art, *Perpetual Motif: The Art of Man Ray* (New York, 1988), figs. 69, 70.

18. Quoted in ibid., p. 129.

19. Man Ray, *Les Champs délicieux* (Paris, 1922); album of 12 rayographs in an edition of 40 signed and numbered copies; preface by Tzara. In *Self-Portrait* (Boston, 1963), p. 130, Man Ray said he himself conceived of assembling a portfolio of photograms, while Arturo Schwarz, *Man Ray: The Rigour of Imagination* (New York, 1977), p. 237, stated that it was Tzara's suggestion.

20. André Breton and Philippe Soupault, "Les Champs magnétiques," in *Literature* I (Paris, October–December 1919) and expanded in *Les Champs magnétiques* (Paris, 1920). See Schwarz, *Man Ray,* p. 236, note 8.

21. Moholy-Nagy, *Painting, Photography, Film,* p. 77.

22. Moholy-Nagy, "Fotoplastische Reklame," *Offsett-, Buch- und Werbekunst* 7 (1926), p. 389.

23. Moholy-Nagy, "Fotografie ist Lichtgestaltung," *Bauhaus* 2 (1928), p. 2.

24. *Dadaphone* 7 (1920).

25. *Broom* 4 (March 1923).

26. Haus, *Moholy-Nagy,* p. 13.

27. Moholy was clearly upset by such accusations and tried to explain his position in letters to Erich Buchholz in 1928, to Walter Gropius in 1935, and to Beaumont Newhall in 1937. Letter from Moholy to Erich Buchholz in 1928, published in *Bauhaus: Idee-Form-Zweck* (Frankfurt, 1964), p. 105. Letter from Moholy to Walter Gropius, 16 December 1935, Bauhaus-Archiv, Berlin; reproduced in part in Haus, *Moholy-Nagy,* p. 51. Letter to Beaumont Newhall, 7 April 1937, quoted in Kostelanetz, *Moholy-Nagy,* p. 57.

28. The Dada-Constructivist Congress was held in Weimar in late September of 1922; Lissitzky was undoubtedly referring to the Düsseldorf Congress of Progressive Artists held in May 1922. El Lissitzky in a letter to his wife, dated 15 September 1925, in Lissitzky-Küppers, *El Lissitzky,* pp. 66–68.

29. Quoted in Haus, *Moholy-Nagy,* p. 21.

30. For earlier views on the fourth dimension, see Linda Dalrymple Henderson, *The Fourth Dimension and Non-Euclidean Geometry in Modern Art* (Princeton, 1983), especially chapter 1, pp. 3–43.

31. Albert Einstein in *Nature* 146 (1941), p. 605. During his life and after, many have been interested in Einstein's views on religion. He was a nonpracticing Jew who was deeply interested in the most profound ideas about the nature of the universe, and he wrote several articles on the relationship between science and religion.

32. Moholy-Nagy, "Fotografie ist Lichtgestaltung," p. 4. Author's translation.

33. Ibid., p. 2.

34. For the Zurich photogram see Haus, *Moholy-Nagy,* no. 123, p. 75. Kunstgewerbemuseum, Zurich (inventory no. 1955–4F).

35. *MPF,* pp. 56–57. In addition to his frequent earlier references to spacetime, he specifically discusses the relationship of the theory to Einstein in *Vision in Motion* (Chicago, 1947), p. 266. See Henderson, *The Fourth Dimension,* especially pp. 297–298, 336–338.

36. Quoted in Haus, *Moholy-Nagy,* p. 21.

37. Moholy-Nagy, "From Pigment to Light," *Telehor* 1 (special issue devoted to Moholy, February 1936), p. 34.

38. Lucia Moholy, *Marginalien,* p. 61.

39. Ernst Kállai, "Malerei und Photographie," *i 10: Internationale Revue,* 4 (1927), pp. 148–157.

40. "Diskussion über Ernst Kállais Artikel Malerei und Fotografie," *i 10: Internationale Revue,* 6 (1927), pp. 233–234.

41. Moholy's interest in these gravitational studies is revealed by their illustration in several of his books. *Von Material zu Architektur* (hereafter cited as *VMA*), pl. 138, p. 153; in the English translation, *The New Vision and Abstract of an Artist,* fig. 28, p. 47.

42. The American photographer Alvin Langdon Coburn had previously used prisms, as had Man Ray in a few isolated photograms. While Coburn's appear in his fractured images inspired by the English vorticists, Moholy employed them to create floating architectural structures.

43. For example, in "Fotoplastische Reklame," p. 390, and in "Die Photographie in der Reklame," *Photographische Korrespondenz* 63 (1927), pls. 4, 5.

44. Moholy's designs for the cover of *Broom,* however, were never used.

45. *Foto-Qualität* 9 (1931).

46. Franz Roh and Jan Tschichold, *Foto-Auge/Oeil et Photo/Photo-Eye* (Stuttgart, 1929).

47. *VMA,* pp. 89, 90 (English trans., p. 39).

48. Hannah Weitemeier, *Licht-Visionen* (Berlin, 1972), p. 5.

49. Moholy described the fabrication of the machine (without crediting Sebők or Ball by name) and its purpose, as well as possible applications for such experiments, in "Lichtrequisit einer elektrischen Bühne," *Die Form* 5 (1930), pp. 297–299.

50. The original sculpture is in the Harvard University Art Museums (Busch-Reisinger Museum), while there are replicas in Eindhoven and Berlin. Unfortunately, a number of years ago, during conservation treatment the entire sculpture received a new chrome coating so the variety of textures is mostly lost. Some variety still exists in the use of perforation and materials other than metal, such as glass and wood.

51. The *Monument* is also described as having been designed with only three forms, omitting the hemisphere. Justification for four forms can be found in John Milner, *Vladimir Tatlin and the Russian Avant-Garde* (New Haven, 1984), pp. 161–165.

52. Among other precedents for kiosks that would project films were those conceived by Rodchenko in 1919–1920 (Milner, *Vladimir Tatlin,* figs. 160, 161) and by Herbert Bayer at the Bauhaus in 1924. Busch-Reisinger Museum, *Concepts of the Bauhaus: The Busch-Reisinger Museum Collection* (Cambridge, 1971), figs. 120, 121.

53. "Fotografie ist Lichtgestaltung," p. 4. The author's translation.

54. "A New Instrument of Vision," *Telehor* 1 (1936), p. 35.

5 Camera Vision as Modernist Metaphor

1. Partially due to the influence of typographers, who were attempting to modernize and simplify the German gothic typeface, the medium even received a new spelling. Upper-case letters (used in German for nouns and for sentence beginnings) were dropped, and the replacement of *ph* with *f* altered words stemming from photography (*fotografie, fotograf, foto*). In keeping with this development, Moholy changed the title of *Malerei, Photographie, Film* to *Malerei, Fotografie, Film* in the second edition in 1927.

2. Heinrich Kühn, in "Umblick," *Photographische Rundschau* 64 (1927), p. 13. The relationship between Kühn and Moholy's interest in light is discussed by Ute Eskildsen, "Heinrich Kühns Arbeiten nach dem I. Weltkrieg bis 1944," in Folkwang Museum, *Heinrich Kühn,* exhibition catalogue (Essen, 1978), p. 10. Eskildsen devotes her essay to Kühn's constant experimentation during this period.

3. Herbert Molderings, "Urbanism and Technological Utopianism," in David Mellor, ed., *Germany: The New Photography 1927–1933* (London, 1978), p. 89.

4. Neue Sachlichkeit or "New Objectivity" painting received its name from the exhibition organized by G. F. Hartlaub at the Mannheim Kunsthalle in 1925. This exhibition, which traveled around central Germany, included paintings by social commentators such as Grosz and Otto Dix, as well as the "magic realists" Georg Schrimpf, Carlo Mense, and Alexander Kanoldt.

5. Lichtwark was Germany's major spokesman for "amateur" or noncommercial photography in the early twentieth century. He outlined the principles of amateur photography, as it appeared in periodicals, camera clubs, and exhibitions, in a series of lectures that were the basis for his book *Die Bedeutung der Amateur-Photographie* (Halle, 1894). By promoting photography as art, Lichtwark and the amateur photographers essentially rejected the notion that a photograph should operate merely as an efficient and economical means of communication, or as a straightforward "window on the world."

6. Marcel Franciscono, *Walter Gropius and the Creation of the Bauhaus in Weimar* (Chicago, 1971), p. 28, n. 37.

7. See Hans Gotthard Vierhuff, *Die neue Sachlichkeit: Malerei und Fotografie* (Cologne, 1980), pp. 20–21.

8. Albert Renger-Patzsch, *Die Welt ist schön* (Munich, 1928).

9. For a discussion of Renger-Patsch's realism and advocacy of pure photography, see Ute Eskildsen, "Innovative Photography in Germany between the Wars," in San Francisco Museum of Modern Art, *Avant-Garde Photography in Germany, 1919–1939* (San Francisco, 1980), p. 36.

10. Albert Renger-Patzsch, "Ziele," *Das Deutsche Lichtbild* (1927), p. 18. Quoted in English in Ute Eskildsen, "Photography and the Neue Sachlichkeit Movement," in Mellor, *Germany: The New Photography,* p. 103.

11. Brecht's comments are quoted in Walter Benjamin, "A Short History of Photography," in Mellor, *Germany: The New Photography,* pp. 72–73.

12. For examples, see Renger-Patzsch's books *Technische Schönheit* (Zurich and Leipzig, 1929) and *Eisen und Stahl* (Berlin, 1930).

13. Molderings, "Urbanism and Technological Utopianism," p. 93.

14. The Werkbund's support of Neue Sachlichkeit photography was marked if indirect. Although *Die Form* used photographs with a "modern look" to promote new product designs, neither the emerging photographic style nor the photographers themselves were credited. The Werkbund also sponsored the landmark *Film und Foto* exhibition discussed below.

15. *MPF*, p. 26.

16. Moholy-Nagy, "Fotografie ist Lichtgestaltung," p. 2.

17. Moholy-Nagy, "A New Instrument of Vision," *Telehor* 1 (February 1936), p. 36.

18. Andreas Haus, *Moholy-Nagy: Photographs and Photograms* (New York, 1980), p. 65.

19. Moholy-Nagy, "A New Instrument of Vision," p. 36.

20. Walter Gropius "Idee und Aufbau des Staatlichen Bauhaus in Weimar," translated in Herbert Bayer, Ise Gropius, and Walter Gropius, eds. *Bauhaus: 1919–1928,* reprint of the 1938 exhibition catalogue, The Museum of Modern Art (New York, 1975), p. 22.

21. Lucia too made photographs of the new Bauhaus buildings, in fact was commissioned by Gropius to do so. A number of these were then published in Gropius's *Bauhausbauten Dessau* (Munich, 1930) and in other Bauhaus publications. It is upon these photographs that her reputation as an architectural photographer is based. See Rolf Sachsse, *Lucia Moholy* (Düsseldorf, 1985), plates 80–110.

22. This photograph, which is in the Bauhaus-Archiv in Berlin, is the only version known to the author; it has been touched up with white paint (now

discolored to gray) along the lowest visible floor of the building apparently to insure the homogeneity of the flat planes of the walls in reproduction.

23. *The Octopus* and the winter view from the Funkturm by Moholy in fig. 61 appeared opposite each other in Beaumont Newhall, *Photography: A Short Critical History* (New York, 1938), unpaginated.

24. Quoted in *Alvin Langdon Coburn, Photographer,* ed. Helmut and Alison Gernsheim (New York, 1978), p. 84.

25. *The Amateur Photographer and Photographic News* (January 12, 1909), pp. 34–35.

26. Kazimir Malevich, *Die gegenstandslose Welt* (Munich, 1927), pp. 22–23; English edition translated by Howard Dearstyne, *The Non-Objective World* (Chicago, 1959), pp. 24–25.

27. Moholy-Nagy, "Geradlinigkeit des Geistes—Umwege der Technik," *Bauhaus* 1 (1926), p. 5. Translation by the author.

28. When the article was reprinted in the first issue of *i 10: Internationale Revue* 1 (1927), pp. 35–37, it was illustrated instead with three works by Moholy (the photomontage *Huhn bleibt Huhn,* 1925 (fig. 88 in this book), and two photographs that had appeared in *Painting, Photography, Film,* pl. nos. 61, 93).

29. Haus, *Moholy-Nagy,* cat. no. 41, pp. 66–67.

6 The Experience of Modernity

1. Maud Lavin, *Cut with the Kitchen Knife: The Weimar Photomontages of Hannah Höch* (New Haven, 1993), p. 4.

2. See Franz Roh, *Moholy-Nagy:* 60 Fotos (Berlin, 1930), nos. 1, 6, 50.

3. Ibid., no. 37.

4. Moholy-Nagy, *Painting, Photography, Film,* trans. Janet Seligmann (Cambridge, 1969), p. 92.

5. Roh, *Moholy-Nagy,* nos. 21 (negative), 48 (positive).

6. See, for example, Hight, *Moholy-Nagy: Photography and Film in Weimar Germany* (Wellesley, 1985), cat. nos. 62, 63, p. 96; and Musée Cantini Marseille, *László Moholy-Nagy* (Marseilles, 1991), pp. 276, 277, for two pairs of photographs (positive and negative) of female nudes taken in an outdoor setting. Julien Levy reported that when he visited Berlin in the summer of 1931 he met Moholy through the experimental film maker Victor Blum and accompanied Moholy and Lucia to a nudist beach. Julien Levy, *Memoir of an Art Gallery* (New York, 1977), pp. 65–66, 297.

7. Irene-Charlotte Lusk, *Montagen ins Blaue: László Moholy-Nagy, Fotomontagen und -collagen 1922–1943* (Giessen, 1980); and The Bronx Museum of the Arts, *Moholy-Nagy Fotoplastiks: The Bauhaus Years,* exhibition catalogue by Julie Saul (Bronx, 1983).

8. Roh, *Moholy-Nagy,* p. 8.

9. See chapter 3, note 20. Lucia Moholy describes Moholy's choice of the term *Fotoplastik* in *Marginalien zu Moholy-Nagy* (Krefeld, 1972), p. 70.

10. Saul, *Moholy-Nagy Fotoplastiks,* p. 44.

11. These firecrackers also resemble a kind of electric curler that was popular at the time.

12. Lusk, *Montagen ins Blaue,* p. 98.

13. Höch, "Lebensüberblick" (A Glance over My Life), 1958, in Berlinische Galerie, *Hannah Höch 1889–1978: ihr Werk, ihr Leben, ihre Freunde* (Berlin,

1989), p. 198. Translated into English by Peter Chametzky in Lavin, *Cut with the Kitchen Knife,* p. 214.

14. Moholy-Nagy, "Fotografie ist Lichtgestaltung," p. 8; English translation in Andreas Haus, *Moholy-Nagy: Photographs and Photograms* (New York, 1980), p. 49.

15. Quoted in Christina Lodder, *Russian Constructivism* (New Haven, 1983), p. 187.

16. Lavin, *Cut with the Kitchen Knife,* pp. 107–116. Moholy couples images of exploited blacks and "civilized man" in his two photomontages entitled *Joseph and the Family,* both dated ca. 1926, and more directly confronts the political issue in *Mother Europa Caring for Her Colonies.* See Saul, *Moholy-Nagy Fotoplastiks,* cat. nos. 43, 44, 48.

17. See Lavin, *Cut with the Kitchen Knife,* chapter 6, for Höch's interest in the issue of androgyny.

18. Moholy-Nagy, *Vision in Motion* (Chicago, 1947), p. 284; the film script was dated by Moholy as 1925–1930 and first published in *Telehor* 1 (February 1936), pp. 43–45. It was later published in *Vision in Motion,* pp. 285–287.

19. MPF, p. 34.

20. See Lusk, *Montagen ins Blaue,* p. 100, for a variation of *Eifersucht.* Moholy also used this photograph of himself in another photomontage entitled *Der Trottel* (ibid., pp. 108–109).

21. For the dating of this photomontage, see Lusk, *Montagen ins Blaue,* p. 92.

7 The Bauhaus Books

1. Moholy's letter to Rodchenko, dated 18 December 1923, archives of the Staatliches Bauhaus in Weimar, is reproduced in Krisztina Passuth, *Moholy-Nagy* (London, 1985), pp. 392–393.

2. For information on the titles and design of the Bauhaus Books, see Hans M. Wingler, *The Bauhaus: Weimar, Dessau, Berlin, Chicago* (Cambridge, 1979), pp. 130–131, 446–447.

3. Moholy himself designed the dust jackets for nine of the Bauhaus books. The exceptions were: Gropius's *Internationale Architektur* (designed by Farkas Molnár), Kandinsky's *Punkt und Linie zu Fläche* (Herbert Bayer), van Doesburg's *Grundbegriffe der neuen gestaltenden Kunst* (van Doesburg), *Die Bühne im Bauhaus* (Oskar Schlemmer), and *Ein Versuchhaus des Bauhauses* (Adolf Meyer).

4. Theo van Doesburg, *Grundbegriffe der neuen gestaltenden Kunst,* Bauhausbücher no. 6 (Munich, 1925). Moholy's letter was pointed out to me by Cees Boekraad, who published it in the Dutch translation of the book, *Grondbegrippen van de nieuwe beeldende kunst* (Nijmegen, 1983), p. 103.

5. The text of the original brochure and the English translation can be found in Wingler, *The Bauhaus,* p. 130, and in Passuth, *Moholy-Nagy,* pp. 155–156.

6. Albert Gleizes, *Kubismus,* Bauhausbücher no. 13 (Munich, 1928).

7. Moholy apparently asked Lissitzky to write a book on typography. Sophie Lissitzky-Küppers, ed., *El Lissitzky* (Greenwich, Conn., 1968), p. 50. Moholy wrote to Rodchenko in the early planning stages of the series to ask him to write a piece on constructivism. Moholy's letter to Rodchenko dated 18 December 1923, in Passuth, *Moholy-Nagy,* pp. 292–293.

8. *Malerei, Photographie, Film,* Bauhausbücher, no. 8 (Munich, 1925). The following discussion of this book is based, unless noted otherwise, on the first edition published in Munich in 1925 (hereafter cited as *MPF*). Page numbers in parentheses are from the English translation of the 1927 edition, *Painting, Photography, Film,* translated by Janet Seligmann (Cambridge, 1969). The book was also published in Russian. See Passuth, *Moholy-Nagy,* pp. 418–422.

9. Portions of Moholy's articles "Produktion-Reproduktion," *De Stijl* 5 (July 1922); "Light—A Medium of Plastic Expression," *Broom* 4 (March 1923); and "Das Simultan- oder Polykino," *Der Film von Morgen* (February 1925), were included in *Malerei, Photographie, Film.*

10. For example, Passuth, *Moholy-Nagy,* pp. 47–49. Hannah Steckel-Weitemeier refers to the book only in passing in her discussion of Moholy's work in photography and film, "Moholy-Nagy: Entwurf seiner Wahrnehmungslehre," Inaugural-Dissertation, Freie Universität Berlin, 1974, pp. 259–283.

11. By 1924 Moholy had adopted sans serif lettering, all lower-case type (including for German nouns), and asymmetrical (as opposed to centered) layouts that were to become the hallmarks of the "New Typography" in Germany during the second half of the 1920s. See for example his design for "An Invitation to Join the 'Circle of Friends' [of the Bauhaus]," in Wingler, *The Bauhaus,* p. 78. However, in *Malerei, Photographie, Film* only the chapter headings and subtitles employed sans serif type, and they were printed in bold. Since the records of the publication of the Bauhaus Books by Verlag Langen Müller in Munich were destroyed during the war, one can only surmise why the books employed conventional serif type and capital letters in the text. It seems safe to assume that a commercial publisher would have been more conservative and also might not have had presses set up to use the new type.

12. Moholy says this on the title page of the first edition. However on p. 25 he refers to 1925 as the "Jahre des Radios." It seems probable that Moholy did some refining of his material after the summer of 1924.

13. *MPF,* p. 5. In the second edition of 1927 and in subsequent editions and translations, this opening statement was eliminated.

14. *MPF,* p. 37 (45).

15. For example, in a letter from Walter Gropius to the periodical *Film-Kultur, Zeitschrift für Forderung des Kulturfilms,* dated 22 July 1925. Bauhaus-Archiv, Berlin.

16. *MPF,* p. 27.

17. Ibid.

18. Ibid., p. 11 (15).

19. Lissitzky also talked about having his own works viewed that way. Lissitzky-Küppers, *El Lissitzky,* p. 348.

20. *MPF,* pp. 19–20 (25–26).

21. Moholy's phrase "in der Zeit maschineller Produktion" (ibid., p. 19) would be echoed in the title of Benjamin's famous essay "L'Oeuvre d'art à l'époque de sa reprduction mécanisée," *Zeitschrift für Sozialforschung* 5 (1936).

22. *MPF,* p. 17 (22).

23. Ibid., p. 10 (14).

24. Ibid., p. 32.

25. Ibid., p. 22 (28).

26. Ibid., p. 22 (29).

27. Moholy expanded upon these proposals in later writings. See his "Letter to František Kalivoda," 1934, printed in *Telehor* 1 (February 1936), a special issue devoted to Moholy's photographs and films, p. 32; and "Light Architecture," *Industrial Arts* 1 (Spring 1936).

28. *MPF,* p. 15 (20).

29. Ibid., p. 114 (122).

30. The exact date of the film script, which appeared in two versions, is unclear. In *Malerei, Photographie, Film* he said it was written in 1921/1922. A first version in a somewhat different form was published while Moholy was at the Bauhaus in the 15 September 1924 issue of *Ma.* It seems probable that Moholy may have begun thinking about such a film earlier but actually laid out the first version close to its *Ma* publication date. The earlier version in *Ma* utilized typography, layout, graphic symbols, various type sizes or typefaces, bold printing, and black-and-white illustrations (either linocuts or woodcuts) to convey something of the effect he hoped to achieve in the film. Moholy expanded the film script from one double page (with a spillover onto a third page) in the first version to seven double-page spreads in *Malerei, Photographie, Film.* He replaced the earlier cryptic linocuts with news service photographs, as well as his own photographs and photomontages.

31. Passuth (*Moholy-Nagy,* p. 38) says this shows the influence of Lissitzky and Arp's *Die Kunstismen.* Both books were published in 1925. According to a letter Lissitzky wrote to Oud dated 14 May 1925, Lissitzky saw the proofs of *Die Kunstismen* in May 1925. Busch-Reisinger Museum, *El Lissitzky* (Cambridge, 1987), p. 191.

32. *MPF,* p. 39 (47).

33. "Das Wunder des Hell-dunkels." *MPF,* p. 42.

34. *Painting, Photography, Film,* p. 71.

35. For example, Werner Gräff, *Es kommt der neue Fotograf!* (Berlin, 1929); and Franz Roh and Jan Tschichold, *Foto-Auge/Oeil et photo/Photo-eye* (Tübingen, 1929).

36. Reyner Banham's analysis of *Von Material zu Architektur* remains the most perceptive to date. Reyner Banham, *Theory and Design in the First Machine Age* (New York, 1960), pp. 311–319.

37. Walter Gropius, "Idee und Aufbau des Staatlichen Bauhaus in Weimar," in *Staatliches Bauhaus in Weimar: 1919–1923* (Munich and Weimar, 1923); translated as "The Theory and Organization of the Bauhaus," in Herbert Bayer, Ise Gropius, and Walter Gropius, eds., *Bauhaus: 1919–1928* (New York, 1975), p. 25.

38. *Von Material zu Architektur* (Munich, 1929), pp. 14, 15 (17, 18). Hereafter cited as *VMA.* Page numbers in parentheses refer to the 1946 English edition, *The New Vision and Abstract of an Artist* (New York), translated by Daphne M. Hoffman and combined with Moholy's autobiographical essay "Abstract of an Artist."

39. Ibid., p. 162, 166 (49, 50).

40. In fact, such concepts were realized in the 1960s and 1970s, when not coincidentally a revival of interest in Moholy's work occurred, by light artists such as Otto Piene and the Hungarian artist György Kepes (who was Moholy's assistant in Berlin in the late 1920s) at the Massachusetts Institute of

Technology. One such proposal was first published in the English edition of *Von Material zu Architektur*, entitled *The New Vision and Abstract of an Artist*, p. 50. Eggeling had expressed a similar idea for projecting colored lights into the sky. Louise O'Konor, *Viking Eggeling 1880–1925, Artist and Film-maker* (Stockholm, 1971), p. 52. Tatlin also had plans to project films from the top of his *Monument to the Third International*, and Rodchenko had such plans for a news kiosk.

41. *VMA*, p. 195 (57). Compare "*Proun* is the creation of form (control of space)," El Lissitzky, "*PROUN*: Not world visions, BUT—world reality," in Lissitzky-Küppers, *El Lissitzky*, p. 347.

42. Moholy-Nagy, *The New Vision and Abstract of an Artist*, p. 58, fig. 35; also illustrated in *VMA*, p. 228, fig. 199.

43. *VMA*, p. 201, fig. 175; *The New Vision and Abstract of an Artist*, p. 61, fig. 38.

44. Ibid., p. 90 (39).

45. Tut Schlemmer, ed., *The Letters and Diaries of Oskar Schlemmer* (Middletown, 1972), p. 184.

46. Eugene Prakapas has discussed the difficulty many, including Gropius, must have had in accepting photography as a medium worthy of aesthetic inquiry in the 1920s in *Bauhaus Photography* (Cambridge, 1985), pp. viii–ix.

47. Moholy-Nagy, *The New Vision and Abstract of an Artist*, p. 22.

48. See for example Jeannine Fiedler, ed., *Photography at the Bauhaus* (Cambridge, 1990); Suzanne E. Pastor, "Photography and the Bauhaus," *The Archive* 21 (March 1985), pp. 4–25; Le Musée Réattu, Arles, and Le Musée d'Art Moderne de la Ville de Paris, *Bauhaus photographie* (Arles, 1983); *Bauhaus Photography* (Cambridge, 1985).

8 The New Vision, Language of Modernism

1. Moholy's photographs were published in such periodicals as *Photographische Korrespondenz, Deutscher Kamera-Almanach, Photographische Rundschau, Das deutsche Lichtbild, Foto-Qualität, Querschnitt, Uhu, Das neue Berlin, Das neue Frankfurt, Telehor, Deutsche Kunst und Dekoration, Die Form, Arts et Métiers Graphiques, Cahiers d'Art*, and *Transition*.

2. Moholy also addressed the concept of a language of vision in, for example, "Die beispiellose Fotografie," *Das deutsche Lichtbild, Jahresschau* (Berlin, 1927), p. 10, English translation by Joel Agee, "Unprecedented Photography" in Christopher Phillips, ed., *Photography in the Modern Era* (New York, 1989), p. 84; and "Die Photographie in der Reklame," *Photographische Korrespondenz* 63 (September 1927), pp. 258, 259, English translation by Agee, "Photography in Advertising," in Phillips, pp. 89, 90.

3. Viktor Shklovsky, "Art as Technique," in Lee T. Lemon and Marion J. Reis, eds., *Russian Formalist Criticism, Four Essays* (Lincoln, 1965), pp. 3–24.

4. Quoted in Daniela Mrázková and Vladimir Remes, "Soviet Photography between the Wars," in *Early Soviet Photographers* (London, 1982), p. 6.

5. As Annette Michelson has pointed out, there were distinct parallels among the photography and film theories of Moholy, Vertov, and the French cinematographer Jean Epstein in the early 1920s. Annette Michelson, ed., *Kino-Eye: The Writings of Dziga Vertov* (Berkeley, 1984), pp. xli–xlvi. Vertov, "WE: Variant of a Manifesto," ibid., pp. 5–9. See *MPF*, pp. 12–14 (16–19).

6. Vertov, "WE," p. 9.

7. Vertov, "The Birth of Kino-Eye," 1924; English translation by Kevin O'Brien in Michelson, *Kino-Eye,* p. 41.

8. Moholy-Nagy, "A New Instrument of Vision," *Telehor* (February 1936), pp. 34–35. Reprinted in Richard Kostelanetz, ed., *Moholy-Nagy* (New York, 1970), pp. 50–52.

9. Ibid., p. 52.

10. Osip Brik, "Foto-kadr protiv kartiny," *Sovetskoe foto* 2 (1926), pp. 40–42. English translation as "The Photograph versus the Painting" by John E. Bowlt, in Phillips, *Photography in the Modern Era,* pp. 213–218. Though he published little, Brik was considered one of the prime intellects in the Russian futurist, formalist, and productivist movements.

11. Krisztina Passuth, *Moholy-Nagy* (London, 1985), note 26, p. 435.

12. For illustrations of Rodchenko's covers for *Kinofot* see Hubertus Gassner, *Rodcenko Fotografien* (Munich, 1982), figs. 12, 22.

13. Rodchenko, "Protiv summirovannogo portreta za momentalnyi snimok," *Novyi Lef* 4 (1928), p. 16; English translation by John E. Bowlt in Phillips, *Photography in the Modern Era,* p. 242.

14. Rodchenko, "Illustracii i fotomontaz," *Lef* 4 (1924), p. 41.

15. The exhibition was shown in Stuttgart from May 18 to July 7 and then traveled to Zurich, Berlin, Danzig, and Vienna. My discussion of Moholy's role in the organization of *Fifo* is indebted to Ute Eskildsen, "Fotokunst statt Kunstphotographie, die Durchsetzung des fotografischen Mediums in Deutschland," in *Film und Foto der zwanziger Jahre* (Stuttgart, 1979), pp 8–25; translated into English as "Innovative Photography in Germany between the Wars," in *Avant-Garde Photography in Germany 1919–1939* (San Francisco Museum of Modern Art, 1980), pp. 35–46.

16. *Internationalle Ausstellung des deutschen Werkbunds Film und Foto,* exhibition catalogue, Stuttgart, 1929 (reprint, New York, 1979), p. 10.

17. Neither this book nor Hans Richter's *Fifo* film program and its companion book, *Filmgegner von Heute—Filmfreunde von Morgen,* included work by Moholy. The fact that there was no mention of Moholy in Richter's book could also indicate he had not made any films by that time. Although Moholy's first film, *Berliner Stilleben,* is commonly dated 1926, Jan-Christopher Horak believes it was not made until 1929, the year in which his film *Marseille vieux port* was made. Therefore, it is possible that Moholy had published his film script for *Dynamik der Gross-stadt* but had not in fact made any films by the time of the *Film und Foto* exhibition. (From a conversation between the author and Horak on April 20, 1985.) There is no documentation for films made by Moholy at the Bauhaus, which he left in the spring of 1928.

18. Ute Eskildsen, "Raum 1—Eine Bildzusammenstellung von László Moholy-Nagy," in *Film und Foto der zwanziger Jahre,* p. 68.

19. Quoted in Ute Eskildsen, "Innovative Photography in Germany between the Wars," pp. 35–36.

9 Exile

1. Viktor Shklovsky, "Art as Technique," in Lee T. Lemon and Marion J. Reis, eds., *Russian Formalist Criticism* (Lincoln, 1965), p. 12.

2. Walter Benjamin, "Kleine Geschichte der Photographie," first published in *Die literarische Welt* (19 September, 25 September, and 20 October, 1931), English translation "A Short History of Photography" by Kingsley Shorter in

David Mellor, ed., *Germany: The New Photography 1927–1933* (London, 1978), pp. 72–73.

3. For more on his commercial use of photomontage, see Irene-Charlotte Lusk, *Montagen ins Blaue* (Giessen, 1980), especially pp. 149–192.

4. Walter Benjamin, "A Short History of Photography," in Mellor, *Germany: The New Photography,* p. 73.

5. English translation by John E. Bowlt of accusations by Boris Kushner and Sergei Tretyakov, as well as Rodchenko's rebuttals, can be found in Christopher Phillips, *Photography in the Modern Era* (New York, 1989), pp. 243–272.

6. *MPF,* p. 27 (34).

7. "Ismus oder Kunst," *Vivos Voco* 5 (September 1926), p. 273; English translation in Richard Kostelanetz, ed., *Moholy-Nagy* (New York, 1970), p. 35.

8. Letter to František Kalivoda, 1934, published in *Telehor* 1 (February 1936), p. 32; and in Kostelanetz, *Moholy-Nagy,* p. 42.

9. Quoted in Beaumont Newhall, *Focus* (Boston, 1993), p. 170.

10. David Bathrick and Andreas Huyssen, "Modernism and the Experience of Modernity," in Bathrick and Huyssen, eds., *Modernity and the Text* (New York, 1989), p. 3.

<div style="writing-mode: vertical-rl;">**selected bibliography**</div>

Books by Moholy-Nagy

Buch neuer Künstler. Új művészek könyve. Coauthored by Lajos Kassák. Vienna and Budapest, 1922; reprint Budapest, 1977.

Die Bühne im Bauhaus. Coauthored by Oskar Schlemmer and Farkas Molnár. Bauhausbücher no. 4. Munich, 1924; reprint Mainz and Berlin, 1964. Translated by Arthur S. Wensinger as *The Theater of the Bauhaus.* Middletown, 1961.

Malerei, Photographie, Film. Bauhausbücher no. 8. Munich, 1925. Revised edition, *Malerei, Fotografie, Film.* Munich, 1927; reprint Mainz and Berlin, 1968. Translated by Janet Seligmann as *Painting, Photography, Film.* Cambridge, 1969.

Von Material zu Architektur. Bauhausbücher no. 14. Munich, 1929; reprint Mainz and Berlin, 1965. Translated by Daphne M. Hoffman as *The New Vision: From Material to Architecture.* New York, 1930. Revised edition with the title *The New Vision: Fundamentals of Design, Painting, Sculpture, and Architecture.* New York, 1938. Combined with the autobiographical essay Moholy wrote in the last several years before his death and entitled *The New Vision and Abstract of an Artist.* New York, 1946, 1947, 1949, 1964.

Vision in Motion. Chicago, 1947.

Books of Moholy's Photographs

Bendetta, Mary. *The Street Markets of London.* London, 1936; reprint 1972.

Betjeman, John. *An Oxford University Chest.* London, 1939.

Fergusson, Bernard. *Eton Portrait.* London, 1937; reprint 1949.

Roh, Franz. *László Moholy-Nagy: 60 Fotos.* Berlin, 1930.

Articles by Moholy-Nagy on Photography

"Aufruf zur elementaren Kunst." *De Stijl* 4 (October 1921), p. 156. Coauthored by Raoul Hausmann, Ivan Puni, and Hans Arp. Translated as "Manifesto on Elementary Art" by Frederic Samson, in Andreas Haus, *Moholy-Nagy: Photographs and Photograms.* New York, 1980, p. 46.

"Produktion-Reproduktion." *De Stijl* 5 (July 1922), pp. 98–100. Translated into English by Frederic Samson in Haus, *Moholy-Nagy,* pp. 46–47.

"Dynamisch-konstruktives Kraftsystem." *Der Sturm* 13 (December 1922), p. 186. Coauthored by Alfréd Kemény. Translated by Joachim Neugroschel as "Dynamic-Constructive Energy System," in Richard Kostelanetz, ed., *Moholy-Nagy.* New York, 1970, pp. 29–30.

"Light—A Medium of Plastic Expression." *Broom* 4 (March 1923), pp. 283–284. Reprinted in Nathan Lyons, ed., *Photographers on Photography,* pp. 72–73. Englewood Cliffs, N.J., 1966.

"Die neue Typographie." *Staatliches Bauhaus in Weimar 1919–1923* (Munich and Weimar, 1923), p. 141.

"Das Simultan- oder Polykino." *Der Film von Morgen* (February 1925). Also published in Moholy-Nagy, *Malerei, Photographie, Film,* pp. 33–35.

"Geradlinigkeit des Geistes—Umwege der Technik." *Bauhaus* 1 (1926), p. 5. Reprinted in *i 10: Internationale Revue* 1 (1927), pp. 35–38. Translated by Sibyl Moholy-Nagy as "Directness of the Mind: Detours of Technology," in Kostelanetz, *Moholy-Nagy,* pp. 187-l89.

"Fotoplastische Reklame." *Offset-, Buch-, und Werbekunst* 7 (1926), pp. 386–394.

"Die beispiellose Fotografie." *Das deutsche Lichtbild, Jahresschau* (Berlin, 1927), pp. 10–11. Reprinted in *i 10: Internationale Revue* 1 (1927), pp. 114–117.

"Diskussion über Ernst Kállai's Artikel 'Malerei und Fotografie.'" *i 10: Internationale Revue* 6 (1927), pp. 233–234.

"Die Photographie in der Reklame." *Photographische Korrespondenz* 63 (September 1927), pp. 258–260.

"Fotografie ist Lichtgestaltung." *Bauhaus* 2 (1928), pp. 2–9.

"Neue Wege in der Photographie." *Photographische Rundschau und Mitteilungen* 65 (1928), pp. 33–36.

"Zum sprechenden Film." *i 10: Internationale Revue* 15 (1928), pp. 69–71.

"Zu den Fotografien von Florence Henri." *i 10: Internationale Revue* 17–18 (1928), p. 117.

"Das Kind des Anderen." *i 10: Internationale Revue* 17–18 (1928), pp. 118–119.

"Johanna von Orleans." *i 10: Internationale Revue* 17–18 (1928), pp. 119–120.

"Sturm über Asien." *i 10: Internationale Revue* 19 (1928), pp. 143–144.

"Scharf oder unscharf." *i 10: Internationale Revue* 20 (1929), pp. 163–167.

"The Future of the Photographic Process." *Transition* 15 (February 1929), pp. 289–290.

"In Answer to Your Interview." *The Little Review* 12 (May 1929), pp. 54–56.

"La Photographie ce qu'elle était, ce qu'elle devra être." *Cahiers d'art* 4 (1929), pp. 29–30.

"Fotogramm und Grenzgebiete." *Die Form* 4 (1929), pp. 256–259; also published in *i 10: Internationale Revue* 21–22 (1929), pp. 190–192.

"Lichtrequisit einer elektrischen Bühne." *Die Form* 5 (1930), pp. 297–299.

"Wohin geht die photographische Entwicklung?" *Afga-Photoblätter* 8 (1931–1932), pp. 267–272.

"Problèmes du nouveau film." *Cahiers d'art* 7 (1932), pp. 277–280. Reprinted in *Telehor* 1 (February 1936), pp. 37–40. Translated by P. Morton Shand as "Problems of the Modern Film," in Kostelanetz, *Moholy-Nagy,* pp. 131–138.

"How Photography Revolutionizes Vision." *The Listener* (November 1933), pp. 688–690. Reprinted with the title "A New Instrument of Vision," *Telehor*

1 (Feb. 1936), pp. 34–46. Reprinted in Kostelanetz, *Moholy-Nagy,* pp. 50–54.

"Offener Brief: An die Filmindustrie und an Alle, die Interesse an der Entwicklung des guten Films haben." *Ekran* 1 (November 1934), pp. 13–15.

"Letter to František Kalivoda." *Telehor* 1 (February 1936), pp. 30–32. Reprinted in Kostelanetz, *Moholy-Nagy,* pp. 37–42.

"From Pigment to Light." *Telehor* 1 (February 1936), pp. 32–36. Reprinted in Lyons, *Photographers on Photography,* pp. 73–80.

"Supplementary Remarks on the Sound and Color Film." *Telehor* 1 (February 1936), pp. 41–43. Reprinted in Kostelanetz, *Moholy-Nagy,* pp. 139–143.

"Light Architecture." *Industrial Arts* 1 (Spring 1936). Reprinted in Kostelanetz, *Moholy-Nagy,* pp. 155–159.

"Photography in a Flash." *Industrial Arts* 1 (Summer 1936), pp. 294–303. Reprinted in Kostelanetz, *Moholy-Nagy,* pp. 54–57.

"Subject without Art." *The Studio* 12 (November 1936), p. 259. Reprinted in Kostelanetz, *Moholy-Nagy,* pp. 42–43.

"Light Painting." In J. L. Martin, Ben Nicholson, and Naum Gabo, eds., *Circle: International Survey of Constructive Art.* London, 1937.

Books, Exhibition Catalogues, and Articles on Moholy

Arts Council of Great Britain, Institute of Contemporary Arts, London. *L. Moholy-Nagy.* Exhibition catalogue with essays by Krisztina Passuth and Terence Senter. London, 1980.

Bauhaus-Archiv, Berlin. *Licht-Visionen: Ein Experiment von Moholy-Nagy.* Publication of the lecture by Hannah Weitemeier given in conjunction with the exhibition *Moholys Licht-Raum-Modulator,* Bauhaus-Archiv, 1972. Berlin, 1972.

Botar, Oliver A. I., ed. "Documents on László Moholy-Nagy." *Hungarian Studies Review* 15 (Spring 1988), pp. 77–87.

Brockhaus, Christof. "Flach, Rodtschenko, Moholy-Nagy, und die Diskussion um die neuen Perspektiven in der Photographie." In Museum Ludwig, *Hannes Maria Flach: Photographien der zwanzigen Jahre,* exhibition catalogue, 1983.

Caton, Joseph Harris. *The Utopian Vision of Moholy-Nagy.* Ann Arbor, 1984.

Fawkes, Caroline. "Photography and Moholy-Nagy's Do-It-Yourself Aesthetic." *Studio International* 190 (July-August 1975), pp. 18–26.

Fedorov-Davydov, Alexei. "Introduction to Moholy-Nagy's *Painting, Photography, Film* " (1929). From the Russian edition. Translated in Krisztina Passuth, *Moholy-Nagy* (London, 1985), pp. 418–422.

Frühe Photographien: László Moholy-Nagy. Das Foto-Taschenbuch, no. 16. Berlin, Nishen, 1989.

Galleries of the Claremont Colleges, Claremont, California. *Photographs of Moholy-Nagy from the Collection of William Larson.* Exhibition catalogue edited by Leland D. Rice and David W. Steadman. Claremont, 1977.

Graphisches Kabinett Kunsthandel Wolfgang Werner, Bremen. *László Moholy-Nagy, László Péri: zwei Künstler der ungarischen Avantgarde in Berlin 1920–1925.* With essays by Krisztina Passuth and Wolfgang Werner. Bremen, 1987.

Grundberg, Andy. "The Radical Failure of László Moholy-Nagy." *New York Times,* July 31, 1983. Reprinted in Grundberg, *Crisis of the Real: Writings on Photography, 1974–1989.* New York, 1990, pp. 42–45.

Haus, Andreas. *Moholy-Nagy: Fotos und Fotogramme.* Munich, 1978. Translated by Frederic Samson as *Moholy-Nagy: Photographs and Photograms.* New York, 1980.

Hight, Eleanor M. *Moholy-Nagy: Photography and Film in Weimar Germany.* Exhibition catalogue, Wellesley College Museum. Wellesley, 1985.

Horak, Jan-Christopher. "The Films of Moholy-Nagy." *Afterimage* 13 (Summer 1985), pp. 20–23.

Kállai, Ernst. "Ladislaus Moholy-Nagy." *Jahrbuch der jungen Kunst* 5 (Leipzig, 1924). English translation in Krisztina Passuth, *Moholy-Nagy.* London, 1985, pp. 415–419.

Kemény, Alfréd. "Bemerkungen." *Das Kunstblatt* 6 (1924). English translation in Krisztina Passuth, *Moholy-Nagy.* London, 1985, pp. 394–395.

Koppe, Richard. "László Moholy-Nagy and His Vision." *Art International* 13 (December 1969), pp. 43–46.

Kostelanetz, Richard, ed. *Moholy-Nagy.* New York, 1970.

Lusk, Irene-Charlotte. *Montagen ins Blaue: László Moholy-Nagy, Fotomontagen und -collagen 1922–1943.* Giessen, 1980.

Mansbach, Steven A. *Visions of Totality: László Moholy-Nagy, Theo van Doesburg, and El Lissitzky.* Ann Arbor, 1980.

Moholy, Lucia. *Marginalien zu Moholy-Nagy: Moholy-Nagy, Marginal Notes.* Krefeld, 1972.

Moholy-Nagy, Sibyl. "Constructivism from Kazimir Malevich to László Moholy-Nagy." *Arts and Architecture* 80 (June 1966), pp. 4–28.

Moholy-Nagy, Sibyl. *Moholy-Nagy: Experiment in Totality.* Cambridge, 1969.

Moholy-Nagy, Sibyl. "László Moholy-Nagy." *Art d'aujourd'hui* 2 (October 1951), pp. 18–25.

Museum of Contemporary Art, Chicago, and The Solomon R. Guggenheim Museum. *László Moholy-Nagy.* Exhibition catalogue. Chicago, 1969.

Newhall, Beaumont. "The Photography of Moholy-Nagy." *Kenyon Review* 3 (1941), pp. 342–351.

Newhall, Beaumont. "Review of Vision in Motion." *Photo Notes* (March 1948), pp. 9–11.

Olbrich, Harald. "Moholy-Nagy und der Konstructivismus: Bemerkungen zum Verständnis." *Wissenschaft zu der Hochschule für Architektur und Bauwesen Weimar* 23 (1976), pp. 525–529.

Passuth, Krisztina. "Début of Moholy-Nagy." *Acta Historiae Artium* 19 (1973), pp. 125–142.

Passuth, Krisztina. *Moholy-Nagy.* London, 1985.

Passuth, Krisztina. "Moholy-Nagy et Walter Benjamin." *Cahiers du Musée National d'Art Moderne* 5–6 (1980–1981), pp. 398–409.

Péter, László. "The Young Years of Moholy-Nagy." *The New Hungarian Quarterly* 13 (Summer 1972), pp. 62–72.

Read, Herbert. "A New Humanism: Review of *The New Vision*." *Architectural Review* 78 (October 1935), pp. 150–152.

Rondolino, Gianni. *László Moholy-Nagy: Pittura, Fotografia, Film.* Turin, 1975.

Rosenthal (Piene), Nan. *László Moholy-Nagy's Light-Space Modulator.* Exhibition brochure, Howard Wise Gallery, New York, 1970.

Rosenthal (Piene), Nan. "Notes on the Lichtrequisit, a Motorized Construction of 1930 by László Moholy-Nagy." Unpublished manuscript in the Harvard University Art Museums (Busch-Reisinger Museum).

Saul, Julie. *Moholy-Nagy Fotoplastiks: The Bauhaus Years.* Exhibition catalogue, Bronx, 1983.

Steckel-Weitemeier, Hannah. "Moholy-Nagy: Entwurf seiner Wahrnehmungslehre." Inaugural-Dissertation. Freie Universität Berlin, 1974.

Stedelijk van Abbemuseum, Eindhoven. *Moholy-Nagy.* Exhibition catalogue. Eindhoven, 1967.

Van der Marck, Jan. "László Moholy-Nagy: Konstruktion in Emaille 1." *Art Press* 106 (September 1986), pp. 84–86.

Weitemeier, Hannah. *Licht-Visionen: Ein Experiment von Moholy-Nagy.* Berlin, 1972.

Württembergischer Kunstverein, Stuttgart. *László Moholy-Nagy.* Exhibition catalogue. Stuttgart, 1974.

General Sources
Ades, Dawn. *Photomontage.* New York, 1976.

Andersen, Troels. *K. S. Malevich. The Artist, Infinity, Suprematism. Unpublished Writings, 1913–1933.* Volumes 1–4. Copenhagen, 1978.

Arp, Hans, and El Lissitzky. *Die Kunstismen.* Zurich, 1925.

Arts Council of Great Britain, Hayward Gallery, London. *The Hungarian Avant Garde: The Eight and the Activists.* Exhibition catalogue with essays by Tamás Aknai, János Brendel, Krisztina Passuth, Júlia Szabó, and John Willett. London, 1980.

Bajkay-Rosch, Éva. "Die KURI-Gruppe." In Hubertus Gassner, ed., *Wechselwirkungen: Ungarische Avantgarde in der Weimarer Republik.* Kassel, 1986, pp. 260–266.

Baljeu, Joost. *Theo van Doesburg.* New York, 1974.

Banham, Reyner. *Theory and Design in the First Machine Age.* New York, 1960.

Bathrick, David, and Andreas Huyssen. "Modernism and the Experience of Modernity." In David Bathrick and Andreas Huyssen, eds., *Modernity and the Text: Revisions of German Modernism.* New York, 1989, pp. 1–16.

Bauhaus Fotografie. Düsseldorf, 1982. Foreword by Eugene Prakapas. English translation by Harvey L. Mendelsohn as *Bauhaus Photography.* Cambridge, 1985.

Benjamin, Walter. "The Author as Producer." Translated by John Heckman in *New Left Review* 62 (July-August 1970), pp. 83–96.

Benjamin, Walter. "A Short History of Photography." Translated by Kingsley Shorter and published in part in David Mellor, ed., *Germany: The New Photography 1927–1923* (London, 1978), pp. 69–75. Originally published as "Kleine Geschichte der Photographie." *Die literarische Welt,* 18 September, 25 September, and 20 October 1921.

Benjamin, Walter. "The Work of Art in the Age of Mechanical Reproduction." In *Illuminations,* edited by Hannah Arendt and translated by Harry Zohn. New York, 1969, pp. 217–251. Originally published as "L'Oeuvre d'art à l'époque de sa reproduction mécanisée," *Zeitschrift für Sozial Forschung* 5 (1936).

Bletter, Rosemarie Haag. "The Interpretation of the Glass Dream—Expressionist Architecture and the History of the Crystal Metaphor." *Journal of the Society of Architectural Historians* 40 (March 1981), pp. 20–43.

Blossfeldt, Karl. *Urformen der Kunst.* Berlin, 1928.

Bondi, Inge. "Modernist Lucia Moholy Rediscovered." *Print Letter* 6 (May/June 1981), p. 13.

Bondi, Inge. "Renaissance of the Schadograph." *Print Letter* 2 (March/April 1976), pp. 3, 10.

Botar, Oliver A. I. "Constructed Reliefs in the Art of the Hungarian Avant-Garde: Kassák, Bortnyik, Uitz, and Moholy-Nagy." *The Structurist* 25–26 (1985–1986), pp. 87–95.

Bowlt, John E., ed. *Russian Art of the Avant-Garde: Theory and Criticism 1902–1934.* New York, 1976.

Bridenthal, Renate, Atina Grossman, and Marion Kaplan, eds. *When Biology Became Destiny: Women in Weimar and Nazi Germany.* New York, 1984.

Brik, Osip. "From Painting to Photography" (1928). In David Elliott, ed., *Rodchenko and the Arts of Revolutionary Russia.* New York, 1979, pp. 90–91.

Bromig, Christian. "Aesthetik des Augenblicks: Ungarische Fotographen in der Bildpresse der Weimarer Republik." In Hubertus Gassner, ed., *Wechselwirkungen: Ungarische Avantgarde in der Weimarer Republik.* Kassel, 1986, pp. 501–521.

Buchloh, Benjamin. "From Faktura to Factography." *October* 30 (Fall 1984), pp. 82–119.

Burckhardt, Lucius. *The Werkbund: History and Ideology, 1907–1933.* New York, 1980.

Campbell, Joan. *The German Werkbund: The Politics of Reform in the Applied Arts.* Princeton, 1978.

Congdon, Lee. *Exile and Social Thought: Hungarian Intellectuals in Germany and Austria, 1919–1933.* Princeton, 1991.

De Stijl. Periodical published by Theo van Doesburg in Amsterdam, 1917–1933; reprinted in Amsterdam, 1968.

Deutscher Werkbund. *Film und Foto: Internationale Ausstellung des Deutschen Werkbunds.* Exhibition catalogue by Gustaf Stotz et al. Stuttgart, 1929. Reprint New York, 1979.

Doesburg, Theo van. *Grundbegriffe der neuen gestaltenden Kunst.* Bauhausbücher no. 6. Munich, 1925. Translated by Janet Seligmann as *Principles of Neo-Plastic Art.* London, 1968. Translation into Dutch as *Grondbegrippen van de nieuwe beeldende kunst.* Nijmegen, 1983.

Doesburg, Theo van. "Der Wille zum Stil. Neugestaltung von Leben, Kunst, und Technique." *De Stijl* 2 (February 1922), pp. 23–32; and *De Stijl* 3 (March 1922), pp. 33–41. Translated by Joost Baljeu as "The Will to Style" in Baljeu, *Theo van Doesburg.* New York, 1974, pp. 115–126.

Droste, Magdalena. *Bauhaus, 1919–1933.* Cologne, Berlin, 1990.

Elliot, David, ed. *Rodchenko and the Arts of Revolutionary Russia.* New York, 1979.

Eskildsen, Ute. *Heinrich Kühn.* Exhibition catalogue, Essen, 1978.

Eskildsen, Ute. "Photography and the Neue Sachlichkeit Movement." In *Neue Sachlichkeit and German Realism of the 1920's.* Exhibition catalogue. London, 1978, pp. 85–97. Reprinted in David Mellor, ed., *Germany: The New Photography 1927–1933* (London, 1978), pp. 100–112.

L'Esprit nouveau. Periodical published by Amédée Ozenfant and Charles-Édouard Jeanneret (Le Corbusier) in Paris, 1921–1925; reprinted in New York, 1968–1969.

Fiedler, Jeannine, ed. *Photography at the Bauhaus.* Cambridge, 1990.

Folgarait, Leonard. "Art-State-Class: Avant-garde Art Production and the Russian Revolution." *Arts Magazine* 60 (1985–1986), pp. 69–75.

Franciscono, Marcel. *Walter Gropius and the Creation of the Bauhaus in Weimar.* Urbana, 1971.

Frank, Suzanne. "*i 10*: Commentary, Bibliography, and Translations." *Oppositions* 7 (Winter 1976), pp. 69–83.

Galerie van Diemen, Berlin. *Erste russische Kunstausstellung.* Exhibition catalogue. Berlin, 1922.

Galleria del Levante, Munich. *Das experimentelle Photo in Deutschland 1918–1940.* Exhibition catalogue by Emilio Bertonati. Munich, 1978.

Galleria del Levante, Munich. *Ungarische Avantgarde 1909–1930.* Exhibition catalogue. Munich, 1971.

Gantner, J. "Photographie und Lichtgestaltung." *Das neue Frankfurt* 3 (1929), pp. 47–57.

Gassner, Hubertus. *Rodčenko Fotografien.* Munich, 1982.

Gassner, Hubertus, ed. *Wechselwirkungen: Ungarische Avantgarde in der Weimarer Republik.* Exhibition catalogue. Marburg, 1986.

Gay, Peter. *Weimar Culture: The Outsider as Insider.* New York, 1968.

Grimes, John, and Charles Traub. *The New Vision: Forty Years of Photography at the Institute of Design.* Millerton, 1982.

Gropius, Walter. "Die Entwicklung moderner Industriebaukunst." *Jahrbuch des Deutschen Werkbundes* 2 (1913), pp. 17–22.

Gropius, Walter. "Idee und Aufbau des Staatlichen Bauhaus in Weimar." In *Staatliches Bauhaus in Weimar: 1919–1923.* Munich and Weimar, 1923, pp. 7–18. Translated as "The Theory and Organization of the Bauhaus," in Herbert Bayer, Ise Gropius, and Walter Gropius, eds., *Bauhaus: 1919–1928,* reprint of the 1938 exhibition catalogue, Museum of Modern Art. New York, 1975, pp. 20–29.

Hahn, Peter. "Kunst und Technik in der Konzeption des Bauhauses." In *Kunst und Technik in den 20er Jahren.* Exhibition catalogue, Stadtische Galerie im Lenbachhaus. Munich, 1980, pp. 138–147.

Hambourg, Maria Morris, and Christopher Phillips. *The New Vision: Photography between the Wars.* Exhibition catalogue, The Metropolitan Museum of Art. New York, 1989.

Harker, Margaret. "From the Margins to the Center: Lucia Moholy." *British Journal of Photography Annual* (1982), pp. 46–55.

Haus, Andreas. "Dokumentarismus, neue Sachlichkeit, und neues Sehen— zur Entwicklung des Mediums Fotografie in den USA und Europa." *Amerika Studien* 26 (1981), pp. 315–39.

Haus, Andreas. "Die Präsenz des Materials: Ungarische Fotografen aus dem Bauhaus-Kreis." In Hubertus Gassner, ed., *Wechselwirkungen: Ungarische Avantgarde in der Weimarer Republik.* Kassel, 1986, pp. 472–490.

Haxthausen, Charles W., and Heidrun Suhr, eds. *Berlin: Culture and Metropolis.* Minneapolis, 1990.

Heise, Carl Georg. "Film und Foto: zur Ausstellung des Deutschen Werkbunds in Stuttgart." *Lübecker Gernalanzeiger,* 18 June 1929, p. 2.

Hermand, Jost. "Unity within Diversity? The History of the Concept 'Neue Sachlichkeit.'" In Keith Bullivant, ed., *Culture and Society in the Weimar Republic.* Manchester, 1977.

Horak, Jan-Christopher. "Discovering Pure Cinema: Avant-Garde Film in the '20s." *Afterimage* 8 (Summer 1980), pp. 4–7.

Horak, Jan-Christopher. "The Films of Moholy-Nagy." *Afterimage* 13 (Summer 1985), pp. 20–23.

Horak, Jan-Christopher. "Film und Foto: Towards a Language of Silent Film." *Afterimage* 7 (December 1979), pp. 8–11.

Hüter, Karl Heinz. *Das Bauhaus in Weimar: Studie zur gesellschaftspolitischen Geschichte einer deutschen Kunstschule.* Berlin, 1976.

Huyssen, Andreas. "Mass Culture as Woman: Modernism's Other." In Tania Modleski, ed., *Studies in Entertainment: Critical Approaches to Mass Culture.* Bloomington, 1986, pp. 188–207.

Internationalle Ausstellung des deutschen Werkbunds Film and Foto, exhibition catalogue, Stuttgart, 1929. Reprint, New York, 1979.

i 10: Internationale Revue. Periodical published in Amsterdam, 1927–1929; reprinted in Nendeln, 1979.

Jaffé, H. L. C. *De Stijl 1917–1931: The Dutch Contribution to Modern Art.* Amsterdam, 1956.

Jagels, Kah. "Frühe Fotografien Christian Schads." *Fotogeschichte* 18 (1985), pp. 23–28.

Jameson, Fredric. *The Prison-House of Language: A Critical Account of Structuralism and Russian Formalism.* Princeton, 1972.

Jaszi, Oscar. *Revolution and Counter Revolution in Hungary.* London, 1924; reprint 1969.

Kállai, Ernst. "Malerei und Photographie." *i 10: Internationale Revue* 4 (1927), pp. 148–157.

Kállai, Ernst. *Neue Malerei in Ungarn. Junge Kunst in Europa,* vol. 2. Leipzig, 1925.

Kandinsky, Wassily. *Punkt und Linie zu Fläche: Beitrage zur Analyse der malerischen Elemente.* Bauhausbücher no. 9. Munich, 1926.

Keller, Ulrich. "Die deutsche Porträtfotografie von 1918 bis 1933." *Kritische Berichte* 5 (1977), pp. 37–66.

Kemp, Wolfgang. "Das neue Sehen: Problemgeschichtliches zur fotografischen Perspektive." In *Foto-Essays zur Geschichte und Theorie der Fotografie.* Munich, 1978, pp. 51–101.

Kemp, Wolfgang. *Theorie der Fotografie,* vol. 2. Munich, 1979.

Kestner-Gesellschaft, Hannover. *Dada Photographie und Photocollage.* Exhibition catalogue with contributions by Carl-Albrecht Haenlein, Richard Hiepe, Eberhard Roters, Arturo Schwarz, and Werner Spies. Hanover, 1979.

Khan-Magomedov, Selim O. *Rodchenko: The Complete Work.* Cambridge, 1987.

Klee, Paul. *Pädagogisches Skizzenbuch.* Bauhausbücher no. 2. Munich, 1925.

Kovacs, Steven. "Man Ray as Film Maker." *Artforum* 11 (November 1972), pp. 77–82; and 11 (December 1972), pp. 62–66.

Kracauer, Siegfried. *From Caligari to Hitler.* Princeton, 1947.

Kraszna-Krausz, Andor. "Exhibition in Stuttgart, June 1929, and Its Effects." *Close Up* 5 (December 1929), pp. 455–464.

Krauss, Rosalind. "Jump over the Bauhaus." *October* 15 (Winter 1980), pp. 102–110.

Kroll, Friedheim. *Bauhaus 1919–1933: Künstler zwischen Isolation und kollektiver Praxis.* Dusseldorf, 1974.

Kühn, Heinrich. "Umblick." *Photographische Rundschau* 64 (1927), p. 13.

Kuspit, Donald B. "The Dynamics of Revelation: German Avant-garde Photography (1919–1939)." *Vanguard* 11 (September 1982), pp. 22–25.

Laqueur, Walter. *Weimar: A Cultural History 1918–1933.* New York, 1976.

Lavin, Maud. *Cut with the Kitchen Knife: The Weimar Photomontages of Hannah Höch.* New Haven, 1993.

Lavrentjev, Alexander. *Rodchenko Photography.* Translated from the German by John William Gabriel. New York, 1982.

Levinger, Esther. "Kassák's Reading of Art History." *Hungarian Studies Review* 15 (Spring 1988).

Levinger, Esther. "Lajos Kassák, *Ma,* and the New Artist 1916–1925." *The Structurist* 25–26 (1986), pp. 78–86.

Levinger, Esther. "The Theory of Hungarian Constructivism." *Art Bulletin* 49 (September, 1987), pp. 455–466.

Levy, Julien. *Memoir of an Art Gallery.* New York, 1977.

Leyda, Jay. *Kino: A History of the Russian and Soviet Film.* Princeton, 1983.

Lissitzky, El. "New Russian Art—A Lecture Given in 1922." *Studio International* 176 (October 1968), pp. 146–151.

Lissitzky-Küppers, Sophie, ed. *El Lissitzky: Life, Letters, Texts.* Translated by Helen Aldwinckle and Mary Whittal. Greenwich, Conn., 1968.

Lodder, Christina. *Russian Constructivism.* New Haven, 1983.

"Lucia Moholy." *Camera* 57 (February 1978), pp. 4–13, 35.

Ma: Aktivista Folyóirat. Periodical published by Lajos Kassák in Budapest, 1916–1919; Vienna, 1920–1925. Reprint, Budapest, 1971.

Malevich, Kazimir. *Die gegenstandlose Welt.* Bauhausbücher no. 11. Munich, 1925. Translated by Howard Dearstyne as *The Non-Objective World.* Chicago, 1959.

Man, Ray. *Self-Portrait.* Boston, 1963.

Mansbach, Steven A. "Science as Artistic Paradigm: A 1920s Utopian Vision." *The Structurist* 21–22 (1981–1982), pp. 33–39.

Mansbach, Steven A. *Standing in the Tempest: Painters of the Hungarian Avant-garde, 1908–1930.* Cambridge, 1991.

Mellor, David, ed. *Germany: The New Photography 1927–1933.* London, 1978.

Mellor, David. "London-Berlin-London: A Cultural History. The Reception and Influence of the New German Photography in Britain 1927–1933." In David Mellor, ed., *Germany: The New Photography 1927–1933.* London, 1978, pp. 113–130.

Michelson, Annette, ed. *Kino-Eye: The Writings of Dziga Vertov.* Berkeley, 1984.

Moholy, Lucia. "Das Bauhaus-Bild." *Werk* 55 (June 1968), pp. 397–402.

Moholy, Lucia. *100 Years of Photography.* London, 1939.

Molderings, Herbert. "Überlegungen zur Fotografie der neuen Sachlichkeit und des Bauhauses." In *Beiträge zur Geschichte und Ästhetik der Fotografie.* Lahn-Giessen, 1977. Revised and translated into English as "Urbanism and Technological Utopianism," in David Mellor, ed., *Germany: The New Photography 1927–1933.* London, 1978, pp. 87–94.

Mrázková, Daniela, and Vladimir Remes. *Early Soviet Photographers.* Museum of Modern Art, Oxford, 1982.

Musée Réattu, Arles, and Musée d'Art Moderne de la Ville de Paris. *Bauhaus photographie.* Exhibition catalogue, Arles, 1983.

National Museum of American Art, Smithsonian Institution, Washington, D.C. *Perpetual Motif: The Art of Man Ray.* Exhibition catalogue. New York, 1988.

Nerdinger, Windfried. *Walter Gropius.* Berlin, 1985.

Nesbit, Molly. "Photography, Art, and Modernity." In Jean-Claude Lemagny and André Rouille, eds., *The History of Photography.* New York, 1987, pp. 150–157.

Neusüss, Floris M. *Fotogramme—die lichtreichen Schatten.* Kassel, 1983.

Neusüss, Floris M., and Renate Heyne. *Das Fotogramm in der Kunst des 20. Jahrhunderts: die andere Seite der Bilder: Fotografie ohne Kamera.* Cologne, 1990.

Newhall, Beaumont. *Focus.* Boston, 1993.

Newhall, Beaumont. "Photo Eye of the 1920's: The Deutscher Werkbund Exhibition of 1929." *New Mexico Studies in the Fine Arts* 2 (1977), pp. 5–12.

Nisbet, Peter. *El Lissitzky, 1890–1941.* Cambridge, 1987.

Nisbet, Peter. "Some Facts on the Organizational History of the Van Diemen Exhibition." In Annely Juda Fine Art, *The First Russian Show. A Commemoration of the Van Diemen Exhibition, Berlin, 1922.* Exhibition catalogue. London, 1983.

O'Konor, Louise. *Viking Eggeling 1880–1925, Artist and Film-maker: Life and Work.* Stockholm, 1971.

Osman, Colin, ed. "Alexsander Michailovitch Rodchenko 1891–1956: Aesthetic, Autobiographical, and Ideological Writings." *Creative Camera International Year Book* (1978), pp. 189–233.

Ozenfant, Amédée, and Charles-Édouard Jeanneret. *La Peinture moderne.* Paris, 1925.

Pachnicke, Peter, and Klaus Honnef, eds. *John Heartfield.* Exhibition catalogue, The Museum of Modern Art. New York, 1992.

Pastor, Suzanne E. "Photography and the Bauhaus." *Archive* 21 (March 1985), pp. 4–25.

Phillips, Christopher. "The Judgement Seat of Photography." *October* 22 (Fall 1982).

Phillips. Christopher. *Photography in the Modern Era: European Documents and Critical Writings, 1913–1940.* New York, 1989.

Renger-Patzsch, Albert. *Eisen und Stahl.* Berlin, 1930.

Renger-Patzsch, Albert. *Technische Schönheit.* Zurich and Leipzig, 1929.

Renger-Patzsch, Albert. *Die Welt ist schön.* Munich, 1928.

Renger-Patzsch, Albert. "Ziele." *Das Deutsche Lichtbild* (1927), p. 18.

Ring, Nancy. *New York Dada and the Crisis of Masculinity: Man Ray, Francis Picabia, and Marcel Duchamp in the United States, 1913–1921.* Dissertation. Ann Arbor, 1991.

Rodchenko, Alexander. "Against the Synthetic-Portrait, for the Snapshot" (1928). Translated by John E. Bowlt in Christopher Phillips, ed., *Photography in the Modern Era.* New York, 1990, pp. 238–242.

Rodchenko, Alexander. "The Paths of Modern Photography." Translated by John E. Bowlt in Christopher Phillips, ed., *Photography in the Modern Era.* New York, 1990, pp. 256–263.

Roh, Franz, and Jan Tschichold. *Foto-Auge/Oeil et photo/Photo-Eye.* Stuttgart, 1929; reprint New York, 1978.

Rose, Barbara. "Kinetic Solutions to Pictorial Problems: The Films of Man Ray and Moholy-Nagy." *Artforum* 10 (September 1971), pp. 68–73.

Sachsse, Rolf. *Lucia Moholy.* Düsseldorf, 1985.

Sachsse, Rolf. *Photografie als Medium der Architekturinterpretation. Studien zur Geschichte der deutschen Architekturphotographie im 20. Jahrhundert.* Munich, 1984.

Sachsse, Rolf. "Skizze zu Lucia Moholy." *Fotografie* 7 (1983), pp. 98–100.

San Francisco Museum of Modern Art. *Avant-Garde Photography in Germany, 1919–1939.* San Francisco, 1980.

Schlemmer, Tut, ed. *The Letters and Diaries of Oskar Schlemmer.* Middletown, 1972.

Schmidt-Linsenhoff, Viktoria. "'Körperseele,' Freilichkeit, und neue Sinnlichkeit: Kulturgeschichtliche Aspekte der Akt-Fotografie in der Weimarer Republik." *Fotogeschichte* 1 (1981), pp. 46–59.

Senter, Terence A. *"Moholy-Nagy in England: May 1935–July 1937."* Unpublished thesis, University of Nottingham, 1975.

Senter, Terence A. "Moholy-Nagy's English Photography." *Burlington Magazine* (November 1981).

Senter, Terence A. "Moholy-Nagy's Vision of Unity." In Arts Council of Great Britain, *L. Moholy-Nagy.* London, 1980.

Shklovsky, Viktor. "Art as Technique." In Lee T. Lemon and Marion J. Reis, eds., *Russian Formalist Criticism, Four Essays.* Lincoln, 1965.

Solomon-Godeau, Abigail. "The Armed Vision Disarmed: Radical Formalism from Weapon to Style." *Afterimage* 10 (January 1983), pp. 9–14.

Solomon-Godeau, Abigail. "Photography after Art Photography." In Brian Wallis, ed. *Rethinking Representation.* New York, 1984, pp. 74–85.

Solomon R. Guggenheim Museum. *The Great Utopia: The Russian and Soviet Avant-Garde, 1915–1932.* New York, 1992.

Solomon R. Guggenheim Museum. *Kandinsky: Russian and Bauhaus Years, 1915–1933.* Exhibition catalogue by Clark V. Poling. New York, 1983.

Staatliches Bauhaus in Weimar 1919–1923. Munich and Weimar, 1923.

Stadt und Kunstverein, Ingolstadt. *Die Fotomontage: Geschichte und Wesen einer Kunstform.* Exhibition catalogue with essay by Richard Hiepe. Ingolstadt, 1969.

Stein, Sally. "The Composite Photographic Image and the Composition of Consumer Ideology." *Art Journal* 41 (Spring 1981), pp. 39–45.

Tafuri, Manfredo. *The Sphere and the Labyrinth: Avant-gardes and Architecture from Piranesi to the 1970s.* Translated by Pellegrino d'Acierno and Robert Connolly. Cambridge, 1990.

Teitelbaum, Matthew, ed. *Montage and Modern Life, 1919–1942.* Cambridge, 1992.

Tendenzen der zwanziger Jahre: Europäische Kunstausstellung, Berlin. Berlin, 1977.

Tökes, Rudolf L. *Béla Kun and the Hungarian Soviet Republic: The Origins and Role of the Communist Party of Hungary in the Revolutions of 1918–1919.* New York, 1967.

Tupitsyn, Margarita. "Fragmentation versus Totality: The Politics of (De)framing." In *The Great Utopia: The Russian and Soviet Avant-Garde, 1915–1932.* New York, 1992, pp. 482–496.

Vierhuff, Hans Gotthard. *Die neue Sachlichkeit: Malerei und Fotografie.* Cologne, 1980.

Von der Heydt-Museum, Wuppertal. *Schadographien 1918–1975, Photogramme von Christian Schad.* Exhibition catalogue. Wuppertal, 1975.

Walker, Ian. "Man Ray and the Rayograph." *Art and Artists* 10 (April 1975), pp. 40–42.

Walker Art Center, Minneapolis. *De Stijl: 1917–1931, Visions of Utopia.* Exhibition catalogue. Minneapolis, 1982.

Warstadt, Willi. "Die entfesselte Kamera und die produktive Kamera." *Deutscher Kamera-Almanach* 19 (1929), p. 44.

Watney, Simon. "Making Strange: The Shattered Mirror." In Victor Burgin, ed., *Thinking Photography.* London, 1982, pp. 154–176.

Weiss, Evelyn, ed. *Rodchenko Fotografien, 1920–38.* Cologne, 1980.

Wescher, Herta. *Die Collage: Geschichte eines künstlerischen Ausdrucksmittels.* Cologne, 1968.

Willett, John. *Art and Politics in the Weimar Period: The New Sobriety 1917–1933.* New York, 1978.

Willett, John. *Culture in Exile: Russian Emigres in Germany 1881–1941.* Ithaca, 1972.

Wingler, Hans Maria. *The Bauhaus: Weimar, Dessau, Berlin, Chicago.* Translated by Wolfgang Jabs and Basil Gilbert. Cambridge, 1979.

Württembergischer Kunstverein, Stuttgart. *Film und Foto der zwanziger Jahre: Eine Betrachtung der Internationalen Werkbundausstellung "Film und Foto" 1929.* Exhibition catalogue with essays by Ute Eskildsen and Jan-Christopher Horak. Stuttgart, 1979.

index

Page numbers in italics indicate illustrations.

Abstract film, 43, 52. *See also Lichtspiel schwarz-weiss-grau*
Abstract of an Artist. See Von Material zu Architektur
Activists, Hungarian, 13–14
AEG (Allgemeine Elektrizitäts-Gesellschaft), 45–46, 91, 222n6
Aerial ("bird's-eye") view in photography, 118–127; *117, 120, 122, 123, 124, 125, 126, 134*
Albers, Josef, 37, 189, 194, 211
Archipenko, Alexander, 43–44
Architecture. *See also* Bauhaus; *Glass Architecture;* "Light architecture"
 drafting techniques and constructivism, 21–24
 and photography, 103–104, 107–127; *108, 109, 111, 113, 115, 117, 119, 120, 123, 124, 125*
 theory, 107–114, 191–194
Arp, Hans, 15, 61, 212; *66*
Art photography. *See Kunstphotographie;* Pictorialism
Ascona, Switzerland, 131–133
Atget, Eugène, 100–101
"Aufruf zur elementaren Kunst," by Moholy-Nagy, Kemény, and Puni, 15–21, 44
Automatism
 and photograms by Man Ray, 67–70
 and writings by Breton and Soupault, 70

Ball, Otto, 91

Bauhaus, 34–40, 43, 61, 72–73, 76–91, 112–121, 175–177, 187–195; *113, 117, 119*

Bauhaus Books (*Bauhausbücher*), 175–195. See also *Bühne im Bauhaus, Die; Malerei, Photographie, Film; Von Material zu Architektur*

Bauhaus photography, 97, 195, 209

Benjamin, Walter, 3, 10–11, 209, 216n1, 217n17, 230n21

Berény, Robert, 13

Bildarchitektur, 219n9

Book of New Artists. See Buch neuer Künstler

Bortnyik, Sándor, 21

Brandt, Marianne, 38

Breton, André, 70

Brik, Osip, 33, 200, 202

Broom, 54, 72, 83, 225n44; *88*

Buch neuer Künstler, 20, 43–46, 176, 185; *46*

Bühne im Bauhaus, Die, by Moholy-Nagy, Schlemmer, and Molnár, 176, 229n3

Champs délicieux, Les, by Man Ray, 70; *69*

"Champs magnétiques, Les," by Breton and Soupault, 70

Chaplin, Charlie, 169; *172*

Citroen, Paul, 35

Coburn, Alvin Langdon, 118, 225n42; *120*

Colonialism, German, 158, 161; *159, 160*

Constructivism. *See also* Photograms; Photomontage; Tatlin, Vladimir
 and the Bauhaus, 34–35
 international, 33
 Russian, 7–8, 20–21, 24, 32–33, 43, 49, 61–67, 72, 147

Counter-composition, 114–118, 129, 130; *113, 116, 117, 130*

Dada, 14–15, 20, 43, 129, 147–156. *See also* Photomontage; Schad, Christian

Dada-Constructivist Congress, Weimar (1922), 34, 72; *35*

"Defamiliarization." *See Ostranenie*

Dell, Christian, 37

Democratization of photography, 181–182, 206, 212

Deutscher Werkbund, 34–36, 100, 103, 203

Doesburg, Theo von, 14, 15, 33, 34, 43, 45, 48, 111, 114–115, 173, 176, 218n7; *116*

"Domestic Pinacotheca," 181–182

Duchamp, Marcel, 67, 206

Dynamic of the Metropolis (Dynamik der Grosstadt), 166, 183–184, 231n30; *184*

"Dynamisch-konstruktives Kraftsystem," by Moholy-Nagy and Kemény, 8, 27

Eggeling, Viking, 43, 45, 52

Ehrenburg, Il'ya, 33, 220n22

Eiffel Tower, Paris, 107–112, 188, 194; *109*
Einstein, Albert, 3, 73–74, 225n31
Elemental art, 15–20
Engineering. *See* Technology
Ernst, Max, 150, 153, 156; *152, 155*
Erste russische Kunstausstellung (First Russian Art Exhibition), Berlin (1902), 32, 34
Es kommt der neue Fotograf! See Gräff, Werner
Esprit nouveau, 45

Factography (documentary photography in the USSR), 199, 209–210
Faktura, 7–8, 49, 57, 61, 76, 93, 198, 224n15
Fedorov-Davydov, Alexei, 8, 10
Feininger, Lux, 191
Feininger, Lyonel, 35–36, 40
Fifo. See Film und Foto exhibition
Film scripts. *See under* Moholy-Nagy, László
Film und Foto exhibition *(Fifo),* 4–6, 195, 203–207, 209; *204, 206*
First Russian Art Exhibition, Berlin (1902). *See Erste russische Kunstausstellung*
Form, Die, 103, 227n14
Formalism. *See* Formalist photography; Shklovsky, Viktor
Formalist photography, 4–6, 197–203, 207, 211–215
Foto-Auge, by Roh and Tschichold (1909), 5, 83
Fotoplastiken (Photoplastics), 147–150, 223n20
Fourth dimension, 73
Frank, Ellen, 133, 138–142, 215; *141, 145*
Funkturm (Radio Tower), Berlin, 121–127; *123, 124, 125*
Futurism, 20, 43

Gabo, Naum, 8, 20, 27, 33, 93, 189
Gemeinschaft, 213
Giedion, Sigfried, 110–111; *111*
Glass Architecture (Ủvegarchitektúra), 21–22, 24, 52, 72; *23. See also* Scheerbart, Paul; Taut, Bruno
Gräff, Werner, 203
Greenberg, Clement, 49
Gropius, Walter, 34–37, 40, 112–114, 118, 175, 180, 187–188, 194–195, 210–212
Grosstadt. See Dynamic of the Metropolis
Grosz, George, 156

Hartwig, Josef, 83
Hausmann, Raoul, 14, 156, 201
Heartfield, John, 201
Henri, Florence, *140*
Hevesy, Iván, 44
Hirschfeld-Mack, Ludwig, 83

Höch, Hannah, 14, 153, 158, 201

Industrialization, 3, 14–15, 20, 173. *See also* Technology
Institute of Design, Chicago, 4, 93
Itten, Johannes, 36–37, 40, 189

Kállai, Ernst (Ernö), 7, 10, 76, 216n4, 216n7
Kandinsky, Vasily, 35, 38, 72, 194, 219n12
Kassák, Lajos, 13–14, 20–21, 43–44, 219n9
Kemény, Alfréd, 7–8, 10, 33
Kepes, György, 210, 231n40
"Kino-Eye," theory of Vertov, 197–199
Kinofot, 201
Klee, Paul, 35, 38, 194
Klutsis, Gustav, 78, 156
Kunstphotographie (art photography in Germany and Austria), 97–100, 203. *See also* Pictorialism
KURI Group (*Konstruktive, Utilitäre, Rationale, Internationale),* at the Bauhaus, 34

Landau, Erzsébet (Erzsi), 104; *frontispiece*
Le Corbusier, 191
Léger, Fernand, 43, 45
Lenin, V. I., 198–199
Lichtspiel schwarz-weiss-grau (Lightplay Black-White-Gray), 67, 93; *95*
Lichtwark, Alfred, 100, 227n5
Light. *See also* Einstein, Albert; *Glass Architecture; Lichtspiel schwarz-weiss-grau;* "Light architecture"; *Light-Space Modulator;* Photograms
 imagery of, 72–77
 as medium, 49–54, 74, 76, 83–91, 182–183, 187–191
 spirituality, as metaphor for, 72–73
"Light—A Medium of Plastic Expression" (1923), 54, 67
"Light architecture" (light displays), 76, 83–91, 183
Lightplay Black-White-Gray. See Lichtspiel schwarz-weiss-grau
Light-Space Modulator, The, 91–93; *92*
Lissitzky, El, 14, 24, 32, 33, 34, 45, 47, 72, 76, 78, 83, 111, 114, 158, 191, 203, 212, 221n42, 229n7
Loeb, Harold, 72
Lozowick, Louis, 72
Lunacharsky, A. V., 198–199

Ma, 7, 13–14, 20, 32, 43, 45; *23*
"Making strange." *See Ostranenie*
Malerei, Photographie, Film, 8, 10, 39, 70–72, 76, 83–84, 103–104, 146, 147, 177–187, 189, 194, 197, 199–201, 212; *180, 184, 185, 186*
Malevich, Kazimir, 24, 32, 45, 57, 74–78, 111, 114, 121, 194; *79*
"Manifesto of Elemental Art." *See* "Aufruf zur elementaren Kunst"
Man Ray, 47, 57–60, 67–72, 75; *69, 71*

index

Marinetti, Filippo Tommaso, 20

Marseilles, 125–127, 184; *126*

Mass media, 76, 147, 150, 156–165, 173, 209, 212

Mass production, 48, 100–103, 181, 188–189

Mayakovsky, Vladimir, 201–202

Metal workshop, Bauhaus, under Moholy-Nagy, 36–38

Metropolis. *See Dynamic of the Metropolis*

Militarism, 158–161; *159, 160*

Modernismus, 3–5, 11, 100, 129, 147, 212–213

Modernist photography. *See* Formalist photography

Moholy, Lucia, 14, 27, 46–47, 57–58, 60–67, 76, 103, 104, 118, 131, 133, 138–142, 169, 227n21; *119, 132, 136, 137, 143*

Moholy-Nagy, László
 in Amsterdam, 210
 and Berlin, 13–34
 in Chicago, 4, 93, 210
 commercial work, 83, 209–210; *88–89, 204*
 and dada, 14–16; *17–18* (*see also* Photograms; Photomontage)
 departure from the Bauhaus, 40
 early years in Hungary, 13–14, 217n1, 218n2
 exhibitions (*see Film und Foto* exhibition; Sturm, Der)
 as exiled artist, 4, 13–14, 209–215
 films by, 184 (*see also Lichtspiel schwarz-weiss-grau*)
 film scripts by, 165, 183–184, 231n30
 in London, 210
 and painting, 14–24, 27, 32–34, 180–182, 212–213, 221n39; *18–19, 22, 23, 25, 51, 87, 157, 186*
 pedagogy, 4, 36, 93, 202–203, 210–211 (*see also* Metal workshop, Bauhaus; *Vorkurs,* Bauhaus)
 political views, 14, 40, 218n2
 portraits of, *2, 13, 35, 106, 170–171*
 publications, 9, 197, 232n1, 232n2 (*see also* "Aufruf zur elementaren Kunst"; *Buch neuer Künstler;* "Dynamisch-konstruktives Kraftsystem"; "Light—A Medium of Plastic Expression"; *Malerei, Photographie, Film;* "Produktion/Reproduktion"; *Von Material zu Architektur*)
 reviewers on, 4–11, 32
 sculpture by, 24–27, 38; *26, 28, 30, 39, 92* (*see also Light-Space Modulator*)
 utopian views of, 3–4, 10–11, 15–21, 33–36, 48, 176, 181–182, 187–195, 211–212
 women, images of, 129–146, 150–156, 158–173; *132, 136–137, 141–149, 151, 154, 160, 162–164, 166, 170, 172*

Moholy-Nagy, Sibyl, 8, 211, 217n14

Molnár, Farkas, 176

Mondrian, Piet, 33, 48

Museum of Modern Art, New York, 5

Muthesius, Hermann, 100

Neoplasticism, 223n20. *See also* Mondrian, Piet

Neue Sachlichkeit, 97–103, 110, 226n4
New Bauhaus, Chicago, 4, 210
Newhall, Beaumont, 5, 6, 213, 216n2
New Objectivity. *See Neue Sachlichkeit*
New Photography, 9–10, 97–103, 209
New Typography. *See* Typography
New Vision, 3–5, 9–10, 97, 107, 121, 195, 202, 206, 209, 211, 213–215,
 217n19
New Vision and Abstract of an Artist, The. See Von Material zu Architektur
New Woman, 129–131, 153, 158–166
Nickel Construction, 24; *28*
Notre Dame, Paris, 102–107; *108*
Nudes, photographs of, 142–146, 228n6; *148, 149*

Ostranenie, theory of (Shklovsky), 104–105, 198, 201

Painting, Photography, Film. See Malerei, Photographie, Film
Péri, László, 21
Peterhans, Walter, 195
Pevsner, Antoine. *See* Gabo, Naum
Photograms. *See also* Einstein, Albert; Man Ray; Schad, Christian
 collaboration with Lucia, 46–47, 57, 76
 commercial applications, 83; *88, 89*
 and constructivism, 70–72, 74–77
 and dada, 67, 70
 definition of, 47
 and film, 52–54, 91–93
 first experiments by the Moholys, 46–47, 60–61
 history of, 59–60
 "positive" photograms, 77; *77, 78, 80, 82*
 and surrealism (*see* Man Ray)
 technique, 60–67
 and the *Vorkurs,* 49–52, 77–91
 writings on, 182–183 (*see also* "Light—A Medium of Plastic Expression";
 "Produktion/Reproduktion")
Photomontage, 146–147. *See also Fotoplastiken;* Höch, Hannah; Mass
 media
 and constructivism, 156–158
 and dada, 147–156
 definition and history of, 146, 147–150
 and film, 165–173
 and surrealism, 165
Photoplastics. *See Fotoplastiken*
Picabia, Francis, 14–15
Pictorialism, 5. *See also Kunstphotographie*
Pietzsch, Sibyl. *See* Moholy-Nagy, Sibyl
Planck, Max, 73
"Poly-cinema," 166, 169, 183–184; *167, 168*
Productivism, 32

"Produktion/Reproduktion," article in *De Stijl* (1922), 43, 46–54, 183, 189
Puni, Ivan, 15, 33, 43

Quantum theory. *See* Einstein, Albert

Radical formalism, in photography. *See* Formalist photography
Rayographs (photograms by Man Ray). *See* Man Ray
"Realistic Manifesto," by Gabo and Pevsner (1919), 8, 20
Relativity, theory of. *See* Einstein, Albert
Renger-Patzsch, Albert, 49, 101–103, 107, 110; *102*
Richter, Hans, 43, 52; *53*
Rodchenko, Alexander, 10, 21, 32, 37, 114, 175, 200–203, 209–210; *115*
Roh, Franz, 5, 6, 83, 133, 138, 204–205
Russian formalist criticism. *See* Shklovsky, Viktor
Russian formalist photography, 10, 197–202
Ruttmann, Walther, 52

Schad, Christian, 47, 57–61, 71; *65*
Scheerbart, Paul, 21, 72
Schlemmer, Oskar, 36, 131, 133, 153, 176, 194
Schmidt, Kurt, 153
Schreyer, Lothar, 73
Schultz, Lucia. *See* Moholy, Lucia
Schwerdtfeger, Kurt, 83
Schwitters, Kurt, 61, 147
Science and scientific photography, 37, 39, 73–74, 182–183, 185–186, 194
Sebök, István (Stephan), 91, 226n49
Shklovsky, Viktor, 10, 33, 104–107, 198, 200–202, 207, 209
Sörensen-Popitz, Irmgard, 78; *85*
Space-time continuum. *See* Einstein, Albert
Sportkultur, 161; *163, 164*
Stalin, Josef, 199
Stieglitz, Alfred, 6, 101, 213
Stijl, De, group and periodical, 15, 20, 34, 45, 48. *See also* Doesburg, Theo van
Strand, Paul, 100–101, 213
Sturm, Der, group and gallery, 24, 32, 33, 72
Suprematism. *See* Malevich, Kazimir
Surrealism, 67–71, 129. *See also* Man Ray

Talbot, William Henry Fox, 59
Tarabukin, Nikolai, 20
Tatlin, Vladimir, 24, 35, 44, 45, 93; *29*
Taut, Bruno, 21, 72
Technology, imagery and materials of, 3, 7, 14–15, 27, 33–35, 37–38, 44, 47, 52, 188–189, 194, 213; *16–18, 28, 31, 39. See also Buch neuer Künstler*

Telephonbilder (*Telephone Pictures*), 7, 27, 34; *31*
Tschichold, Jan. *See Foto-Auge*
Typography, 38–39, 177–180, 221n42, 226n1, 229n7, 230n11
Tzara, Tristan, 61, 67–70, 72

Uitz, Béla, 33
Umanskii, Konstantin, 32
Utopianism, 3–4, 15–21, 32–34, 48. *See also under* Moholy-Nagy, László
Üvegarchitektúra. See Glass Architecture

Vertov, Dziga, 10, 166, 197–202, 205
"Virtual volume," 189
VKhUTEMAS (Higher State Artistic and Technical Workshops, Moscow), 37
Von Material zu Architektur, 4, 39, 83, 91, 176, 180, 187–195
Vorkurs, Bauhaus, under Moholy, 36–38, 49, 77–91, 186–195

Wagenfeld, Wilhelm, 221n39
Welt ist schön, Die (The World Is Beautiful). See Renger-Patzsch, Albert
Werkbund. *See* Deutscher Werkbund
Weston, Edward, 203, 213
Wright, Frank Lloyd, 112, 191